English Literature Series

General Editor:—J. H. FOWLER, M.A.

SELECTIONS
FROM 'THE STONES OF VENICE'

MACMILLAN AND CO., Limited
LONDON · BOMBAY · CALCUTTA · MADRAS
MELBOURNE

THE MACMILLAN COMPANY
NEW YORK · BOSTON · CHICAGO
DALLAS · SAN FRANCISCO

THE MACMILLAN CO. OF CANADA, Ltd.
TORONTO

Selections

from

'The Stones of Venice'

By

John Ruskin

Edited by

Edward A. Parker, M.A., Ph.D.

Professor of English, Wilson College, Bombay

MACMILLAN AND CO., LIMITED
ST. MARTIN'S STREET, LONDON
1925

PRINTED IN GREAT BRITAIN

CONTENTS

ILLUSTRATIONS

INTRODUCTION

JOHN RUSKIN'S ancestry has always fascinated his biographers. His grandmother, Catherine Tweddale, had Viking and Celtic blood in her from her great-grandfather, John Adair of South Galloway, and Norman blood from John Adair's wife, Mary Agnew ; Catherine's grandfather had married into a family of soldiers and Arctic explorers, and her father came of a great Covenanting family, the Tweddales of Glenluce, who held the original Covenant. Viking, Celt, and Norman, Catherine Tweddale showed something of her blood by running away at sixteen with John Ruskin of Edinburgh in 1781, and, four years later, our writer's father, John James Ruskin, was born to them in their house in the Old Town and, in due time, received the solid classical education of the age at the High School of Edinburgh.

Thus much is well known to biography, but the best of the story is yet to tell and is not generally known. Ruskin used to amuse himself with guesses at the origin of his surname. Erskine, Roskeen, Rogerkins, even Roughskin, all possibilities were reviewed and laughingly rejected. It appears, however, that the name is Celtic, from the word " ruisg " meaning " bark," and that Ruskin's paternal ancestors received it from their collecting bark for the tanners. Ruskin's great-grandfather would seem to have driven this humble trade, but what catches poetry-lovers' attention is that this man lived in the village of Taynuilt * in Argyllshire, whence had also sprung the ancestors of Burns. This knowledge might well have delighted Ruskin. For us this particular Celtic strain suggests an origin for his marvellous descriptive powers. His great-aunt, wife of a tanner at Perth, possessed, it is related, a passion for sunrises and mountain

* In Gaelic " Tigh-an-Uillt," " House of the Burn," whence the Burns family chose its name.

scenery, revealing characteristics of that strain that everyone connected with Ruskin himself.

Ruskin's father's practicality and caution recall rather the Norman inheritance and Lowland Scots upbringing. The grand-father, wine merchant in Edinburgh, had spent magnificently in hospitality to a fine circle of friends and left the family heavily in debt. John James Ruskin, finishing his education at 22, entered the wine trade as a clerk in a famous London firm, showing such ability that a fellow-clerk, Peter Domecq, who owned great plantations at Macharnudo in Spain, took him into partnership, a third person, Telford, supplying the capital. The business brains and intense application of Ruskin's father paid off the family debts in nine years and allowed him to marry his first cousin, Margaret Cox, whose father had been a master mariner in the Yarmouth herring trade.

Their only child, John Ruskin, was born in London on the 8th February, 1819. At the age of four he was taken to live at Herne Hill, south of London and at that time in the country and with a view of the Norwood Hills, Harrow and Windsor. Here and at Denmark Hill, where the family afterwards lived, he spent forty years with his parents and a further seven with his mother after his father's death in 1864, a period broken only by journeys and the brief failure of his marriage.

Whatever was handed down to Ruskin by mingled strains of ancestry was purged and corrected by a parental husbandry without parallel in the history of literature. Ruskin's father looked upon life as a field for honest and strenuous individual effort and irreproachable respectability ; to these Early Victorian virtues he added the graces of friendship and hospitality and a fine taste in art. Ruskin's mother was born strong-minded, and her pre-Darwinian belief in the literal inspiration of the Bible established her in severe and narrow ways of thinking and living. Ruskin, up to the age of 17, received only the scrappiest education from tutors and classes ; he lived and moved and grew up under the shadow of his parents. It is fair to speak of a " shadow " because, despite the solidly comfortable home, the extreme care of his sometimes delicate health, and the great diversion of travelling, there was no outside world known to the child's and youth's mind till an age when that mind was set, and inside the

home Ruskin lived like a minute adult. He was precociously clever, taught himself to read by whole sentences at four, was made to read the Bible from beginning to end, two or three chapters a day without omissions, to his mother, added Pope's *Homer* and Scott for pleasure, *Robinson Crusoe* and *The Pilgrim's Progress* on Sundays, had no toys and was frequently whipped.

With the opening of spring every year, the father Ruskin set out on a tour by carriage through some part of England and Scotland, collecting orders for sherry. This diversion the child shared in as soon as he could bear the fatigue and, in this open and leisurely style of travelling, came to know the main-roads and most cross-roads and all the castles, cathedrals, ruins, country houses, colleges and picture-galleries of any consequence in the country. At six he saw Paris, Brussels, and Waterloo ; at fourteen, Flanders, the Rhine, the Black Forest, and caught his first vivid impression of the Alps from Schaffhausen.

Expression, too, came very early. His first letter dates from near his fourth birthday, his first sermon from before it. He wrote, by imitating print, verse from the age of seven, journals of every spring tour, long poems, a play, some of these illustrated and bound with his own hands as presents on his father's birthday. His writings before *Modern Painters* are almost entirely echoes of his favourite authors. Of Ruskin there appears only a constant love of description.

In 1836 he entered Christ Church, Oxford, knowing, of the ordinary courses of study, some Latin, Euclid and algebra, a very little Greek and French ; really strong and far beyond his peers he was in physics, geology, botany and mineralogy, having his own classified collections and an acquired power of intense observation and extreme fidelity of description. Destined by his parents for a bishopric, he found himself, as a gentleman-commoner, in a crowd of sporting youths with exactly the opposite upbringing to his own. Christ's, Oxford, had now its " lady " as Christ's, Cambridge, had had in Milton just 200 years earlier.

Ruskin's wit, brains and sherry won him, however, a place in University society and, against his natural bent for science, he mastered Latin, came to know Thucydides word for word by heart, and, in 1842, after a serious breakdown in health, took his

degree with the very uncommon distinction of a Double Fourth in Classics and Mathematics, a rank equivalent in the Pass examination to a Double First in Honours. His undergraduate-ship is memorable for the capture of the Newdigate verse prize in 1839 with *Salsette and Elephanta* and for a love-affair with Adèle, the eldest of M. Domecq's four daughters, which the girl of fifteen found amusing enough but which Ruskin at seventeen took with characteristic earnestness. This emotion bore fruit in a series of poems and plays reminiscent of Byron and Shelley, a tubercular attack in 1840 when Adèle married Baron Duquesne, and a memory poignant for forty years. The breakdown neces-sitated an absence of eighteen months from Oxford, spent in a journey to Italy but in such a weak condition that Florence, Rome and Siena left only impressions of falseness and failure.

By 1842, however, Ruskin had made two discoveries of the first importance : first, that he was destined, not for a bishopric in the English Church, but for a high-priesthood of Nature and, to a less extent, of Art ; second, that Turner was the greatest painter of Nature of all time. In 1837 his father bought him " Richmond, Surrey," the first of a long series of Turner acquisi-tions ; in June 1840 he was taken to see Turner himself—" a somewhat eccentric, keen-mannered, matter-of-fact, English-minded gentleman," as he notes in his diary.

The two discoveries concerning himself and Turner required but one condition to produce an outburst of literary power, and this presented itself in the general misunderstanding in England of Turner's later manner of painting, recently taken up, which promised to lose him general and critical favour, whatever it was worth. Ruskin had written for the public since 1834, first on scientific subjects for Loudon's *Magazine of Natural History*, then, in 1836, a reply to an attack on Turner in *Blackwood's Magazine* ; in 1837 he had written a series of papers for Loudon's *Architectural Magazine* under the pen-name " Kata Phusin," which had won him such recognition that his opinion was asked, the following year, on a site and form for the proposed Scott memorial for Edinburgh.

" Kata Phusin "—" According to Nature "—was a name prophetic of Ruskin's outlook on life and of the whole of his work. From early childhood he had bent his immense powers of observa-

tion, deduction and vivid description on stones, trees, the sky and sea, lakes and, above all, mountains. He knew their character, detailed and general, with an intimacy rare among men, and to this technical knowledge he was able to add a marvellous skill and fidelity of technique in drawing with pencil or with pen and light sepia washes, learnt in study under Copley Fielding at the age of 15 and under Harding at 22, that established the veracity and power of his written accounts. A vision had come to him, just before graduation, from the drawing of a tendril of ivy seen encircling a thorn-stem at Herne Hill that " if he could express his sense of the charm of the natural arrangement, what use in substituting an artificial composition ? . . . Be sincere with Nature, and take her as she is ; neither casually glancing at her ' effects,' nor dully labouring at her parts, with the intention of improving and blending them into something better; but taking her all in all " (Collingwood).

So trained and inspired, he set out at 23 years of age, in the autumn of 1842, to show that, in faithful portrayal of Nature, the admired masters of the age—Claude, Gaspar Poussin and Canaletto, in particular—were ignorant and careless bunglers where Prout, Fielding and Harding were painstakingly sound, while Turner, perfectly faithful always as none of these even were, far surpassed all in an imaginative truth and beauty which are Art's crown to Nature. As a general principle arising from this, he laid it down that artists should go to Nature " rejecting nothing, selecting nothing, scorning nothing."

This is the bare kernel of the first volume of *Modern Painters*, which, published in May 1843, as by " A Graduate of Oxford," for modesty's sake, created an immense stir and gave Ruskin a place in the forefront of art teachers and critics that, though fiercely combated at times, he held henceforth and still largely holds.

Each day's work at the book had been read, as it was finished, to the delighted parents, and the father particularly desired its continuation. Mainly for rest, the family journeyed to Switzerland in May 1844, and, on the way back, Ruskin discovered, in the galleries of the Louvre in Paris, that Italian painters in the Middle Ages had practised superbly all that he believed in. Canvases of Titian and Veronese, of Bellini and Perugino, opened

a new world to him in painting. Returned to England, he spent the autumn and winter in reading the history of Italian Art, and, in April 1845, he set out, without his parents for the first time, to explore Italy with an understanding eye at last, and to gather material for an extended application of the main principles of *Modern Painters*.

Unexpectedly enough, it was architecture that seized his awakened attention first. The tomb of Ilaria di Caretto at Lucca and the Spina Chapel at Pisa, where he spent ten hours a day drawing with his exquisite fidelity, proved revelations to a mind that had thought on the art of building ten years earlier but had experienced no supreme example of that art hitherto. With his mind on the new discovery Ruskin moved on to Florence, visiting monasteries and chapels, and here he was drawn back again to painting by the work of Angelico and Ghirlandajo. Filled with new ideas and emotions, he was about to turn homewards when, following a suggestion from Harding, whom he had met at Baveno, he moved on with his friend to Verona—a city full of influence on his thought—and, at last, to Venice. Here artist and critic spent a week together gathering impressions of light-effects on sea and city, and, in a chance moment, entered the then neglected Scuola di San Rocco. Here burst upon Ruskin the third artistic revelation—following on the ivy at Herne Hill and Caretto's tomb—the paintings of Venice's greatest master, Tintoretto.

Far advanced, in two and a half years, beyond the position of the first volume, Ruskin worked, at Denmark Hill, on the second volume of *Modern Painters*. The contrast between the glorious mediæval artistry of Italy and her decayed moral and social life when he saw her set him a problem his ethical nature could not avoid. Besides introducing two schools of painting then unknown to England—those of Angelico and Tintoretto—the second volume sets out to connect beauty with healthy conditions of life, whether in Nature or Man.

Thus, almost unknown to himself, Ruskin had taken his first step out of the realm of pure art into that neighbouring country in which the second half of his life was really spent, Socialism. Or, to change the metaphor, he had hitherto been content to revel in the surface beauty of natural phenomena and man's creations; he was now, without losing that delight, about to

dig below the surface and enquire into the nature of the ground
whence they sprung, the subsoil and rocky structure of man's
ways and the character of human society.

To combat the exhaustion produced by the writing of the
second volume of *Modern Painters*, Ruskin again tried foreign
travel. With his parents, the journey was made across the Mont
Cenis to Turin, Verona and Venice, then back to Chamounix,
where days of delight were spent in faithful drawing of rocks and
glaciers.

In the autumn of 1846 he found literary men in England eager
for his acquaintance and help. Lockhart particularly desired
from him a review of Lord Lindsay's *Christian Art* for the *Quarterly
Review*. The labour spent on this, and an attraction for Charlotte
Lockhart, Sir Walter Scott's granddaughter, that ended fruit-
lessly, reduced Ruskin, in mind and body alike, to severe illness
and depression.

Ruskin's parents, considering marriage to be the cure, directed
his thoughts to Euphemia Chalmers Gray, the daughter of Perth-
shire friends, and the girl for whom, seven years earlier when
she was staying with the Ruskins, John had written the fairy
story *The King of the Golden River*. The marriage was arranged
and took place on the 10th April, 1848. After a brief sojourn in
Normandy to cure a chill on the lungs Ruskin had caught while
sketching on Salisbury Plain, the couple set up house in Park
Street, London. Ruskin worked hard through the winter at the
composition of *The Seven Lamps of Architecture*, which was
published in the spring of 1849.

Ruskin's growing preoccupation with the human aspects of
art had by now, to some extent, displaced the less-understood art
of painting with that art which, dealing as it does with houses,
churches and public buildings, faces the public gaze everywhere
and should receive, therefore, public understanding—the art of
architecture. The young critic found in London generally, that
architects and builders for the most part were supinely following
eighteenth century styles of building which claimed the title
" classical " from their avowed descent, through Renascence
models, from Greek and Latin styles. Ruskin's studies, in England
and Italy, had immersed him, on the other hand, in mediæval or so-
called Gothic architecture, and his parallel studies of the social

conditions underlying the mediæval practice of this art had taught
him lessons about the moral aspect of it which, he felt, contained
the only hope for a resurrection in England of a true understand-
ing of architecture. Seven of these lessons (he could have added
several more)—those dealing with the place of Truth, Beauty,
Power, Sacrifice, Obedience, Labour and Memory in the artistic
labour of architect and builder—he enunciated as *The Seven Lamps
of Architecture* ; and he enforced his meaning with aphorisms in
black type, with marvellous illustrations from his own pencil,
and with an eloquence and power of description beyond what
even *Modern Painters* had promised.

The Seven Lamps was the first book in English to make Archi-
tecture a public question. It moralised and socialised what is
the most public of arts, and is probably the book by which Ruskin
is best known, though he himself later came to despise its gorgeous
purple writing and to correct many statements in it hostile to
the Greeks.

Ruskin's marriage, as his own silence and his biographers'
extreme reticence show, was a marriage merely in name. Between
the student-recluse and the brilliant, high-spirited, society-loving
girl there proved to be little community of interest. She left her
husband in 1853, instituted a case for nullity of marriage in the
Scottish court which was not defended, and soon after married
the painter and later President of the Royal Academy, Everett
Millais, who had painted both her and Ruskin a little previously
and has shown her as the wife in the picture " The Order for
Release."

Venice Ruskin had first seen when, as a boy of 18, he had been
sent on the Continent to recruit from pleurisy. Six years later,
in May 1841, he again spent two days there, and, after the dis-
appointment of Rome, felt the sea-city's enchantment and made
drawings of its beauty with his usual care. It was not, however,
till he saw it again with Harding in 1847 that Venice laid a
compelling hold on him, and then it was the almost chance
discovery of the Tintoretto paintings in the then desolate Scuola
di San Rocco that converted what had been to Ruskin till then
only the expiring wonder-city of Byron and Turner into a dream-
impulse toward new things. The paintings of the Venetian
master drove him to a study of the life-history of Venice and

especially of the social conditions accompanying her growth, her glory, and her decay.

He gave himself to the reading of Venetian history in the available authorities. Then, in November 1849, he settled in Venice with his wife and spent the four winter months in the detailed study of each separate stone of importance in the fabric of St. Mark's and of the Doges' Palace. He took the exactest possible measurements of each piece, attempted to fix its date and made scrupulously accurate as well as beautiful drawings. Returned to England in the spring of 1850, he set himself to the writing of volume I. of *The Stones of Venice*, while superintending with interminable care the conversion of selected drawings into exquisite engravings by the first craftsmen of the day.

The first volume appeared in 1851. The following year Ruskin again visited Venice, whose enchantment over him was already beginning to wane, and the material gathered went into volumes II. and III., published together in 1853.

The substance of the work is given in minature by itself just before the selections. The book was an extension of the principles of *The Seven Lamps* and the application of its social and moral implications to the history and architecture of Venice, with a constant reference to the London that Ruskin knew. There was a twofold plan : first, to show that the virtues of early Venice had made both her history and her architecture glorious and that her moral decay had destroyed both, and, second, that her buildings had been most nobly constructed and beautifully decorated when the common workman had been allowed the greatest liberty, as under mediæval conditions. The first part of the plan has been constantly disputed. It has been shown fairly conclusively that the world's finest buildings were created in ages of great moral depravity, and, apart from that line of attack, it has been held a fundamental error to associate questions of ethics with architecture at all. In deference to the former proof it is essential to qualify greatly Ruskin's original pcsition, but the latter attack would undermine the whole book, for the ethical basis of architecture in general is essential to Ruskin.

The second part of the plan has proved very acceptable to modern socialistic doctrine. The famous chapter on the nature of Gothic became the manifesto of the early intellectual Socialists,

and Ruskin was henceforth classed definitely with Carlyle as a prophet of a new social order based upon honest work, and as a corrector of economic views based upon Adam Smith.

With the consideration of the inherited endowment of Ruskin's mind and its development by environment and study up to the completion of the three volumes of the *Stones* the purpose of this introduction is effected. It remains only to sketch lightly the long remainder of his life, so that some perspective may be gained for these selections among the mass of his productions and against the great extent of his activity.

From the time of *The Seven Lamps*, and even before, there has been evident the bending of Ruskin's mind to a consideration of socio-economic conditions of life as a background to studies in art. The bent rapidly became a preoccupation, and matters artistic, scientific and mythologic, dealt with in his later works, were increasingly subordinated to studies of labour conditions and social and moral freedom in England.

The year 1853, when the *Stones* were completed, saw him enter the public arena as lecturer, with the grave disapproval of his parents. In 1854 and the three following years he gave much of his time to the teaching of drawing and engraving in the Working Men's College founded by Frederick Denison Maurice as an effect of the Chartist movement of 1848. Thus he had already made his new leanings known to a small circle when, in 1860, immediately on the completion of *Modern Painters* at his father's earnest desire, he, to the same person's horror, launched his first attack against the then all-conquering economic system of Malthus and Ricardo in four essays, published in the *Cornhill Magazine* at the editor Thackeray's request, and appearing as *Unto This Last* in 1862. The burthen of the essays, that economics was wrong if conducted as a separate science, right if regarded as a part of a living sociological view of man, was supported by *Munera Pulveris* in 1862 and, through storm and stress within his mind and ever more violent attacks from without, repeated for the remainder of his working days. In 1865-6 he gave the four lectures that appear now as *A Crown of Wild Olive*, and in 1869 he attained the summit of public influence in the arts as the first Slade Professor of Fine Arts at Oxford, being re-elected in 1873, 1876 and 1883. In ten years of professorial activity he

published nine volumes of lectures, founded a museum of art, organised a drawing school and travelling parties, and, best of all, stimulated future leaders in their student days.

The year 1871 recorded several great events for him. A final home in Brantwood on Lake Coniston had scarcely been made when his mother died. His father had passed away seven years earlier, leaving him houses and land and £157,000, half of which had already gone in gifts private and public and in charitable endowments. He now devoted one-tenth of the remainder to assist the St. George's Company (later Guild), an Utopian scheme of colonisation and work, projected in the fifth letter of the series known as *Fors Clavigera*, which this year saw begun and which grew to ninety-six letters of the most direct and impassioned speaking on all manner of subjects, the wrestling of one of the greatest Victorian minds with the life-problems of his day and, to some extent, of ours.

The crisis of his later life met Ruskin in 1872 in the death of Rose La Touche, a woman then of 24, of great power of mind and charm of character, with strong and narrow Protestant principles, whom he had known from her childhood. Her refusal to marry him for a religious reason—though their love was mutual—and her death a few months later, finally broke his health. He was often ill and always in mental misery till, early in 1878, came the first attack of brain-fever. Recovery came in two months, but the next ten years saw repetitions of the trouble, one obliging him to resign the Slade Professorship finally in 1884.

Brantwood became his place of final retirement in 1879. Hither he brought mementoes of his parents and his long years with them, here he hung his Turners and Italian masters and set up his collections of manuscripts and minerals. The bare grounds he converted into a natural garden of great beauty, watered by a brook that he delighted to turn in devious ways. The waters and shores of Coniston Lake provided all the further recreation he desired. Rendered unfit for sustained mental effort, he turned, in 1885, by a friend's suggestion, to autobiography and published *Præterita*, one of the simplest yet most fascinating records of the early life of a genius. His last ten years were spent in great seclusion among intimates, and the end came on 20th January, 1900.

Ruskin in old age is well enough known from Hollyer's photograph. Here is a portrait of him in his prime (1860) by a critical co-worker and admirer, the Positivist, Frederic Harrison :

" I recall him as a man of slight figure, rather tall (he was five feet ten inches), except that he had a stoop from the shoulders, with a countenance of singular mobility and expressiveness. His eyes were blue and very keen, full of fire and meaning ; the hair was brown, luxuriant, and curly ; the brows rather marked, and with somewhat shaggy eyebrows. The lips were full of movement and character. . . . His countenance was eminently *spirituel*—winning, magnetic, and radiant. . . . His ideas, his admirations, and his fears seemed to flash out of his spirit and escape his control. But (in private life) it was always what he loved, not what he hated, that roused his interest. Now all this was extraordinary in one who, in writing, treated what he hated and scorned with really savage violence. . . . The world must judge his writings as they stand. I can only say that, in personal intercourse, I have never known him, in full health, betrayed into a harsh word, or an ungracious phrase, or an unkind judgment, or a trace of egotism. . . . Not only was he in social intercourse one of the most courteous and sweetest of friends, but he was in manner one of the most fascinating and impressive beings whom I ever met. I have talked with Carlyle and Tennyson, with Victor Hugo and Mazzini, with Garibaldi and Gambetta, with John Bright and with Robert Browning, but no one of these ever impressed me more vividly with a sense of intense personality, with the inexplicable light of genius which seemed to well up spontaneously from heart and brain. It remains a psychological puzzle how one who could write with passion and scorn such as Carlyle and Byron never reached, who in print was so often *Athanasius contra mundum*, who opened every written assertion with ' I know,' was in private life one of the gentlest, gayest, humblest of men."

To this eulogium, from one competent to praise Ruskin, there need only be added an estimate, necessarily slight since this is a book of selections, of the general influence of *The Stones of Venice*.

It is the purpose of these selections to present what may be called the main movement of thought of the whole work within a compass suitable for college studies in India or secondary

schools in England. Long excerpts are the rule followed, since short pieces tend to be scrappy in themselves and discontinuous in relation to each other. It is hoped that this body of selections will be felt to give a fair idea of the *Stones* and that the gaps between each portion are not unbridgeable.

There is a double thesis in the *Stones*. First, an attempt to found architecture upon natural principles *a priori* instead of on laws such as the Italian Renascence drew from Vitruvius ; second, a linking of the art produced with the moral character of the age which produced it and with the social and economic relations existing between architects and craftsmen.

A study of both these aspects of architecture in relation to Venetian buildings and history propelled Ruskin in a single direction. The rich freedom of the Byzantine and Gothic styles bred in him a disgust for the cold and lifeless imitations of Renaissance or " Palladian " architecture of which mid-nineteenth century London and England were full ; the discovery that Gothic architecture particularly was created in an age when workmen were craftsmen and were evidently permitted—so Ruskin's study of Gothic architectural details showed him—to develop individual conceptions in the general scheme of the building, and when society as a whole was permeated with a living religious feeling, forced him to reflect on the slavish condition of the Victorian working-man and the necessity of relating the art of architecture at least with the best religious and social emotions of his own time.

The chapter on " The Nature of Gothic " was distributed among the students of the Working Men's College as a guide and incentive to the new movement of free and cultivated handicrafts which they represented, and, by such means, the *Stones* came to be regarded as a recall of England to Gothic architecture and mediæval guild-socialism, and as such it is still largely regarded, the broader principles enunciated being neglected in favour of the more evident and sharply defined chief example. Ruskin has been, therefore, mainly held responsible for the so-called " Gothic Revival." It is, however, to be remembered that, for a generation before 1853, English writers on architecture had been rediscovering Gothic and urging its restoration to favour. The worst that can be said against Ruskin, in this particular, is that his book appeared when the impulse towards Gothic had

attained the dimensions of a " movement," and that his unmatched eloquence brought what might have remained an interest for mere technicians into public view and esteem.

Ruskin's architectural principles brought him into collision with the reigning architectural theories of his own time, and he power-fully affected them, if he did not succeed in carrying them the whole way back to Nature. His social and economic principles, similarly, declared war on Adam Smith, Malthus, Ricardo and the reigning Utilitarianism. Again, it must be said that the result has proved very partial. The opponents here were far stronger and more deeply entrenched in primitive human considerations. Few in the modern age troubled about architecture ; everyone was concerned in money and trade, and the ruling class of capitalists and employers scented in Ruskin's thesis of the freedom of the workman an overthrow of economic arrangements and principles which had brought immense wealth to the upper middle classes and were being more and more bound up with political principles of Free Trade and Imperialism. The second half of the nineteenth century being the heyday of such principles, there was no hope of Ruskin being listened to by the general, every expectation of his being contemned and even execrated. Single persons, like Carlyle and Morris, hailed and even practised his ideas ; small groups of Socialists numbered him among their prophets. It is probable that only an earthquake from within the Utilitarian economic system could drive men, even to-day, to consider whether Ruskin's social and economic contributions are worth general attention or not.

To-day's estimate of him is still undecided and would be happier if it could tear him piecemeal and consider him as man of letters apart from his enthusiasms and theories. Thus Dr. A. C. Benson, in a volume of *Selections from Ruskin*, printed 1923, states that his book " is designed to illustrate the development of his personality and literary style rather than his literary and critical methods, or his economic principles, or his social theories. It is on his merits as a writer and a moralist that his ultimate fame will probably be based. . . . " Yet, a few pages further, the Master of Magdalene is fain to say, " The remarkable thing is that, though much of his art criticism has hardly stood the test of time, the social theories, at the time both novel and distasteful,

have become ideas so familiar that we forget how profound and clear-sighted Ruskin's foresight was."

It is, indeed, impossible, if not a heresy, to consider Ruskin's style and his matter so entirely apart from each other. The "moralist" in Ruskin, which may help to establish his fame, is the same man as the art critic who has, perhaps, effected all the main changes in public taste that he aimed at and is therefore spent, the same man as the Socialist and economist still under a cloud, and as the glorious writer who, because fine writing can be enjoyed as a delicacy in itself, is read for his beauty—and kept as innocuous as possible.

When a writer has ceased to be a man, it is time to relegate him to the back-shelf and the limbo of forgotten things. It is in the belief that Ruskin is still very much alive, and that his writings affect men still in thought and action, and that they express a single, though an abounding, personality, that the *Stones* are thus offered in miniature to present youth.

ARGUMENT OF "THE STONES OF VENICE"

Vol. I. 1851. Vols. II. and III. 1853

VOL. I. "THE FOUNDATIONS."

Ruskin sets forth a theory of architectural forms 'a priori,' rejecting all previous authorities, especially those following Vitruvius and Renaissance writers and based on the "five orders." He bases himself on Nature—the nature of materials used and the nature of forces met and employed in building. He treats accordingly each portion of a building, section by section, from wall-base to roof, with great wealth of illustration by diagrams of abstract forms and drawings of actual architectural details from Venice and Verona. The general tendency is to show that fidelity to natural principles, coupled with high technical skill and freedom of the workman, produces the finest art.

VOL. II. "SEA-STORIES."

Considers the Byzantine and Gothic architectures of Venice historically, artistically and sociologically. The sociological aspect—the moral elevation of the Venetians of earlier days, the true division of labour between architect and workman, the freedom of the latter to carve his own conceptions—is given increasingly greater importance. Byzantine buildings show the youth, Gothic the maturity of Venetian architecture under relatively sound moral and natural conditions.

VOL. III. "THE FALL."

A short treatment of the Third, or Renaissance Period, setting forth the signs of decadence in over-enrichment, in deadness of line, in infidelity to Nature, in the subjection of the workman to the conception of the architect, which is both beyond the former's powers of free execution and foreign to his style of thought and art.

I

THE QUARRY

ALL European architecture, bad and good, old and new, is derived from Greece through Rome, and coloured and perfected from the East. The history of architecture is nothing but the tracing of the various modes and directions of this derivation. Understand this, once for all: if you hold fast this great connecting clue, you may string all the types of successive architectural invention upon it like so many beads. The Doric and the Corinthian orders [1] are the roots, the one of all Romanesque massy-capitaled buildings—Norman, Lombard, Byzantine, and what else you can name of the kind; and the Corinthian of all Gothic, Early English, French, German, and Tuscan. Now observe: those old Greeks gave the shaft; Rome gave the arch; the Arabs pointed and foliated the arch. The shaft and arch, the framework and strength of architecture, are from the race of Japheth: the spirituality and sanctity of it from Ishmael, Abraham, and Shem. [2]

There is high probability that the Greek received his shaft system from Egypt; but I do not care to keep this earlier derivation in the mind of the reader. It is only necessary that he should be able to refer to a fixed point of origin, when the form of the shaft was first perfected. But it may be incidentally observed, that if the Greeks did indeed receive their Doric from Egypt, then the three families of the earth have each contributed their part to its noblest architecture; and Ham, the servant of the others, furnishes the sustaining

or bearing member, the shaft ; Japheth the arch ; Shem the spiritualisation of both.

I have said that the two orders, Doric and Corinthian, are the roots of all European architecture. You have, perhaps, heard of five orders : but there are only two real orders ; and there never can be any more until doomsday. On one of these orders the ornament is convex : those are Doric, Norman, and what else you recollect of the kind. On the other the ornament is concave : those are Corinthian, Early English, Decorated, and what else you recollect of that kind. The transitional form, in which the ornamental line is straight, is the centre or root of both. All other orders are varieties of these, or phantasms and grotesques, altogether indefinite in number and species.

This Greek architecture, then, with its two orders, was clumsily copied and varied by the Romans with no particular result, until they began to bring the arch into extensive practical service ; except only that the Doric capital was spoiled in endeavours to mend it, and the Corinthian much varied and enriched with fanciful, and often very beautiful imagery. And in this state of things came Christianity : seized upon the arch as her own ; decorated it, and delighted in it ; invented a new Doric capital to replace the spoiled Roman one : and all over the Roman empire set to work, with such materials as were nearest at hand, to express and adorn herself as best she could. This Roman Christian architecture is the exact expression of the Christianity of the time, very fervid and beautiful—but very imperfect ; in many respects ignorant, and yet radiant with a strong, childlike light of imagination, which flames up under Constantine, illumines all the shores of the Bosphorus and the Ægean and the Adriatic Sea, and then gradually, as the people give themselves up to idolatry, becomes corpse-light. The architecture sinks into a settled form—a strange, gilded, and embalmed repose : it, with the religion it expressed ; [3] and so would have remained for ever,—so *does* remain, where its languor

has been undisturbed.* But rough wakening was ordained for it.

This Christian art of the declining empire is divided into two great branches, western and eastern ; one centred at Rome, the other at Byzantium, of which the one is the early Christian Romanesque, properly so called, and the other, carried to higher imaginative perfection by Greek workmen, is distinguished from it as Byzantine. But I wish the reader, for the present, to class these two branches of art together in his mind, they being, in points of main importance, the same ; that is to say, both of them a true continuance and sequence of the art of old Rome itself, flowing uninterruptedly down from the fountain-head, and entrusted always to the best workmen who could be found—Latins in Italy and Greeks in Greece ; and thus both branches may be ranged under the general term of Christian Romanesque, an architecture which had lost the refinement of Pagan art in the degradation of the empire, but which was elevated by Christianity to higher aims, and by the fancy of the Greek workmen endowed with brighter forms. And this art the reader may conceive as extending in its various branches over all the central provinces of the empire, taking aspects more or less refined, according to its proximity to the seats of government ; dependent for all its power on the vigour and freshness of the religion which animated it ; and as that vigour and purity departed, losing its own vitality, and sinking into nerveless rest, not deprived of its beauty, but benumbed, and incapable of advance or change.

Meantime there had been preparation for its renewal. While in Rome and Constantinople, and in the districts under their immediate influence, this Roman art of pure descent was practised in all its refinement, an impure form of it—a patois of Romanesque—was carried by inferior workmen into

* The reader will find the *weak* points of Byzantine architecture shrewdly seized, and exquisitely sketched, in the opening chapter of the most delightful book of travels I ever opened,—Curzon's " Monasteries of the Levant." (Ruskin.)

distant provinces ; and still ruder imitations of this patois
were executed by the barbarous nations on the skirts of the
empire. But these barbarous nations were in the strength of
their youth ; and while, in the centre of Europe, a refined and
purely descended art was sinking into graceful formalism, on
its confines a barbarous and borrowed art was organising itself
into strength and consistency. The reader must therefore
consider the history of the work of the period as broadly
divided into two great heads : the one embracing the elabor-
ately languid succession of the Christian art of Rome ; and
the other, the imitations of it executed by nations in every
conceivable phase of early organisation, on the edges of the
empire, or included in its now merely nominal extent.

Some of the barbaric nations were, of course, not susceptible
of this influence ; and, when they burst over the Alps, appear,
like the Huns, as scourges only, or mix, as the Ostrogoths,[4]
with the enervated Italians, and give physical strength to the
mass with which they mingle, without materially affecting
its intellectual character. But others, both south and north
of the empire, had felt its influence, back to the beach of the
Indian Ocean on the one hand, and to the ice creeks of the
North Sea on the other. On the north and west the influence
was of the Latins ; on the south and east, of the Greeks.
Two nations, preeminent above all the rest, represent to us
the force of derived mind on either side. As the central power
is eclipsed, the orbs of reflected light gather into their fulness ;
and when sensuality and idolatry had done their work, and
the religion of the empire was laid asleep in a glittering
sepulchre, the living light rose upon both horizons, and the
fierce swords of the Lombard and Arab were shaken over its
golden paralysis.

The work of the Lombard was to give hardihood and system
to the enervated body and enfeebled mind of Christendom ;
that of the Arab was to punish idolatry, and to proclaim the
spirituality of worship. The Lombard covered every church
which he built with the sculptured representations of bodily

exercises—hunting and war. The Arab banished all imagination of creature form from his temples, and proclaimed from their minarets, "There is no god but God." Opposite in their character and mission, alike in their magnificence of energy, they came from the North and from the South, the glacier torrent and the lava stream: they met and contended over the wreck of the Roman empire; and the very centre of the struggle, the point of pause of both, the dead water of the opposite eddies, charged with embayed fragments of the Roman wreck, is Venice.

The Ducal palace of Venice contains the three elements in exactly equal proportions—the Roman, Lombard, and Arab. It is the central building of the world.

II

TREATMENT OF ORNAMENT

WE have, then, three orders of ornament, classed according
to the degrees of correspondence of the executive and con-
ceptive minds. We have the servile ornament, in which the
executive is absolutely subjected to the inventive,— the orna-
ment of the great Eastern nations, more especially Hamite, and
all pre-Christian, yet thoroughly noble in its submissiveness.
Then we have the mediæval system, in which the mind of the
inferior workman is recognised, and has full room for action,
but is guided and ennobled by the ruling mind. This is the
truly Christian and only perfect system. Finally, we have
ornaments expressing the endeavour to equalise the executive
and inventive,—endeavour which is Renaissance and revolu-
tionary, and destructive of all noble architecture.

Thus far, then, of the incompleteness or simplicity of
execution necessary in architectural ornament, as referred to
the mind. Next we have to consider that which is required
when it is referred to the sight, and the various modifications
of treatment which are rendered necessary by the variation
of its distance from the eye. I say necessary : not merely
expedient or economical. It is foolish to carve what is to be
seen forty feet off with the delicacy which the eye demands
within two yards ; not merely because such delicacy is lost
in the distance, but because it is a great deal worse than lost :
—the delicate work has actually worse effect in the distance
than rough work. This is a fact well known to painters, and,
for the most part, acknowledged by the critics of painting,

6

namely, that there is a certain distance for which a picture is painted; and that the finish, which is delightful if that distance be small, is actually injurious if the distance be great : and, moreover, that there is a particular method of handling which none but consummate artists reach, which has its effect at the intended distance, and is altogether hieroglyphical and unintelligible at any other. This, I say, is acknowledged in painting, but it is not practically acknowledged in architecture; nor, until my attention was specially directed to it, had I myself any idea of the care with which this great question was studied by the mediæval architects. On my first careful examination of the capitals of the upper arcade of the Ducal Palace at Venice, I was induced, by their singular inferiority of workmanship, to suppose them posterior to those of the lower arcade. It was not till I discovered that some of those which I thought the worst above, were the best when seen from below, that I obtained the key to this marvellous system of adaptation ; a system which I afterwards found carried out in every building of the great times which I had opportunity of examining.

There are two distinct modes in which this adaptation is effected. In the first, the same designs which are delicately worked when near the eye, are rudely cut, and have far fewer details when they are removed from it. In this method it is not always easy to distinguish economy from skill or slovenliness from science. But, in the second method, a different kind of design is adopted, composed of fewer parts and of simpler lines, and this is cut with exquisite precision. This is of course the higher method, and the more satisfactory proof of purpose ; but an equal degree of imperfection is found in both kinds when they are seen close ; in the first, a bald execution of a perfect design ; the second, a baldness of design with perfect execution. And in these very imperfections lies the admirableness of the ornament.

It may be asked whether, in advocating this adaptation to the distance of the eye, I obey my adopted rule of observance

of natural law. Are not all natural things, it may be asked,
as lovely near as far away ? Nay, not so. Look at the clouds,
and watch the delicate sculpture of their alabaster sides, and
the rounded lustre of their magnificent rolling. They were
meant to be beheld far away ; they were shaped for their
place, high above your head ; approach them, and they fuse
into vague mists, or whirl away in fierce fragments of thun-
derous vapour. Look at the crest of the Alp, from the far-
away plains over which its light is cast, whence human souls
have communion with it by their myriads. The child looks
up to it in the dawn, and the husbandman in the burden and
heat of the day, and the old man in the going down of the sun,
and it is to them all as the celestial city on the world's horizon ;
dyed with the depth of heaven, and clothed with the calm of
eternity. There was it set, for holy dominion, by Him who
marked for the sun his journey, and bade the moon know her
going down. It was built for its place in the far-off sky ;
approach it, and, as the sound of the voice of man dies away
about its foundation, and the tide of human life, shallowed
upon the vast aërial shore, is at last met by the Eternal
" Here shall thy waves be stayed," the glory of its aspect
fades into blanched fearfulness ; its purple walls are rent into
grisly rocks, its silver fretwork saddened into wasting snow ;
the storm-brands of ages are on its breast, the ashes of its
own ruin lie solemnly on its white raiment.

Nor in such instances as these alone, though, strangely
enough, the discrepancy between apparent and actual beauty
is greater in proportion to the unapproachableness of the
object, is the law observed. For every distance from the
eye there is a peculiar kind of beauty, or a different system
of lines of form ; the sight of that beauty is reserved for that
distance, and for that alone. If you approach nearer, that
kind of beauty is lost, and another succeeds, to be disorganised
and reduced to strange and incomprehensible means and
appliances in its turn. If you desire to perceive the great
harmonies of the form of a rocky mountain, you must not

ascend upon its sides. All is there disorder and accident, or seems so; sudden starts of its shattered beds hither and thither; ugly struggles of unexpected strength from under the ground; fallen fragments, toppling one over another into more helpless fall. Retire from it, and, as your eye commands it more and more, as you see the ruined mountain world with a wider glance, behold! dim sympathies begin to busy themselves in the disjointed mass; line binds itself into stealthy fellowship with line; group by group, the helpless fragments gather themselves into ordered companies; new captains of hosts and masses of battalions become visible, one by one, and far away answers of foot to foot, and of bone to bone, until the powerless chaos is seen risen up with girded loins, and not one piece of all the unregarded heap could now be spared from the mystic whole.

Now it is indeed true that where nature loses one kind of beauty, as you approach it, she substitutes another; this is worthy of her infinite power: and, as we shall see, art can sometimes follow her even in doing this; but all I insist upon at present is, that the several effects of nature are each worked with means referred to a particular distance, and producing their effect at that distance only. Take a singular and marked instance: When the sun rises behind a ridge of pines, and those pines are seen from a distance of a mile or two, against his light, the whole form of the tree, trunk, branches, and all, becomes one frostwork of intensely brilliant silver, which is relieved against the clear sky like a burning fringe, for some distance on either side of the sun.* Now

* Shakspeare and Wordsworth (I think they only) have noticed this. Shakspeare, in Richard II. :—

> "But when, from under this terrestrial ball,
> He fires the proud tops of the eastern pines."

And Wordsworth, in one of his minor poems, on leaving Italy :—

> "My thoughts become bright like yon edging of pines
> On the steep's lofty verge—how it blackened the air !
> But, touched from behind by the sun, it now shines
> With threads that seem part of his own silver hair."

(Ruskin.)

suppose that a person who had never seen pines were, for the first time in his life, to see them under this strange aspect, and, reasoning as to the means by which such effect could be produced, laboriously to approach the eastern ridge, how would he be amazed to find that the fiery spectres had been produced by trees with swarthy and grey trunks, and dark green leaves ! We, in our simplicity, if we had been required to produce such an appearance, should have built up trees of chased silver, with trunks of glass, and then been grievously amazed to find that, at two miles off, neither silver nor glass were any more visible ; but nature knew better, and prepared for her fairy work with the strong branches and dark leaves, in her own mysterious way.

Now this is exactly what you have to do with your good ornament. It may be that it is capable of being approached, as well as likely to be seen far away, and then it ought to have microscopic qualities, as the pine leaves have, which will bear approach. But your calculation of its purpose is for a glory to be produced at a given distance ; it may be here, or may be there, but it is a *given* distance ; and the excellence of the ornament depends upon its fitting that distance, and being seen better there than anywhere else, and having a particular function and form which it can only discharge and assume there. You are never to say that ornament has great merit because " you cannot see the beauty of it here ; " but, it has great merit because " you *can* see its beauty *here only*." And to give it this merit is just about as difficult a task as I could well set you. I have above noted the two ways in which it is done : the one, being merely rough cutting, may be passed over ; the other, which is scientific alteration of design, falls, itself, into two great branches, Simplification and Emphasis.

A word or two is necessary on each of these heads.

When an ornamental work is intended to be seen near, if its composition be indeed fine, the subdued and delicate portions of the design lead to, and unite, the energetic parts,

and those energetic parts form with the rest a whole, in which
their own immediate relations to each other are not perceived.
Remove this design to a distance, and the connecting delica-
cies vanish, the energies alone remain, now either disconnected
altogether, or assuming with each other new relations, which,
not having been intended by the designer, will probably be
painful. There is a like, and a more palpable, effect, in the
retirement of a band of music in which the instruments are
of very unequal powers ; the fluting and fifeing expire, the
drumming remains, and that in a painful arrangement, as
demanding something which is unheard. In like manner, as
the designer at arm's length removes or elevates his work,
fine gradations, and roundings, and incidents, vanish, and a
totally unexpected arrangement is established between the
remainder of the markings, certainly confused, and in all
probability painful.

The art of architectural design is therefore, first, the pre-
paration for this beforehand, the rejection of all the delicate
passages as worse than useless, and the fixing the thought
upon the arrangement of the features which will remain
visible far away. Nor does this always imply a diminution
of resource ; for, while it may be assumed as a law that fine
modulation of surface in light becomes quickly invisible as
the object retires, there are a softness and mystery given to
the harder markings, which enable them to be safely used
as media of expression. There is an exquisite example of
this use, in the head of the Adam of the Ducal Palace.[5] It
is only at the height of 17 or 18 feet above the eye ; never-
theless, the sculptor felt it was no use to trouble himself
about drawing the corners of the mouth, or the lines of the
lips, delicately, at that distance ; his object has been to
mark them clearly, and to prevent accidental shadows from
concealing them, or altering their expression. The lips are
cut thin and sharp, so that their line cannot be mistaken,
and a good deep drill-hole struck into the angle of the mouth ;
the eye is anxious and questioning, and one is surprised, from

below, to perceive a kind of darkness in the iris of it, neither like colour, nor like a circular furrow. The expedient can only be discovered by ascending to the level of the head ; it is one which would have been quite inadmissible except in distant work, six drill holes cut into the iris, round a central one for the pupil.

By just calculation, like this, of the means at our disposal, by beautiful arrangement of the prominent features, and by choice of different subjects for different places, choosing the broadest forms for the farthest distance, it is possible to give the impression, not only of perfection, but of an exquisite delicacy, to the most distant ornament. And this is the true sign of the right having been done, and the utmost possible power attained :—The spectator should be satisfied to stay in his place, feeling the decoration, wherever it may be, equally rich, full, and lovely : not desiring to climb the steeples in order to examine it, but sure that he has it all, where he is. Perhaps the capitals of the cathedral of Genoa are the best instances of absolute perfection in this kind : seen from below, they appear as rich as the frosted silver of the Strada degli Orefici ; and the nearer you approach them, the less delicate they seem.

This is, however, not the only mode, though the best, in which ornament is adapted for distance. The other is emphasis,—the unnatural insisting upon explanatory lines, where the subject would otherwise become unintelligible. It is to be remembered that, by a deep and narrow incision, an architect has the power, at least in sunshine, of drawing a black line on stone, just as vigorously as it can be drawn with chalk on grey paper ; and that he may thus, wherever and in the degree that he chooses, substitute *chalk sketching* for sculpture. They are curiously mingled by the Romans. The bas-reliefs on the Arc d'Orange [6] are small, and would be confused, though in bold relief, if they depended for intelligibility on the relief only ; but each figure is outlined by a strong *incision* at its edge into the background, and all

the ornaments on the armour are simply drawn with incised lines, and not cut out at all. A similar use of lines is made by the Gothic nations in all their early sculpture, and with delicious effect. Now, to draw a mere pattern—as, for instance, the bearings of a shield—with these simple incisions, would, I suppose, occupy an able sculptor twenty minutes or half an hour ; and the pattern is then clearly seen, under all circumstances of light and shade ; there can be no mistake about it, and no missing it. To carve out the bearings in due and finished relief would occupy a long summer's day, and the results would be feeble and indecipherable in the best lights, and in some lights totally and hopelessly invisible, ignored, non-existent. Now the Renaissance architects, and our modern ones, despise the simple expedient of the rough Roman or barbarian. They do not care to be understood. They care only to speak finely, and be thought great orators, if one could only hear them. So I leave you to choose between the old men, who took minutes to tell things plainly, and the modern men, who take days to tell them unintelligibly.

All expedients of this kind, both of simplification and energy, for the expression of details at a distance where their actual forms would have been invisible, but more especially this linear method, I shall call Proutism ; for the greatest master of the art in modern times has been Samuel Prout.[7] He actually takes up buildings of the later times in which the ornament has been too refined for its place, and translates it into the energised linear ornament of earlier art : and to this power of taking the life and essence of decoration, and putting it into a perfectly intelligible form, when its own fulness would have been confused, is owing the especial power of his drawings. Nothing can be more closely analogous than the method with which an old Lombard uses his chisel, and that with which Prout uses the reed-pen ; and we shall see presently farther correspondence in their feeling about the enrichment of luminous surfaces.

Now, all that has been hitherto said refers to ornament

whose distance is fixed, or nearly so ; as when it is at any considerable height from the ground, supposing the spectator to desire to see it, and to get as near it as he can.　But the distance of ornament is never fixed to the *general* spectator. The tower of a cathedral is bound to look well, ten miles off, or five miles, or half a mile, or within fifty yards.　The ornaments of its top have fixed distances, compared with those of its base ; but quite unfixed distances in their relation to the great world : and the ornaments of the base have no fixed distance at all.　They are bound to look well from the other side of the cathedral close, and to look equally well or better, as we enter the cathedral door.　How are we to manage this ?

As nature manages it.　I said above, that for every distance from the eye there was a different system of form in all natural objects : this is to be so then in architecture. The lesser ornament is to be grafted on the greater, and third or fourth orders of ornaments upon this again, as need may be, until we reach the limits of possible sight ; each order of ornament being adapted for a different distance : first, for example, the great masses,—the buttresses and stories and black windows and broad cornices of the tower, which give it make, and organism, as it rises over the horizon, half a score of miles away : then the traceries and shafts and pinnacles, which give it richness as we approach : then the niches and statues and knobs and flowers, which we can only see when we stand beneath it.　At this third order of ornament, we may pause, in the upper portions ; but on the roofs of the niches, and the robes of the statues, and the rolls of the mouldings, comes a fourth order of ornament, as delicate as the eye can follow, when any of these features may be approached.

All good ornamentation is thus arborescent, as it were, one class of it branching out of another and sustained by it ; and its nobility consists in this, that whatever order or class of it we may be contemplating, we shall find it subordinated

to a greater, simpler, and more powerful ; and if we then contemplate the greater order, we shall find it again subordinated to a greater still ; until the greatest can only be quite grasped by retiring to the limits of distance commanding it.

And if this subordination be not complete, the ornament is bad : if the figurings and chasings and borderings of a dress be not subordinated to the folds of it,—if the folds are not subordinate to the action and mass of the figure,—if this action and mass not to the divisions of the recesses and shafts among which it stands,—if these not to the shadows of the great arches and buttresses of the whole building, in each case there is error ; much more if all be contending with each other and striving for attention at the same time.

It is nevertheless evident, that, however perfect this distribution, there cannot be orders adapted to *every* distance of the spectator. Between the ranks of ornament there must always be a bold separation ; and there must be many intermediate distances, where we are too far off to see the lesser rank clearly, and yet too near to grasp the next higher rank wholly : and at all these distances the spectator will feel himself ill-placed, and will desire to go nearer or farther away. This must be the case in all noble work, natural or artificial. It is exactly the same with respect to Rouen cathedral or the Mont Blanc. We like to see them from the other side of the Seine, or of the lake of Geneva ; from the Marché aux Fleurs, or the Valley of Chamouni ; from the parapets of the apse, or the crags of the Montagne de la Côte : but there are intermediate distances which dissatisfy us in either case, and from which one is in haste either to advance or to retire.

Directly opposed to this ordered, disciplined, well officered, and variously ranked ornament, this type of divine, and therefore of all good human government, is the democratic ornament, in which all is equally influential, and has equal office and authority ; that is to say, none of it any office nor authority, but a life of continual struggle for independence

and notoriety, or of gambling for chance regards. The English perpendicular work [8] is by far the worst of this kind that I know ; its main idea, or decimal fraction of an idea, being to cover its walls with dull, successive, eternity of reticulation, to fill with equal foils the equal interstices between the equal bars, and charge the interminable blanks with statues and rosettes, invisible at a distance, and uninteresting near.

The early Lombardic, Veronese, and Norman work is the exact reverse of this ; being divided first into large masses, and these masses covered with minute chasing and surface work, which fill them with interest, and yet do not disturb nor divide their greatness. The lights are kept broad and bright, and yet are found on near approach to be charged with intricate design. This, again, is a part of the great system of treatment which I shall hereafter call " Proutism ; " much of what is thought mannerism and imperfection in Prout's work, being the result of his determined resolution that minor details shall never break up his large masses of light.

III

THE VESTIBULE

I HAVE hardly kept my promise. The reader has decorated but little for himself as yet ; but I have not, at least, attempted to bias his judgment. Of the simple forms of decoration which have been set before him, he has always been left free to choose ; and the stated restrictions in the methods of applying them have been only those which followed on the necessities of construction previously determined. These having been now defined, I do indeed leave my reader free to build ; and with what a freedom ! All the lovely forms of the universe set before him, whence to choose, and all the lovely lines that bound their substance or guide their motion ; and of all these lines,—and there are myriads of myriads in every bank of grass and every tuft of forest ; and groups of them, divinely harmonised, in the bell of every flower, and in every several member of bird and beast,—of all these lines, for the principal forms of the most important members of architecture, I have used but Three ! [9] What, therefore, must be the infinity of the treasure in them all ? There is material enough in a single flower for the ornament of a score of cathedrals : but suppose we were satisfied with less exhaustive appliance, and built a score of cathedrals, each to illustrate a single flower ? that would be better than trying to invent new styles, I think. There is quite difference of style enough, between a violet and a harebell, for all reasonable purposes.

Perhaps, however, even more strange than the struggle of

B

our architects to invent new styles, is the way they commonly speak of this treasure of natural infinity. Let us take our patience to us for an instant, and hear one of them, not among the least intelligent :—

" It is not true that all natural forms are beautiful. We may hardly be able to detect this in Nature herself ; but when the forms are separated from the things, and exhibited alone (by sculpture or carving), we then see that they are not all fitted for ornamental purposes ; and indeed that very few, perhaps none, are so fitted without correction. Yes, I say *correction*, for though it is the highest aim of every art to imitate nature, this is not to be done by imitating any natural form, but by *criticising* and *correcting* it,—criticising it by Nature's rules gathered from all her works, but never completely carried out by her in any one work ; correcting it, by rendering it more natural, *i.e.* more conformable to the general tendency of Nature, according to that noble maxim recorded of Raffaelle, ' that the artist's object was to make things not as Nature makes them, but as she WOULD make them : ' as she ever tries to make them, but never succeeds, though her aim may be deduced from a comparison of her efforts ; just as if a number of archers had aimed unsuccessfully at a mark upon a wall, and this mark were then removed, we could by the examination of their arrow marks point out the most probable position of the spot aimed at, with a certainty of being nearer to it than any of their shots." *

I had thought that, by this time, we had done with that stale, second-hand, one-sided, and misunderstood saying of Raffaelle's ; or that at least, in these days of purer Christian light, men might have begun to get some insight into the meaning of it : Raffaelle was a painter of humanity, and assuredly there is something the matter with humanity, a few *dovrebbe's*,[10] more or less, wanting in it. We have most of us heard of original sin, and may perhaps, in our modest

* Garbett on Design, p. 74.

moments, conjecture that we are not quite what God, or nature, would have us to be. Raffaelle *had* something to mend in Humanity : I should have liked to have seen him mending a daisy !—or a pease-blossom, or a moth, or a mustard seed,[11] or any other of God's slightest works. If he had accomplished that, one might have found for him more respectable employment,—to set the stars in better order, perhaps, (they seem grievously scattered as they are, and to be of all manner of shapes and sizes,—except the ideal shape, and the proper size) ; or to give us a corrected view of the ocean : that, at least, seems a very irregular and improveable thing ; the very fishermen do not know, this day, how far it will reach, driven up before the west wind :—perhaps Some One else does, but that is not our business. Let us go down and stand by the beach of it,—of the great, irregular sea, and count whether the thunder of it is not out of time. One,— two :—here comes a well-formed wave at last, trembling a little at the top, but, on the whole, orderly. So, crash among the shingle, and up as far as this grey pebble ; now stand by and watch ! Another :—Ah, careless wave ! why couldn't you have kept your crest on ? it is all gone away into spray, striking up against the cliffs there—I thought as much— missed the mark by a couple of feet ! Another :—How now, impatient one ! couldn't you have waited till your friend's reflux was done with, instead of rolling yourself up with it in that unseemly manner ? You go for nothing. A fourth, and a goodly one at last. What think we of yonder slow rise, and crystalline hollow, without a flaw ? Steady, good wave ; not so fast, not so fast ; where are you coming to ?—By our architectural word, this is too bad ; two yards over the mark, and ever so much of you in our face besides ; and a wave which we had some hope of, behind there, broken all to pieces out at sea, and laying a great white tablecloth of foam all the way to the shore, as if the marine gods were to dine off it ! Alas, for these unhappy arrow shots of Nature ; she will never hit her mark with those unruly waves of hers, nor get

one of them into the ideal shape, if we wait for her a thousand
years. Let us send for a Greek architect to do it for her.
He comes—the great Greek architect, with measure and rule.
Will he not also make the weight for the winds ? and weigh
out the waters by measure ? and make a decree for the rain,
and a way for the lightning of the thunder ? [12] He sets him-
self orderly to his work, and behold ! this is the mark of
nature, and this is the thing into which the great Greek
architect improves the sea—

Θάλαττα, θάλαττα : Was it this, then, that they wept to
see from the sacred mountain—those wearied ones ? [13]

But the sea was meant to be irregular ! Yes, and were
not also the leaves, and the blades of grass ; and, in a sort,
as far as may be without mark of sin, even the counten-
ance of man ? Or would it be pleasanter and better to have
us all alike, and numbered on our foreheads, that we might
be known one from the other ?

Is there, then, nothing to be done by man's art ? Have
we only to copy, and again copy, for ever, the imagery of
the universe ? Not so. We have work to do upon it ; there
is not any one of us so simple, nor so feeble, but he has work
to do upon it. But the work is not to improve, but to explain.
This infinite universe is unfathomable, inconceivable, in its
whole ; every human creature must slowly spell out, and long
contemplate, such part of it as may be possible for him to
reach ; then set forth what he has learned of it for those
beneath him ; extricating it from infinity, as one gathers a
violet out of grass ; one does not improve either violet or
grass in gathering it, but one makes the flower visible ; and
then the human being has to make its power upon his own
heart visible also, and to give it the honour of the good

thoughts it has raised up in him, and to write upon it the history of his own soul. And sometimes he may be able to do more than this, and to set it in strange lights, and display it in a thousand ways before unknown : ways specially directed to necessary and noble purposes, for which he had to choose instruments out of the wide armoury of God. All this he may do : and in this he is only doing what every Christian has to do with the written, as well as the created word, " rightly *dividing* the word of truth." [14] Out of the infinity of the written word, he has also to gather and set forth things new and old,[15] to choose them for the season and the work that are before him, to explain and manifest them to others, with such illustration and enforcement as may be in his power, and to crown them with the history of what, by them, God has done for his soul. And, in doing this, is he improving the Word of God ? Just such difference as there is between the sense in which a minister may be said to improve a text, to the people's comfort, and the sense in which an atheist might declare that he could improve the Book, which, if any man shall add unto, there shall be added unto him the plagues that are written therein ; [16] just such difference is there between that which, with respect to Nature, man is, in his humbleness, called upon to do, and that which, in his insolence, he imagines himself capable of doing.

Have no fear therefore, reader, in judging between nature and art, so only that you love both. If you can love one only, then let it be Nature ; you are safe with her : but do not then attempt to judge the art, to which you do not care to give thought, or time. But if you love both, you may judge between them fearlessly ; you may estimate the last, by its making you remember the first, and giving you the same kind of joy. If, in the square of the city, you can find a delight, finite, indeed, but pure and intense, like that which you have in a valley among the hills, then its art and archi-tecture are right ; but if, after fair trial, you can find no delight

in them, nor any instruction like that of nature, I call on you fearlessly to condemn them.

We are forced, for the sake of accumulating our power and knowledge, to live in cities : but such advantage as we have in association with each other is in great part counterbalanced by our loss of fellowship with nature. We cannot all have our gardens now, nor our pleasant fields to meditate in at eventide. Then the function of our architecture is, as far as may be, to replace these ; to tell us about nature ; to possess us with memories of her quietness ; to be solemn and full of tenderness, like her, and rich in portraitures of her ; full of delicate imagery of the flowers we can no more gather, and of the living creatures now far away from us in their own solitude. If ever you felt or found this in a London Street, —if ever it furnished you with one serious thought, or one ray of true and gentle pleasure,—if there is in your heart a true delight in its grim railings and dark casements, and wasteful finery of shops, and feeble coxcombry of club-houses, —it is well : promote the building of more like them. But if they never taught you anything, and never made you happier as you passed beneath them, do not think they have any mysterious goodness nor occult sublimity. Have done with the wretched affectation, the futile barbarism, of pretending to enjoy : for, as surely as you know that the meadow grass, meshed with fairy rings, is better than the wood pavement, cut into hexagons ; and as surely as you know the fresh winds and sunshine of the upland are better than the choke-damp of the vault, or the gas-light of the ball-room, you may know, as I told you that you should, that the good architecture, which has life, and truth, and joy in it, is better than the bad architecture, which has death, dishonesty, and vexation of heart in it, from the beginning to the end of time.

And now come with me,[17] for I have kept you too long from your gondola : come with me, on an autumnal morning, through the dark gates of Padua, and let us take the broad road leading towards the East.

It lies level, for a league or two, between its elms, and vine festoons full laden, their thin leaves veined into scarlet hectic, and their clusters deepened into gloomy blue; then mounts an embankment above the Brenta, and runs between the river and the broad plain, which stretches to the north in endless lines of mulberry and maize. The Brenta flows slowly, but strongly; a muddy volume of yellowish-grey water, that neither hastens nor slackens, but glides heavily between its monotonous banks, with here and there a short, babbling eddy twisted for an instant into its opaque surface and vanishing, as if something had been dragged into it and gone down. Dusty and shadeless, the road fares along the dyke on its northern side; and the tall white tower of Dolo is seen trembling in the heat mist far away, and never seems nearer than it did at first. Presently, you pass one of the much vaunted " villas on the Brenta : " a glaring, spectral shell of brick and stucco, its windows with painted architraves like picture-frames, and a court-yard paved with pebbles in front of it, all burning in the thick glow of the feverish sunshine, but fenced from the high road, for magnificence' sake, with goodly posts and chains; then another, of Kew Gothic, with Chinese variations, painted red and green; a third, composed for the greater part of dead-wall, with fictitious windows painted upon it, each with a pea-green blind, and a classical architrave in bad perspective; and a fourth, with stucco figures set on the top of its garden-wall : some antique, like the kind to be seen at the corner to the New Road, and some of clumsy grotesque dwarfs, with fat bodies and large boots. This is the architecture to which her studies of the Renaissance have conducted modern Italy.

The sun climbs steadily, and warms into intense white the walls of the little piazza of Dolo, where we change horses. Another dreary stage among the now divided branches of the Brenta, forming irregular and half-stagnant canals; with one or two more villas on the other side of them, but these

of the old Venetian type, which we may have recognised
before at Padua, and sinking fast into utter ruin, black,
and rent, and lonely, set close to the edge of the dull water,
with what were once small gardens beside them, kneaded
into mud, and with blighted fragments of gnarled hedges and
broken stakes for their fencing ; and here and there a few
fragments of marble steps, which have once given them
graceful access from the water's edge, now settling into the
mud in broken joints, all aslope, and slippery with green
weed.　At last the road turns sharply to the north, and there
is an open space, covered with bent grass, on the right of it :
but do not look that way.

Five minutes more, and we are in the upper room of the
little inn at Mestre, glad of a moment's rest in shade.　The
table is (always, I think) covered with a cloth of nominal
white and perennial grey, with plates and glasses at due inter-
vals, and small loaves of a peculiar white bread, made with
oil, and more like knots of flower than bread.　The view from
its balcony is not cheerful : a narrow street, with a solitary
brick church and barren campanile on the other side of it ;
and some conventual buildings, with a few crimson remnants
of fresco about their windows ; and, between them and the
street, a ditch with some slow current in it, and one or two
small houses beside it, one with an arbour of roses at its door,
as in an English tea-garden ; the air, however, about us
having in it nothing of roses, but a close smell of garlic and
crabs, warmed by the smoke of various stands of hot chest-
nuts.　There is much vociferation also going on beneath the
window respecting certain wheelbarrows which are in rivalry
for our baggage ; we appease their rivalry with our best
patience, and follow them down the narrow street.

We have but walked some two hundred yards when we
come to a low wharf or quay, at the extremity of a canal,
with long steps on each side down to the water, which latter
we fancy for an instant has become black with stagnation ;
another glance undeceives us,—it is covered with the black

boats of Venice. We enter one of them, rather to try if they be real boats or not, than with any definite purpose, and glide away ; at first feeling as if the water were yielding continually beneath the boat and letting her sink into soft vacancy. It is something clearer than any water we have seen lately, and of a pale green ; the banks only two or three feet above it, of mud and rank grass, with here and there a stunted tree ; gliding swiftly past the small casement of the gondola, as if they were dragged by upon a painted scene.

Stroke by stroke, we count the plunges of the oar, each heaving up the side of the boat slightly as her silver beak shoots forward. We lose patience, and extricate ourselves from the cushions : the sea air blows keenly by, as we stand leaning on the roof of the floating cell. In front, nothing to be seen but long canal and level bank ; to the west, the tower of Mestre is lowering fast, and behind it there have risen purple shapes, of the colour of dead rose leaves, all round the horizon, feebly defined against the afternoon sky, —the Alps of Bassano. Forward still : the endless canal bends at last, and then breaks into intricate angles about some low bastions, now torn to pieces and staggering in ugly rents towards the water,—the bastions of the fort of Malghera. Another turn, and another perspective of canal ; but not interminable. The silver beak cleaves it fast,—it widens : the rank grass of the banks sinks lower, and lower, and at last dies in tawny knots along an expanse of weedy shore. Over it, on the right, but a few years back, we might have seen the lagoon stretching to the horizon, and the warm southern sky bending over Malamocco to the sea. Now we can see nothing but what seems a low and monotonous dockyard wall, with flat arches to let the tide through it ;—this is the railroad bridge, conspicuous above all things. But at the end of those dismal arches there rises, out of the wide water, a straggling line of low and confused brick buildings, which, but for the many towers which are mingled among them, might be the suburbs of an English manufacturing town.

Four or five domes, pale, and apparently at a greater distance, rise over the centre of the line ; but the object which first catches the eye is a sullen cloud of black smoke brooding over the northern half of it, and which issues from the belfry of a church.

It is Venice.

IV

TORCELLO

THE pulpit, however, is not among the least noticeable of its features. It is sustained on the four small detached shafts marked at p in the plan,[18] between the two pillars at the north side of the screen; both pillars and pulpit studiously plain, while the staircase [19] which ascends to it is a compact mass of masonry (shaded in the plan), faced by carved slabs of marble; the parapet of the staircase being also formed of solid blocks like paving-stones, lightened by rich, but not deep, exterior carving. Now these blocks, or at least those which adorn the staircase towards the aisle, have been brought from the mainland; [20] and, being of size and shape not easily to be adjusted to the proportions of the stair, the architect has cut out of them pieces of the size he needed, utterly regardless of the subject or symmetry of the original design. The pulpit is not the only place where this rough procedure has been permitted: at the lateral door [21] of the church are two crosses, cut out of slabs of marble, formerly covered with rich sculpture over their whole surfaces, of which portions are left on the surface of the crosses; the lines of the original design being, of course, just as arbitrarily cut by the incisions between the arms, as the patterns upon a piece of silk which has been shaped anew. The fact is, that in all early Romanesque [22] work, large surfaces are covered with sculpture for the sake of enrichment only; sculpture which indeed had always meaning, because it was easier for the sculptor to work with some chain of thought to guide

27

his chisel, than without any ; but it was not always intended, or at least not always hoped, that this chain of thought might be traced by the spectator. All that was proposed appears to have been the enrichment of surface, so as to make it delightful to the eye ; and this being once understood, a decorated piece of marble became to the architect just what a piece of lace or embroidery is to a dressmaker, who takes of it such portions as she may require, with little regard to the places where the patterns are divided. And though it may appear, at first sight, that the procedure is indicative of bluntness and rudeness of feeling, we may perceive, upon reflection, that it may also indicate the redundance of power which sets little price upon its own exertion. When a barbarous nation builds its fortress-walls out of fragments of the refined architecture it has overthrown, we can read nothing but its savageness in the vestiges of art which may thus chance to have been preserved ; but when the new work is equal, if not superior, in execution, to the pieces of the older art which are associated with it, we may justly conclude that the rough treatment to which the latter have been subjected is rather a sign of the hope of doing better things, than of want of feeling for those already accomplished. And, in general, this careless fitting of ornament is, in very truth, an evidence of life in the school of builders, and of their making a due distinction between work which is to be used for architectural effect, and work which is to possess an abstract perfection ; and it commonly shows also that the exertion of design is so easy to them, and their fertility so inexhaustible, that they feel no remorse in using somewhat injuriously what they can replace with so slight an effort.

It appears however questionable in the present instance, whether, if the marbles had not been carved to his hand, the architect would have taken the trouble to enrich them. For the execution of the rest of the pulpit is studiously simple, and it is in this respect that its design possesses, it seems to me, an interest to the religious spectator greater

than he will take in any other portion of the building. It is
supported, as I said, on a group of four slender shafts ; itself
of a slightly oval form, extending nearly from one pillar of
the nave to the next, so as to give the preacher free room for
the action of the entire person, which always gives an un-
affected impressiveness to the eloquence of the southern
nations. In the centre of its curved front, a small bracket
and detached shaft sustain the projection of a narrow marble
desk (occupying the place of a cushion in a modern pulpit),
which is hollowed out into a shallow curve on the upper
surface, leaving a ledge at the bottom of the slab, so that a
book laid upon it, or rather into it, settles itself there, opening
as if by instinct, but without the least chance of slipping to
the side, or in any way moving beneath the preacher's hands.
Six balls, or rather almonds, of purple marble veined with
white are set round the edge of the pulpit, and form its only
decoration. Perfectly graceful, but severe and almost cold
in its simplicity, built for permanence and service, so that no
single member, no stone of it, could be spared, and yet all are
firm and uninjured as when they were first set together, it
stands in venerable contrast both with the fantastic pulpits
of mediæval cathedrals and with the rich furniture of those
of our modern churches. It is worth while pausing for a
moment to consider how far the manner of decorating a
pulpit may have influence on the efficiency of its service,
and whether our modern treatment of this, to us all-important,
feature of a church be the best possible.

When the sermon is good we need not much concern
ourselves about the form of the pulpit. But sermons cannot
always be good ; and I believe that the temper in which
the congregation set themselves to listen may be in some
degree modified by their perception of fitness or unfitness,
impressiveness or vulgarity, in the disposition of the place
appointed for the speaker,—not to the same degree, but
somewhat in the same way, that they may be influenced
by his own gestures or expression, irrespective of the sense

of what he says. I believe, therefore, in the first place, that pulpits ought never to be highly decorated ; the speaker is apt to look mean or diminutive if the pulpit is either on a very large scale or covered with splendid ornament, and if the interest of the sermon should flag the mind is instantly tempted to wander. I have observed that in almost all cathedrals, when the pulpits are peculiarly magnificent, sermons are not often preached from them ; but rather, and especially if for any important purpose, from some temporary erection [23] in other parts of the building : and though this may often be done because the architect has consulted the effect upon the eye more than the convenience of the ear in the placing of his larger pulpit, I think it also proceeds in some measure from a natural dislike in the preacher to match himself with the magnificence of the rostrum, lest the sermon should not be thought worthy of the place. Yet this will rather hold of the colossal sculptures, and pyramids of fantastic tracery which encumber the pulpits of Flemish and German churches, than of the delicate mosaics and ivory-like carving of the Romanesque basilicas, for when the form is kept simple, much loveliness of colour and costliness of work may be introduced, and yet the speaker not be thrown into the shade by them.

But in the second place, whatever ornaments we admit ought clearly to be of a chaste, grave, and noble kind ; and what furniture we employ, evidently more for the honouring of God's word than for the ease of the preacher. For there are two ways of regarding a sermon, either as a human composition, or a Divine message. If we look upon it entirely as the first, and require our clergymen to finish it with their utmost care and learning, for our better delight whether of ear or intellect, we shall necessarily be led to expect much formality and stateliness in its delivery, and to think that all is not well if the pulpit have not a golden fringe round it, and a goodly cushion in front of it, and if the sermon be not fairly written in a black book, to be smoothed upon the

cushion in a majestic manner before beginning ; all this we
shall duly come to expect : but we shall at the same time
consider the treatise thus prepared as something to which it
is our duty to listen without restlessness for half an hour or
three quarters, but which, when that duty has been decorously
performed, we may dismiss from our minds in happy confidence
of being provided with another when next it shall be necessary.
But if once we begin to regard [24] the preacher, whatever his
faults, as a man sent with a message to us, which it is a matter
of life or death whether we hear or refuse ; if we look upon
him as set in charge over many spirits in danger of ruin, and
having allowed to him but an hour or two in the seven days
to speak to them ; if we make some endeavour to conceive
how precious these hours ought to be to him, a small vantage
on the side of God after his flock have been exposed for six
days together to the full weight of the world's temptation,
and he has been forced to watch the thorn and the thistle
springing in their hearts, and to see what wheat had been
scattered there snatched from the wayside by this wild bird
and the other,[25] and at last, when breathless and weary with
the week's labour they give him this interval of imperfect and
languid hearing, he has but thirty minutes to get at the
separate hearts of a thousand men, to convince them of all
their weaknesses, to shame them for all their sins, to warn
them of all their dangers, to try by this way and that to stir
the hard fastenings of those doors where the Master himself
has stood and knocked [26] yet none opened, and to call at the
openings of those dark streets where Wisdom herself hath
stretched forth her hands and no man regarded,[27]—thirty
minutes to raise the dead in,—let us but once understand
and feel this, and we shall look with changed eyes upon that
frippery of gay furniture about the place from which the
message of judgment must be delivered, which either breathes
upon the dry bones [28] that they may live, or, if ineffectual,
remains recorded in condemnation, perhaps against the utterer
and listener alike, but assuredly against one of them. We

shall not so easily bear with the silk and gold upon the seat
of judgment, nor with ornament of oratory in the mouth of
the messenger : we shall wish that his words may be simple,
even when they are sweetest, and the place from which he
speaks like a marble rock in the desert,[29] about which the
people have gathered in their thirst.

But the severity which is so marked in the pulpit at Torcello
is still more striking in the raised seats and episcopal throne
which occupy the curve of the apse. The arrangement at
first somewhat recalls to the mind that of the Roman amphi-
theatres ; the flight of steps which lead up to the central
throne divides the curve of the continuous steps or seats
(it appears in the first three ranges questionable which were
intended, for they seem too high for the one, and too low
and close for the other), exactly as in an amphitheatre the
stairs for access intersect the sweeping ranges of seats. But
in the very rudeness of this arrangement, and especially in
the want of all appliances of comfort (for the whole is of
marble, and the arms of the central throne are not for con-
venience, but for distinction, and to separate it more con-
spicuously from the undivided seats), there is a dignity which
no furniture of stalls nor carving of canopies ever could attain,
and well worth the contemplation of the Protestant, both as
sternly significative of an episcopal authority which in the
early days of the Church was never disputed, and as dependent
for all its impressiveness on the utter absence of any expres-
sion either of pride or self-indulgence.[30]

But there is one more circumstance which we ought to
remember as giving peculiar significance to the position which
the episcopal throne occupies in this island church, namely,
that in the minds of all early Christians the Church itself
was most frequently symbolised under the image of a ship,
of which the bishop was the pilot. Consider the force which
this symbol would assume in the imaginations of men to
whom the spiritual Church had become an ark of refuge [31] in
the midst of a destruction hardly less terrible than that from

which the eight souls were saved of old, a destruction in which
the wrath of man had become as broad as the earth and as
merciless as the sea, and who saw the actual and literal edifice
of the Church raised up, itself like an ark in the midst of the
waters. No marvel if with the surf of the Adriatic rolling
between them and the shores of their birth, from which they
were separated for ever, they should have looked upon each
other as the disciples did when the storm came down on the
Tiberias Lake, and have yielded ready and loving obedience
to those who ruled them in His name, who had there rebuked
the winds and commanded stillness to the sea.[32] And if
the stranger would yet learn in what spirit it was that the
dominion of Venice was begun, and in what strength she
went forth conquering and to conquer, let him not seek to
estimate the wealth of her arsenals or number of her armies,
nor look upon the pageantry of her palaces, nor enter into
the secrets of her councils ; but let him ascend the highest
tier of the stern ledges that sweep round the altar of Torcello,
and then, looking as the pilot [33] did of old along the marble
ribs of the goodly temple-ship, let him repeople its veined
deck with the shadows of its dead mariners, and strive to
feel in himself the strength of heart that was kindled within
them, when first, after the pillars of it had settled in the
sand, and the roof of it had been closed against the angry
sky that was still reddened by the fires of their homesteads,
—first, within the shelter of its knitted walls, amidst the
murmur of the waste of waves and the beating of the wings
of the sea-birds round the rock that was strange to them,—
rose that ancient hymn, in the power of their gathered voices :

> THE SEA IS HIS, AND HE MADE IT :
> AND HIS HANDS PREPARED THE DRY LAND.[34]

V

ST. MARK'S (1)

This, however, I only wish the reader to recollect in order that I may speak generally of the Byzantine architecture [35] of St. Mark's, without leading him to suppose the whole church to have been built and decorated by Greek artists. Its later portions, with the single exception of the seventeenth century mosaics, have been so dexterously accommodated to the original fabric that the general effect is still that of a Byzantine building; and I shall not, except when it is absolutely necessary, direct attention to the discordant points, or weary the reader with anatomical criticism. Whatever in St. Mark's arrests the eye, or affects the feelings, is either Byzantine, or has been modified by Byzantine influence; and our inquiry into its architectural merits need not therefore be disturbed by the anxieties of antiquarianism, or arrested by the obscurities of chronology.

And now I wish that the reader, before I bring him into St Mark's Place, would imagine himself for a little time in a quiet English cathedral town, and walk with me to the west front of its cathedral. [36] Let us go together up the more retired street, at the end of which we can see the pinnacles of one of the towers, and then through the low grey gateway, with its battlemented top and small latticed window in the centre, into the inner private-looking road or close, where nothing goes in but the carts of the tradesmen who supply the bishop and the chapter, [37] and where there are little shaven grass-plots, fenced in by neat rails, before old-fashioned

34

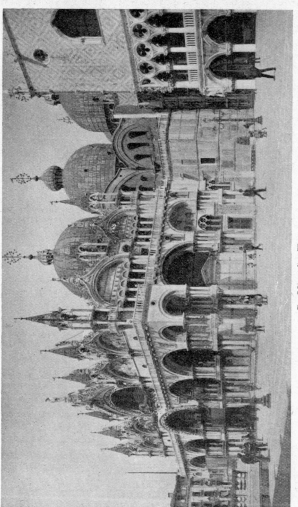

St Mark's, Venice.

(Face page 34.)

groups of somewhat diminutive and excessively trim houses, with little oriel and bay windows jutting out here and there, and deep wooden cornices and eaves painted cream colour and white, and small porches to their doors in the shape of cockle shells, or little, crooked, thick, indescribable wooden gables warped a little on one side ; and so forward till we come to larger houses, also old-fashioned, but of red brick, and with gardens behind them, and fruit walls, which show here and there, among the nectarines, the vestiges of an old cloister arch or shaft, and looking in front on the cathedral square itself, laid out in rigid divisions of smooth grass and gravel walk, yet not uncheerful, especially on the sunny side where the canons' children are walking with their nursery-maids. And so, taking care not to tread on the grass, we will go along the straight walk to the west front, and there stand for a time, looking up at its deep-pointed porches and the dark places between their pillars where there were statues once, and where the fragments, here and there, of a stately figure are still left, which has in it the likeness of a king, perhaps indeed a king on earth, perhaps a saintly king long ago in heaven ; and so higher and higher up to the great mouldering wall of rugged sculpture and confused arcades, shattered, and grey, and grisly with heads of dragons and mocking fiends, worn by the rain and swirling winds into yet unseemlier shape, and coloured on their stony scales by the deep russet-orange lichen, melancholy gold ; and so, higher still, to the bleak towers, so far above that the eye loses itself among the bosses of their traceries, though they are rude and strong, and only sees like a drift of eddying black points, now closing, now scattering, and now settling suddenly into invisible places among the bosses and flowers, the crowd of restless birds that fill the old square with that strange clangour of theirs, so harsh and yet so soothing, like the cries of birds on a solitary coast between the cliffs and sea.

Think for a little while of that scene, and the meaning

of all its small formalisms, mixed with its serene sublimity. Estimate its secluded, continuous, drowsy felicities, and its evidence of the sense and steady performance of such kind of duties as can be regulated by the cathedral clock ; and weigh the influence of those dark towers on all who have passed through the lonely square at their feet for centuries, and on all who have seen them rising far away over the wooded plain, or catching on their square masses the last rays of the sunset, when the city at their feet was indicated only by the mist at the bend of the river. And then let us quickly recollect that we are in Venice, and land at the extremity of the Calla Lunga San Moisè, which may be considered as there answering to the secluded street that led us to our English cathedral gateway.

We find ourselves in a paved alley, some seven feet wide where it is widest, full of people, and resonant with cries of itinerant salesmen,—a shriek in their beginning, and dying away into a kind of brazen ringing, all the worse for its confinement between the high houses of the passage along which we have to make our way. Over-head an inextricable confusion of rugged shutters, and iron balconies and chimney flues pushed out on brackets to save room, and arched windows with projecting sills of Istrian stone, and gleams of green leaves here and there where a fig-tree branch escapes over a lower wall from some inner cortile,[38] leading the eye up to the narrow stream of blue sky high over all. On each side, a row of shops, as densely set as may be, occupying, in fact, intervals between the square stone shafts, about eight feet high, which carry the first floors : intervals of which one is narrow and serves as a door ; the other is, in the more respectable shops, wainscotted to the height of the counter and glazed over, but in those of the poorer tradesmen left open to the ground, and the wares laid on benches and tables in the open air, the light in all cases entering at the front only, and fading away in a few feet from the threshold into a gloom which the eye from

without cannot penetrate, but which is generally broken by
a ray or two from a feeble lamp at the back of the shop,
suspended before a print of the Virgin. The less pious
shopkeeper sometimes leaves his lamp unlighted, and is
contented with a penny print; the more religious one has
his print coloured and set in a little shrine with a gilded or
figured fringe, with perhaps a faded flower or two on each
side, and his lamp burning brilliantly. Here at the fruiterer's,
where the dark-green water-melons are heaped upon the
counter like cannon balls, the Madonna has a tabernacle of
fresh laurel leaves; but the pewterer next door has let his
lamp out, and there is nothing to be seen in his shop but
the dull gleam of the studded patterns on the copper pans,
hanging from his roof in the darkness. Next comes a
" Vendita Frittole e Liquori," [39] where the Virgin, enthroned
in a very humble manner beside a tallow candle on a back
shelf, presides over certain ambrosial morsels of a nature
too ambiguous to be defined or enumerated. But a few
steps farther on, at the regular wine-shop of the calle,[40] where
we are offered " Vino Nostrani a Soldi 28.32 " [41] the Madonna
is in great glory, enthroned above ten or a dozen large red
casks of three-year-old vintage, and flanked by goodly ranks
of bottles of Maraschino, and two crimson lamps; and for
the evening, when the gondoliers will come to drink out,
under her auspices, the money they have gained during the
day, she will have a whole chandelier.

A yard or two farther, we pass the hostelry of the Black
Eagle, and, glancing as we pass through the square door
of marble, deeply moulded, in the outer wall, we see the
shadows of its pergola of vines resting on an ancient well,
with a pointed shield carved on its side; and so presently
emerge on the bridge and Campo San Moisè, whence to the
entrance into St. Mark's Place, called the Bocca di Piazza
(mouth of the square), the Venetian character is nearly
destroyed, first by the frightful façade of San Moisè, which
we will pause at another time to examine, and then by the

modernising of the shops as they near the piazza, and the
mingling with the lower Venetian populace of lounging groups
of English and Austrians.[42] We will push fast through them
into the shadow of the pillars at the end of the " Bocca di
Piazza," and then we forget them all ; [43] for between those
pillars there opens a great light, and, in the midst of it, as
we advance slowly, the vast tower of St. Mark seems to lift
itself visibly forth from the level field of chequered stones ;
and, on each side, the countless arches prolong themselves into
ranged symmetry, as if the rugged and irregular houses that
pressed together above us in the dark alley had been struck
back into sudden obedience and lovely order, and all their
rude casements and broken walls had been transformed into
arches charged with goodly sculpture, and fluted shafts of
delicate stone.

And well may they fall back, for beyond those troops
of ordered arches there rises a vision out of the earth, and
all the great square seems to have opened from it in a kind
of awe, that we may see it far away ;—a multitude of pillars
and white domes, clustered into a long low pyramid of coloured
light ; a treasure-heap, it seems, partly of gold, and partly
of opal and mother-of pearl, hollowed beneath into five great
vaulted porches, ceiled with fair mosaic, and beset with
sculpture of alabaster, clear as amber and delicate as ivory,—
sculpture fantastic and involved, of palm leaves and lilies,
and grapes and pomegranates, and birds clinging and flutter-
ing among the branches, all twined together into an endless
network of buds and plumes ; and, in the midst of it, the
solemn forms of angels, sceptred, and robed to the feet, and
leaning to each other across the gates, their figures indistinct
among the gleaming of the golden ground through the leaves
beside them, interrupted and dim, like the morning light as
it faded back among the branches of Eden, when first its gates
were angel-guarded long ago. And round the walls of the
porches there are set pillars of variegated stones, jasper and
porphyry, and deep-green serpentine spotted with flakes of

snow,- and marbles, that half refuse and half yield to the
sunshine, Cleopatra-like, "their bluest veins to kiss" [44]—
the shadow, as it steals back from them, revealing line after
line of azure undulation, as a receding tide leaves the waved
sand ; their capitals rich with interwoven tracery, rooted
knots of herbage, and drifting leaves of acanthus and vine,
and mystical signs,[45] all beginning and ending in the Cross ;
and above them, in the broad archivolts, a continuous chain
of language and of life—angels, and the signs of heaven, and
the labours of men, each in its appointed season upon the
earth ; and above these, another range of glittering pinnacles,
mixed with white arches edged with scarlet flowers,—a con-
fusion of delight, amidst which the breasts of the Greek
horses [46] are seen blazing in their breadth of golden strength,
and the St. Mark's Lion,[47] lifted on a blue field covered with
stars, until at last, as if in ecstasy, the crests of the arches
break into a marble foam, and toss themselves far into the
blue sky in flashes and wreaths of sculptured spray, as if the
breakers on the Lido shore [48] had been frost-bound before
they fell, and the sea-nymphs had inlaid them with coral and
amethyst.

Between that grim cathedral of England and this, what
an interval ! There is a type of it in the very birds that
haunt them ; for, instead of the restless crowd, hoarse-
voiced and sable-winged, drifting on the bleak upper air,
the St. Mark's porches are full of doves, that nestle among
the marble foliage, and mingle the soft iridescence of their
living plumes, changing at every motion, with the tints,
hardly less lovely, that have stood unchanged for seven
hundred years.

And what effect has this splendour on those who pass
beneath it ? You may walk from sunrise to sunset, to and
fro, before the gateway of St. Mark's, and you will not see
an eye lifted to it, nor a countenance brightened by it. Priest
and layman, soldier and civilian, rich and poor, pass by it
alike regardlessly. Up to the very recesses of the porches,

the meanest tradesmen of the city push their counters ; nay,
the foundations of its pillars are themselves the seats—not
" of them that sell doves " [49] for sacrifice, but of the venders
of toys and caricatures. Round the whole square in front of
the church there is almost a continuous line of cafés, where
the idle Venetians of the middle classes lounge, and read
empty journals ; in its centre the Austrian bands play during
the time of vespers, their martial music jarring with the organ
notes,—the march drowning the miserere,[50] and the sullen
crowd thickening round them,—a crowd, which, if it had its
will, would stiletto every soldier that pipes to it. And in
the recesses of the porches, all day long, knots of men of the
lowest classes, unemployed and listless, lie basking in the sun
like lizards ; and unregarded children,—every heavy glance
of their young eyes full of desperation and stony depravity,
and their throats hoarse with cursing,—gamble, and fight,
and snarl, and sleep, hour after hour, clashing their bruised
centesimi upon the marble ledges of the church porch. And
the images of Christ and His angels look down upon it con-
tinually.

That we may not enter the church out of the midst of
the horror of this, let us turn aside under the portico which
looks towards the sea, and passing round within the two
massive pillars brought from St. Jean d'Acre,[51] we shall find
the gate of the Baptistery ; let us enter there. The heavy
door closes behind us instantly, and the light, and the turbu-
lence of the Piazzetta,[52] are together shut out by it.

We are in a low vaulted room ; vaulted, not with arches,
but with small cupolas starred with gold, and chequered with
gloomy figures : in the centre is a bronze font charged with
rich bas-reliefs,[53] a small figure of the Baptist standing above
it in a single ray of light that glances across the narrow room,
dying as it falls from a window high in the wall, and the first
thing that it strikes, and the only thing that it strikes brightly,
is a tomb. We hardly know if it be a tomb indeed ; for it is
like a narrow couch set beside the window, low-roofed and

curtained, so that it might seem, but that it is some height
above the pavement, to have been drawn towards the window,
that the sleeper might be wakened early ;—only there are
two angels who have drawn the curtain back, and are looking
down upon him. Let us look also, and thank that gentle
light that rests upon his forehead for ever, and dies away
upon his breast.

The face is of a man in middle life, but there are two deep
furrows right across the forehead, dividing it like the founda-
tions of a tower : the height of it above is bound by the
fillet of the ducal cap. The rest of the features are singularly
small and delicate, the lips sharp, perhaps the sharpness of
death being added to that of the natural lines ; but there is
a sweet smile upon them, and a deep serenity upon the whole
countenance. The roof of the canopy above has been blue,
filled with stars ; beneath, in the centre of the tomb on which
the figure rests, is a seated figure of the Virgin, and the border
of it all around is of flowers and soft leaves, growing rich
and deep, as if in a field in summer.

It is the Doge Andrea Dandolo,[54] a man early great among
the great of Venice ; and early lost. She chose him for
her king in his 36th year ; he died ten years later, leaving
behind him that history to which we owe half of what we
know of her former fortunes.

Look round at the room in which he lies. The floor of it
is of rich mosaic, encompassed by a low seat of red marble,
and its walls are of alabaster, but worn and shattered, and
darkly stained with age, almost a ruin,—in places the slabs
of marble have fallen away altogether, and the rugged brick-
work is seen through the rents, but all beautiful ; the ravaging
fissures fretting their way among the islands and channelled
zones of the alabaster, and the time-stains on its translucent
masses darkened into fields of rich golden brown, like the
colour of seaweed when the sun strikes on it through deep
sea. The light fades away into the recess of the chamber
towards the altar, and the eye can hardly trace the lines of

the bas-relief behind it of the baptism of Christ : but on the
vaulting of the roof the figures are distinct, and there are
seen upon it two great circles, one surrounded by the " Princi-
palities and powers in heavenly places," [55] of which Milton
has expressed the ancient division in the single massy line,

"Thrones, Dominations, Princedoms, Virtues, Powers," [56]

and around the other, the Apostles ; Christ the centre of
both : and upon the walls, again and again repeated, the
gaunt figure of the Baptist, in every circumstance of his
life and death ; and the streams of the Jordan running
down between their cloven rocks ; the axe laid to the root
of a fruitless tree [57] that springs upon their shore. " Every
tree that bringeth not forth good fruit shall be hewn down,
and cast into the fire." [58]	Yes, verily : to be baptized with
fire, or to be cast therein ; it is the choice set before all men.
The march-notes still murmur through the grated window,
and mingle with the sounding in our ears of the sentence of
judgment, which the old Greek has written on that Baptistery
wall.	Venice has made her choice.

He who lies under that stony canopy would have taught
her another choice, in his day, if she would have listened to
him ; but he and his counsels have long been forgotten by
her, and the dust lies upon his lips.

Through the heavy door whose bronze network closes the
place of his rest, let us enter the church itself. It is lost in
still deeper twilight, to which the eye must be accustomed
for some moments before the form of the building can be
traced ; and then there opens before us a vast cave, hewn
out into the form of a Cross, and divided into shadowy
aisles by many pillars. Round the domes of its roof the
light enters only through narrow apertures like large stars ;
and here and there a ray or two from some far away case-
ment wanders into the darkness, and casts a narrow phos-
phoric stream upon the waves of marble that heave and fall
in a thousand colours along the floor. What else there is

of light is from torches, or silver lamps, burning ceaselessly
in the recesses of the chapels ; the roof sheeted with gold,[59]
and the polished walls covered with alabaster, give back at
every curve and angle some feeble gleaming to the flames ;
and the glories round the heads of the sculptured saints flash
out upon us as we pass them, and sink again into the gloom.
Under foot and over head, a continual succession of crowded
imagery, one picture passing into another, as in a dream ;
forms beautiful and terrible mixed together ; dragons and
serpents, and ravening beasts of prey, and graceful birds that
in the midst of them drink from running fountains and feed
from vases of crystal ; the passions and the pleasures of
human life symbolised together, and the mystery of its
redemption ; for the mazes of interwoven lines and changeful
pictures lead always at last to the Cross, lifted and carved in
every place and upon every stone ; sometimes with the
serpent of eternity wrapt round it, sometimes with doves
beneath its arms, and sweet herbage growing forth from its
feet ; but conspicuous most of all on the great rood [60] that
crosses the church before the altar, raised in bright blazonry
against the shadow of the apse. And although in the recesses
of the aisles and chapels, when the mist of the incense hangs
heavily, we may see continually a figure traced in faint lines
upon their marble, a woman standing with her eyes raised to
heaven, and the inscription above her, " Mother of God," [61]
she is not here the presiding deity. It is the Cross that is
first seen, and always, burning in the centre of the temple ;
and every dome and hollow of its roof has the figure of Christ
in the utmost height of it, raised in power, or returning in
judgment.[62]

Nor is this interior without effect on the minds of the
people. At every hour of the day there are groups collected
before the various shrines, and solitary worshippers scattered
through the darker places of the church, evidently in prayer
both deep and reverent, and, for the most part, profoundly
sorrowful. The devotees at the greater number of the renowned

shrines of Romanism [63] may be seen murmuring their ap-
pointed prayers with wandering eyes and unengaged gestures;
but the step of the stranger does not disturb those who kneel
on the pavement of St. Mark's; and hardly a moment passes,
from early morning to sunset, in which we may not see some
half-veiled figure enter beneath the Arabian porch,[64] cast
itself into long abasement on the floor of the temple, and
then rising slowly with more confirmed step, and with a
passionate kiss and clasp of the arms given to the feet of the
crucifix, by which the lamps burn always in the northern
aisle, leave the church, as if comforted.

But we must not hastily conclude from this that the
nobler characters of the building have at present any influence
in fostering a devotional spirit. There is distress enough in
Venice to bring many to their knees, without excitement
from external imagery; and whatever there may be in the
temper of the worship offered in St. Mark's more than can
be accounted for by reference to the unhappy circumstances
of the city, is assuredly not owing either to the beauty of
its architecture or to the impressiveness of the Scripture
histories embodied in its mosaics. That it has a peculiar
effect, however slight, on the popular mind, may perhaps be
safely conjectured from the number of worshippers which it
attracts, while the churches of St. Paul and the Frari, larger
in size and more central in position, are left comparatively
empty.* But this effect is altogether to be ascribed to its
richer assemblage of those sources of influence which address
themselves to the commonest instincts of the human mind,
and which, in all ages and countries, have been more or less
employed in the support of superstition. Darkness and
mystery; confused recesses of building; artificial light em-
ployed in small quantity, but maintained with a constancy
which seems to give it a kind of sacredness; preciousness of

* The mere warmth of St. Mark's in winter, which is much greater than
that of the other two churches above named, must, however, be taken
into consideration, as one of the most efficient causes of its being then
more frequented. (R.)

material easily comprehended by the vulgar eye ; close air loaded with a sweet and peculiar odour associated only with religious services, solemn music, and tangible idols or images having popular legends attached to them,—these, the stage properties of superstition, which have been from the beginning of the world, and must be to the end of it, employed by all nations, whether openly savage or nominally civilised, to produce a false awe in minds incapable of apprehending the true nature of the Deity, are assembled in St. Mark's to a degree, as far as I know, unexampled in any other European church. The arts of the Magus and the Brahmin [65] are exhausted in the animation of a paralysed Christianity ; and the popular sentiment which these arts excite is to be regarded by us with no more respect than we should have considered ourselves justified in rendering to the devotion of the worshippers at Eleusis, Ellora or Edfou.* [66]

* I said above that the larger number of the devotees entered by the " Arabian " porch ; the porch, that is to say, on the north side of the church, remarkable for its rich Arabian archivolt, and through which access is gained immediately to the northern transept. The reason is, that in that transept is the chapel of the Madonna, which has a greater attraction for the Venetians than all the rest of the church besides. The old builders kept their images of the Virgin subordinate to those of Christ ; but modern Romanism has retrograded from theirs, and the most glittering portions of the whole church are the two recesses behind this lateral altar, covered with silver hearts dedicated to the Virgin. (R.)

VI

ST. MARK'S (2)

I SHALL, in a future portion of this work, endeavour to dis-
cover what probabilities there are of our being able to use
this kind of art [67] in modern churches; but at present it
remains for us to follow out the connection of the subjects
represented in St. Mark's, so as to fulfil our immediate object,
and form an adequate conception of the feelings of its builders,
and of its uses to those for whom it was built.

Now there is one circumstance to which I must, in the
outset, direct the reader's special attention, as forming a
notable distinction between ancient and modern days. Our
eyes are now familiar and wearied with writing; and if an
inscription is put upon a building, unless it be large and
clear, it is ten to one whether we ever trouble ourselves to
decipher it. But the old architect was sure of readers. He
knew that every one would be glad to decipher all that he
wrote; that they would rejoice in possessing the vaulted
leaves of his stone manuscript; and that the more he gave
them, the more grateful would the people be. We must
take some pains, therefore, when we enter St. Mark's, to read
all that is inscribed, or we shall not penetrate into the feeling
either of the builder or of his times.

A large atrium or portico is attached to two sides of the
church, a space which was especially reserved for unbaptised
persons and new converts. It was thought right that, before
their baptism, these persons should be led to contemplate
the great facts of the Old Testament history; the history

of the Fall of Man, and of the lives of Patriarchs up to the period of the Covenant by Moses : the order of the subjects in this series being very nearly the same as in many Northern churches, but significantly closing with the Fall of the Manna, in order to mark to the catechumen the insufficiency of the Mosaic covenant for salvation,—" Our fathers did eat manna in the wilderness, and are dead," [68]—and to turn his thoughts to the true Bread of which that manna was the type.

Then, when after his baptism he was permitted to enter the church, over its main entrance he saw, on looking back, a mosaic of Christ enthroned, with the Virgin on one side and St. Mark on the other, in attitudes of adoration. Christ is represented as holding a book open upon his knee, on which is written : " I AM THE DOOR ; BY ME IF ANY MAN ENTER IN, HE SHALL BE SAVED." [69] On the red marble moulding which surrounds the mosaic is written : " I AM THE GATE OF LIFE ; LET THOSE WHO ARE MINE ENTER BY ME." Above, on the red marble fillet which forms the cornice of the west end of the church, is written, with reference to the figure of Christ below : " WHO HE WAS, AND FROM WHOM HE CAME, AND AT WHAT PRICE HE REDEEMED THEE, AND WHY HE MADE THEE, AND GAVE THEE ALL THINGS, DO THOU CONSIDER."

Now observe, this was not to be seen and read only by the catechumen when he first entered the church ; every one who at any time entered, was supposed to look back and to read this writing ; their daily entrance into the church was thus made a daily memorial of their first entrance into the spiritual Church ; and we shall find that the rest of the book which was opened for them upon its walls continually led them in the same manner to regard the visible temple as in every part a type of the invisible Church of God.

Therefore the mosaic of the first dome, which is over the head of the spectator as soon as he has entered by the great door (that door being the type of baptism), represents the effusion of the Holy Spirit,[70] as the first consequence and seal of the entrance into the Church of God. In the centre

of the cupola is the Dove, enthroned in the Greek manner, as the Lamb is enthroned, when the Divinity of the Second and Third Persons [71] is to be insisted upon together with their peculiar offices. From the central symbol of the Holy Spirit twelve streams of fire descend upon the heads of the twelve apostles, who are represented standing around the dome ; and below them, between the windows which are pierced in its walls, are represented, by groups of two figures for each separate people, the various nations who heard the apostles speak, at Pentecost, every man in his own tongue. Finally, on the vaults, at the four angles which support the cupola, are pictured four angels, each bearing a tablet upon the end of a rod in his hand : on each of the tablets of the three first angels is inscribed the word " Holy ; " on that of the fourth is written " Lord ; " and the beginning of the hymn being thus put into the mouths of the four angels, the words of it are continued around the border of the dome, uniting praise to God for the gift of the Spirit, with welcome to the redeemed soul received into His Church :

> " HOLY, HOLY, HOLY, LORD GOD OF SABAOTH :
> HEAVEN AND EARTH ARE FULL OF THY GLORY.
> HOSANNA IN THE HIGHEST :
> BLESSED IS HE THAT COMETH IN THE NAME OF THE LORD."

And observe in this writing that the convert is required to regard the outpouring of the Holy Spirit especially as a work of *sanctification*. It is the *holiness* of God manifested in the giving of His Spirit to sanctify those who had become His children, which the four angels celebrate in their ceaseless praise ; and it is on account of this holiness that the heaven and earth are said to be full of His glory.

After thus hearing praise rendered to God by the angels for the salvation of the newly-entered soul, it was thought fittest that the worshipper should be led to contemplate in the most comprehensive forms possible, the past evidence and the future hopes of Christianity, as summed up in the

three facts without assurance of which all faith is vain ; namely, that Christ died, that He rose again, and that He ascended into heaven, there to prepare a place for His elect. On the vault between the first and second cupolas are represented the crucifixion and resurrection of Christ, with the usual series of intermediate scenes,[72]—the treason of Judas, the judgment of Pilate, the crowning with thorns, the descent into Hades, the visit of the women to the Sepulchre, and the apparition to Mary Magdalene. The second cupola itself, which is the central and principal one of the church, is entirely occupied by the subject of the Ascension. At the highest point of it Christ is represented as rising into the blue heaven, borne up by four angels, and throned upon a rainbow, the type of reconciliation.[73] Beneath him, the twelve apostles are seen upon the Mount of Olives, with the Madonna, and, in the midst of them, the two men in white apparel who appeared at the moment of the Ascension, above whom, as uttered by them, are inscribed the words, " Ye men of Galilee, why stand ye gazing up into heaven ? This Christ, the Son of God, as He is taken from you, shall so come,[74] the arbiter of the earth, trusted to do judgment and justice."

Beneath the circle of the apostles, between the windows of the cupola, are represented the Christian virtues, as sequent upon the crucifixion of the flesh, and the spiritual ascension together with Christ. Beneath them, on the vaults which support the angles of the cupola, are placed the four Evangelists, because on their evidence our assurance of the fact of the Ascension rests ; and, finally, beneath their feet, as symbols of the sweetness and fulness of the Gospel which they declared, are represented the four rivers of Paradise, Pison, Gihon, Tigris, and Euphrates.

The third cupola, that over the altar, represents the witness of the Old Testament to Christ ; [75] showing him enthroned in its centre, and surrounded by the patriarchs and prophets. But this dome was little seen by the people ; their contemplation was intended to be chiefly drawn to that of the centre

of the church, and thus the mind of the worshipper was at once fixed on the main groundwork and hope of Christianity, —" Christ is risen," and " Christ shall come." If he had time to explore the minor lateral chapels and cupolas, he could find in them the whole series of New Testament history, the events of the Life of Christ, and the Apostolic miracles in their order, and finally the scenery of the Book of Revelation ;* but if he only entered, as often the common people do to this hour, snatching a few moments before beginning the labour of the day to offer up an ejaculatory prayer, and advanced but from the main entrance as far as the altar screen, all the splendour of the glittering nave and variegated dome, if they smote upon his heart, as they might often, in strange contrast with his reed cabin among the shallows of the lagoon, smote upon it only that they might proclaim the two great messages, —" Christ is risen," and " Christ shall come." Daily, as the white cupolas rose like wreaths of sea-foam in the dawn, while the shadowy campanile and frowning palace were still withdrawn into the night, they rose with the Easter Voice of Triumph,—" Christ is risen ; " and daily, as they looked down upon the tumult of the people, deepening and eddying in the wide square that opened from their feet to the sea, they uttered above them the sentence of warning,—" Christ shall come."

And this thought may surely dispose the reader to look with some change of temper upon the gorgeous building and wild blazonry of that shrine of St. Mark's. He now perceives that it was in the hearts of the old Venetian people far more than a place of worship. It was at once a type of the Redeemed Church of God, and a scroll for the written word of God. It was to be to them, both an image of the Bride,[76] all glorious within, her clothing of wrought gold ; and the actual Table of the Law and the Testimony, written within and without. And whether honoured as the Church or as

* The old mosaics from the Revelation have perished, and have been replaced by miserable work of the seventeenth century. (R.)

the Bible, was it not fitting that neither the gold nor the
crystal should be spared in the adornment of it ; that, as the
symbol of the Bride, the building of the wall thereof should
be of jasper,* and the foundations of it garnished with all
manner of precious stones ; and that, as the channel of the
Word, that triumphant utterance of the Psalmist should be .
true of it,—" I have rejoiced in the way of thy testimonies,
as much as in all riches ? " [77] And shall we not look with
changed temper down the long perspective of St. Mark's
Place towards the sevenfold gates and glowing domes of its
temple, when we know with what solemn purpose the shafts
of it were lifted above the pavement of the populous square ?
Men met there from all countries of the earth, for traffic or
for pleasure ; but, above the crowd swaying for ever to and
fro in the restlessness of avarice or thirst of delight, was
seen perpetually the glory of the temple, attesting to them,
whether they would hear or whether they would forbear,
that there was one treasure which the merchantman might
buy without a price, and one delight better than all others,
in the word and the statutes of God. Not in the wantonness
of wealth, not in vain ministry to the desire of the eyes or
the pride of life,[78] were those marbles hewn into transparent
strength, and those arches arrayed in the colours of the iris.
There is a message written in the dyes of them, that once
was written in blood ; and a sound in the echoes of their
vaults, that one day shall fill the vault of heaven,—" He shall
return, to do judgment and justice." The strength of
Venice was given her, so long as she remembered this : her
destruction found her when she had forgotten this ; and it
found her irrevocably, because she forgot it without excuse.
Never had city a more glorious Bible. Among the nations
of the North, a rude and shadowy sculpture filled their temples
with confused and hardly legible imagery ; but, for her, the
skill and the treasures of the East had gilded every letter,
and illumined every page, till the Book-Temple shone from

* Rev. xxi. 18. (R.)

afar off like the star of the Magi.[79] In other cities, the meetings of the people were often in places withdrawn from religious association, subject to violence and to change ; and on the grass of the dangerous rampart, and in the dust of the troubled street, there were deeds done and counsels taken, which, if we cannot justify, we may sometimes forgive. But the sins of Venice, whether in her palace or in her piazza, were done with the Bible at her right hand. The walls on which its testimony was written were separated but by a few inches of marble from those which guarded [80] the secrets of her councils, or confined the victims of her policy.[81] And when in her last hours she threw off all shame and all restraint, and the great square of the city became filled with the madness of the whole earth, be it remembered how much her sin was greater, because it was done in the face of the House of God, burning with the letters of His Law. Mountebank and masquer laughed their laugh, and went their way ; and a silence has followed them, not unforetold ; for amidst them all, through century after century of gathering vanity and festering guilt, that white dome of St. Mark's had uttered in the dead ear of Venice, " Know thou, that for all these things God will bring thee into judgment." [82]

VII

BYZANTINE PALACES

THIS cross,[83] though graceful and rich, and given because
it happens to be one of the best preserved, is uncharacteristic
in one respect ; for, instead of the central rose at the meeting
of the arms, we usually find a hand raised in the attitude of
blessing, between the sun and moon, as in the two smaller
crosses seen in the Plate. In nearly all representations of
the Crucifixion, over the whole of Europe, at the period in
question,[84] the sun and moon are introduced, one on each
side of the cross,—the sun generally, in paintings, as a red
star ; but I do not think with any purpose of indicating the
darkness at the time of the agony ; especially because, had
this been the intention, the moon ought not to have been
visible, since it could not have been in the heavens during
the day at the time of passover. I believe rather that the
two luminaries are set there in order to express the entire
dependence of the heavens and the earth upon the work of
the Redemption : and this view is confirmed by our frequently
finding the sun and moon set in the same manner beside the
figure of Christ, as in the centre of the great archivolt of St.
Mark's, or beside the hand signifying benediction, without
any cross, in some other early archivolts ;* while, again, not
unfrequently they are absent from the symbol of the cross
itself, and its saving power over the whole of creation is
indicated only by fresh leaves springing from its foot, or doves

* Two of these are represented in the second number of my folio work
upon Venice. (R.)

feeding beside it ; and so also, in illuminated Bibles, we find
the series of pictures representing the Creation terminate in
the Crucifixion, as the work by which all the families of created
beings subsist, no less than that in sympathy with which " the
whole creation groaneth and travaileth in pain together until
now." [85]

This habit of placing the symbol of the Christian faith in
the centres of their palaces, was, as I above said, universal
in early Venice ; it does not cease till about the middle of the
fourteenth century. The other sculptures, which were set
above or between the arches, consist almost invariably of
groups of birds or beasts ; either standing opposite to each
other with a small pillar or spray of leafage between them,
or else tearing and devouring each other. The multitude of
these sculptures,[86] especially of the small ones enclosed in
circles, as figs. 5 and 6, Plate XI., which are now scattered
through the city of Venice, is enormous, but they are seldom
to be seen in their original positions. When the Byzantine
palaces were destroyed, these fragments were generally pre-
served, and inserted again in the walls of the new buildings
with more or less attempt at symmetry ; fragments of friezes
and mouldings being often used in the same manner ; so that
the mode of their original employment can only be seen in
St. Mark's, the Fondaco de' Turchi,[87] Braided House,[88] and
one or two others. The most remarkable point about them
is, that the groups of beasts or birds on each side of the small
pillars bear the closest possible resemblance to the group of
Lions over the gate of Mycenæ ; [89] and the whole of the
ornamentation of that gate, as far as I can judge of it from
drawings, is so like Byzantine sculpture, that I cannot help
sometimes suspecting the original conjecture of the French
antiquarians, that it was a work of the middle ages, to be
not altogether indefensible. By far the best among the
sculptures at Venice are those consisting of groups thus
arranged ; the first figure in Plate XI. is one of those used
on St. Mark's, and, with its chain of wreathen work round it,

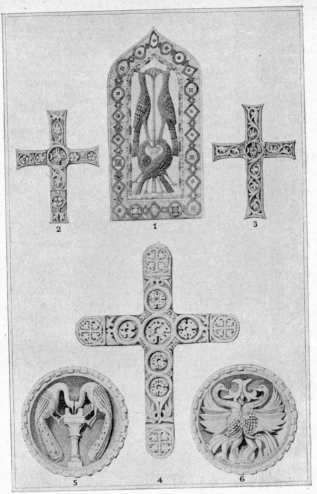

Byzantine Sculpture.

1. Peacocks from St. Mark's. 2, 3. Crosses. 4. A Cross from the house of
Marco Polo. 5. Peacocks from the Church of the Carmini. 6. Animals
in a circle.

Reproduced from Plate XI. (*Face page* 54.)

is very characteristic of the finest kind, except that the immediate trunk or pillar often branches into luxuriant leafage, usually of the vine, so that the whole ornament seems almost composed from the words of Ezekiel. " A great eagle with great wings, long-winged, full of feathers, which had divers colours, came into Lebanon, and took the highest branch of the cedar : He cropped off the top of his young twigs ; and *carried it into a city of traffic ; he set it in a city of merchants.* He took also of the seed of the land, . . . and it grew, and became a spreading vine of low stature, *whose branches turned towards him, and the roots thereof were under him.*" [90]

The groups of contending and devouring animals are always much ruder in cutting, and take somewhat the place in Byzantine sculpture which the lower grotesques do in the Gothic ; true, though clumsy, grotesques being sometimes mingled among them, as four bodies joined to one head in the centre ; but never showing any attempt at variety of invention, except only in the effective disposition of the light and shade, and in the vigour and thoughtfulness of the touches which indicate the plumes of the birds, or foldings of the leaves. Care, however, is always taken to secure variety enough to keep the eye entertained, no two sides of these Byzantine ornaments being in all respects the same : for instance, in the chainwork round the first figure in Plate XI. there are two circles enclosing squares on the left-hand side of the arch at the top, but two smaller circles and a diamond on the other, enclosing one square, and two small circular spots or bosses ; and in the line of chain at the bottom there is a circle on the right, and a diamond on the left, and so down to the working of the smallest details. I have represented this upper sculpture as dark, in order to give some idea of the general effect of these ornaments when seen in shadow against light ; an effect much calculated upon by their designer, and obtained by the use of a golden ground, formed of glass mosaic inserted in the hollows of the marble. Each square of glass has the leaf gold upon its surface protected by another thin film of

glass above it, so that no time or weather can affect its lustre, until the pieces of glass are bodily torn from their setting. The smooth glazed surface of the golden ground is washed by every shower of rain, but the marble usually darkens into an amber colour in process of time ; and when the whole ornament is cast into shadow, the golden surface, being perfectly reflective, refuses the darkness, and shows itself in bright and burnished light behind the dark traceries of the ornament. Where the marble has retained its perfect whiteness, on the other hand, and is seen in sunshine, it is shown as a snowy tracery on a golden ground ; and the alternations and intermingling of these two effects form one of the chief enchantments of Byzantine ornamentation.

How far the system of grounding with gold and colour, universal in St. Mark's, was carried out in the sculptures of the private palaces, it is now impossible to say. The wrecks of them which remain, as above noticed, show few of their ornamental sculptures in their original position ; and from those marbles which were employed in succeeding buildings during the Gothic period, the fragments of their mosaic grounds would naturally rather have been removed than restored. Mosaic, while the most secure of all decorations if carefully watched and refastened when it loosens, may, if neglected and exposed to weather, in process of time disappear so as to leave no vestige of its existence. However this may have been, the assured facts are, that both the shafts of the pillars and the facing of the whole building were of veined or variously coloured marble : the capitals and sculptures were either, as they now appear, of pure white marble, relieved upon the veined ground ; or, which is infinitely the more probable, grounded in the richer palaces with mosaic of gold, in the inferior ones with blue colour ; and only the leaves and edges of the sculpture gilded. These brighter hues were opposed by bands of deeper colour, generally alternate russet and green, in the archivolts,—bands which still remain in the Casa Loredan and Fondaco de'

Turchi, and in a house in the Corte del Remer near the Rialto, as well as in St. Mark's; and by circular discs of green serpentine and porphyry, which, together with the circular sculptures, appear to have been an ornament peculiarly grateful to the Eastern mind, derived probably in the first instance from the suspension of shields upon the wall, as in the majesty of ancient Tyre. "The men of Arvad with thine army were upon thy walls round about, and the Gammadims were in thy towers: they hanged their shields upon thy walls round about; they have made thy beauty perfect."* The sweet and solemn harmony of purple with various green (the same,[91] by the by, to which the hills of Scotland owe their best loveliness) remained a favourite chord of colour with the Venetians, and was constantly used even in the later palaces; but never could have been seen in so great perfection as when opposed to the pale and delicate sculpture of the Byzantine time.

Such then, was that first and fairest Venice which rose out of the barrenness of the lagoon, and the sorrow of her people; a city of graceful arcades and gleaming walls, veined with azure and warm with gold, and fretted with white sculpture like frost upon forest branches turned to marble. And yet, in this beauty of her youth, she was no city of thoughtless pleasure. There was still a sadness of heart upon her, and a depth of devotion, in which lay all her strength. I do not insist upon the probable religious signification of many of the sculptures which are now difficult of interpretation; but the temper which made the cross the principal ornament of every building is not to be misunderstood, nor can we fail to perceive, in many of the minor sculptural subjects, meanings perfectly familiar to the mind of early Christianity. The peacock, used in preference to every other bird, is the well-known symbol of the resurrection; and, when drinking from a fountain (Plate XI. fig.1) or from a font (Plate XI. fig. 5), is, I doubt not, also a type of the new

* Ezekiel, xxvii. 11. (R.)

life received in faithful baptism. The vine, used in preference
to all other trees, was equally recognised as, in all cases, a
type [92] either of Christ Himself or of those who were in a
state of visible or professed union with Him. The dove,[93]
at its foot, represents the coming of the Comforter ; and
even the groups of contending animals had, probably, a
distinct and universally apprehended reference to the powers
of evil. But I lay no stress on these more occult meanings.
The principal circumstance which marks the seriousness of
the early Venetian mind is perhaps the last in which the
reader would suppose it was traceable ; that love of bright
and pure colour which, in a modified form, was afterwards
the root of all the triumph of the Venetian schools of painting,[94]
but which, in its utmost simplicity, was characteristic of the
Byzantine period only ; and of which, therefore, in the close
of our review of that period, it will be well that we should
truly estimate the significance. The fact is, we none of us
enough appreciate the nobleness and sacredness of colour.
Nothing is more common than to hear it spoken of as a
subordinate beauty,—nay, even as the mere source of a
sensual pleasure ; and we might almost believe that we were
daily among men who

> " Could strip, for aught the prospect yields
> To them, their verdure from the fields ;
> And take the radiance from the clouds
> With which the sun his setting shrouds."

But it is not so. Such expressions are used for the most
part in thoughtlessness ; and if the speakers would only take
the pains to imagine what the world and their own existence
would become, if the blue were taken from the sky, and the
gold from the sunshine, and the verdure from the leaves, and
the crimson from the blood which is the life of man, the
flush from the cheek, the darkness from the eye, the radiance
from the hair,—if they could but see, for an instant, white
human creatures living in a white world,—they would soon
feel what they owe to colour. The fact is, that, of all God's

gifts to the sight of man, colour is the holiest, the most
divine, the most solemn. We speak rashly of gay colour,
and sad colour, for colour cannot at once be good and gay.
All good colour is in some degree pensive, the loveliest is
melancholy, and the purest and most thoughtful minds are
those which love colour the most.

I know that this will sound strange in many ears, and
will be especially startling to those who have considered
the subject chiefly with reference to painting ; for the great
Venetian schools of colour are not usually understood to be
either pure or pensive, and the idea of its pre-eminence is
associated in nearly every mind with the coarseness of Rubens,[95]
and the sensualities of Correggio [96] and Titian. But a more
comprehensive view of art will soon correct this impression.
It will be discovered, in the first place, that the more faithful
and earnest the religion of the painter, the more pure and
prevalent is the system of his colour. It will be found, in the
second place, that where colour becomes a primal intention
with a painter otherwise mean or sensual, it instantly elevates
him, and becomes the one sacred and saving element in his
work. The very depth of the stoop to which the Venetian
painters and Rubens sometimes condescend, is a consequence
of their feeling confidence in the power of their colour to keep
them from falling. They hold on by it, as by a chain let down
from heaven, with one hand, though they may sometimes
seem to gather dust and ashes with the other. And, in the
last place, it will be found that so surely as a painter is irre-
ligious, thoughtless, or obscene in disposition, so surely is
his colouring cold, gloomy, and valueless. The opposite poles
of art in this respect are Frà Angelico [97] and Salvator Rosa ; [98]
of whom the one was a man who smiled seldom, wept often,
prayed constantly, and never harboured an impure thought.
His pictures are simply so many pieces of jewellery, the
colours of the draperies being perfectly pure, as various as
those of a painted window, chastened only by paleness and
relieved upon a gold ground. Salvator was a dissipated jester

and satirist, a man who spent his life in masquing and revelry.
But his pictures are full of horror, and their colour is for the
most part gloomy grey. Truly it would seem as if art had
so much of eternity in it, that it must take its dye from the
close rather than the course of life :—" In such laughter the
heart of man is sorrowful, and the end of that mirth is
heaviness." [99]

These are no singular instances. I know no law more
severely without exception than this of the connection of
pure colour with profound and noble thought. The late
Flemish pictures,[100] shallow in conception and obscene in
subject, are always sober in colour. But the early religious
painting of the Flemings [101] is as brilliant in hue as it is holy
in thought. The Bellinis, Francias, Peruginos [102] painted in
crimson, and blue, and gold. The Caraccis, Guidos, and
Rembrandts [103] in brown and grey. The builders of our
great cathedrals veiled their casements and wrapped their
pillars with one robe of purple splendour. The builders of the
luxurious Renaissance left their palaces filled only with cold
white light, and in the paleness of their native stone.

Nor does it seem difficult to discern a noble reason for
this universal law. In that heavenly circle which binds the
statutes of colour upon the front of the sky, when it became
the sign of the covenant of peace, the pure hues of divided
light were sanctified to the human heart for ever ; nor this,
it would seem, by mere arbitrary appointment, but in con-
sequence of the fore-ordained and marvellous constitution
of those hues into a sevenfold, or, more strictly still, a three-
fold order,[104] typical of the Divine nature itself. Observe
also, the name Shem, or Splendour, given to that son of
Noah in whom this covenant with mankind was to be fulfilled,
and see how that name was justified by every one of the
Asiatic races which descended from him. Not without
meaning was the love of Israel [105] to his chosen son expressed
by the coat " of many colours ; " not without deep sense
of the sacredness of that symbol of purity, did the lost daughter

of David tear it from her breast :—" With such robes were
the king's daughters that were virgins apparelled."* We
know it to have been by Divine command [106] that the Israelite,
rescued from servitude, veiled the tabernacle with its rain of
purple and scarlet, while the under sunshine flashed through
the fall of the colour from its tenons of gold : but was it less
by Divine guidance that the Mede, as he struggled out of
anarchy, encompassed his king with the sevenfold burning of
the battlements of Ecbatana ? [107]—of which one circle was
golden like the sun, and another silver like the moon ; and
then came the great sacred chord of colour, blue, purple, and
scarlet ; and then a circle white like the day, and another
dark, like night ; so that the city rose like a great mural
rainbow, a sign of peace amidst the contending of lawless
races, and guarded, with colour and shadow, that seemed to
symbolise the great order which rules over Day, and Night,
and Time, the first organisation of the mighty statutes,—the
law of the Medes and Persians, that altereth not.[108]

Let us not dream that it is owing to the accidents of tradi-
tion or education that those races [109] possess the supremacy
over colour which has always been felt, though but lately
acknowledged among men. However their dominion might
be broken, their virtue extinguished, or their religion defiled,
they retained alike the instinct and the power : the instinct
which made even their idolatry more glorious than that of
others, bursting forth in fire-worship from pyramid, cave, and
mountain, taking the stars for the rulers of its fortune,
and the sun for the God of its life ; [110] the power which
so dazzled and subdued the rough crusader into forgetfulness
of sorrow and of shame, that Europe put on the splendour
which she had learnt of the Saracen, as her sackcloth of
mourning for what she suffered from his sword ;—the power
which she confesses to this day, in the utmost thoughtlessness
of her pride, or her beauty, as it treads the costly carpet, or
veils itself with the variegated Cachemire ; and in the emula-

* 2 Samuel, xiii. 18. (R.)

tion of the concourse of her workmen, who, but a few months back, perceived, or at least admitted, for the first time, the pre-eminence which has been determined from the birth of mankind, and on whose charter Nature herself has set a mysterious seal, granting to the Western races, descended from that son of Noah whose name was Extension,[111] the treasures of the sullen rock, and stubborn ore, and gnarled forest, which were to accomplish their destiny across all distance of earth and depth of sea, while she matured the jewel in the sand, and rounded the pearl in the shell, to adorn the diadem of him whose name was Splendour.

And observe, farther, how in the Oriental mind a peculiar seriousness is associated with this attribute of the love of colour ; a seriousness rising out of repose, and out of the depth and breadth of the imagination, as contrasted with the activity, and consequent capability of surprise, and of laughter, characteristic of the Western mind : as a man on a journey must look to his steps always, and view things narrowly and quickly ; while one at rest may command a wider view, though an unchanging one, from which the pleasure he receives must be one of contemplation, rather than of amusement or surprise. Wherever the pure Oriental spirit manifests itself definitely, I believe its work is serious ; and the meeting of the influences of the Eastern and Western races is perhaps marked in Europe more by the dying away of the grotesque laughter of the Goth [112] than by any other sign. I shall have more to say on this head in other places of this volume ; but the point I wish at present to impress upon the reader is, that the bright hues of the early architecture of Venice were no sign of gaiety of heart, and that the investiture with the mantle of many colours by which she is known above all other cities of Italy and of Europe, was not granted to her in the fever of her festivity, but in the solemnity of her early and earnest religion. She became in after times the revel of the earth, the masque of Italy ; [113] and *therefore* is she now desolate : but her glorious robe of gold and purple was given her

when first she rose a vestal from the sea, not when she
became drunk with the wine of her fornication.[114]

And we have never yet looked with enough reverence upon
the separate gift which was thus bestowed upon her ; we
have never enough considered what an inheritance she has
left us, in the works of those mighty painters who were
the chief of her children. That inheritance is indeed less
than it ought to have been, and other than it ought to
have been ; for before Titian and Tintoret arose,—the
men in whom her work and her glory should have been
together consummated,—she had already ceased to lead her
sons in the way of truth and life, and they erred much, and
fell short of that which was appointed for them. There is no
subject of thought more melancholy, more wonderful, than
the way in which God permits so often His best gifts to be
trodden under foot of men, His richest treasures to be wasted
by the moth, and the mightiest influences of His Spirit, given
but once in the world's history, to be quenched and shortened
by miseries of chance and guilt. I do not wonder at what
men Suffer, but I wonder often at what they Lose. We may
see how good rises out of pain and evil ; but the dead, naked,
eyeless loss, what good comes of that ? The fruit struck to
the earth before its ripeness ; the glowing life and goodly
purpose dissolved away in sudden death ; the words, half
spoken, choked upon the lips with clay for ever ; or, stranger
than all, the whole majesty of humanity raised to its fulness,
and every gift and power necessary for a given purpose, at
a given moment, centred in one man, and all this perfected
blessing permitted to be refused, perverted, crushed, cast aside
by those who need it most,—the city which is Not set on a hill,
the candle that giveth light to None that are in the house ; [115]
—these are the heaviest mysteries of this strange world, and
it seems to me, those which mark its curse the most. And it
is true that the power with which this Venice had been
entrusted, was perverted, when at its highest, in a thousand
miserable ways : still, it was possessed by her alone ; to

her all hearts have turned which could be moved by its
manifestation, and none without being made stronger and
nobler by what her hand had wrought. That mighty Land-
scape,[116] of dark mountains that guard the horizon with their
purple towers, and solemn forests, that gather their weight
of leaves, bronzed with sunshine, not with age, into those
gloomy masses fixed in heaven, which storm and frost have
power no more to shake, or shed ;—that mighty Humanity,
so perfect and so proud, that hides no weakness beneath the
mantle, and gains no greatness from the diadem ; the majesty
of thoughtful form, on which the dust of gold and flame of
jewels are dashed as the sea-spray upon the rock, and still
the great Manhood seems to stand bare against the blue sky ;
—that mighty Mythology, which fills the daily walks of men
with spiritual companionship, and beholds the protecting
angels break with their burning presence through the arrow-
flights of battle:—measure the compass of that field of creation,
weigh the value of the inheritance that Venice thus left to the
nations of Europe, and then judge if so vast, so beneficent
a power could indeed have been rooted in dissipation or
decay. It was when she wore the ephod of the priest, not
the motley of the masquer, that the fire fell upon her from
heaven ; and she saw the first rays of it through the rain of
her own tears, when, as the barbaric deluge ebbed from the
hills of Italy, the circuit of her palaces, and the orb of her
fortunes, rose together, like the Iris, painted upon the Cloud.

VIII

THE NATURE OF GOTHIC

IF the reader will look back to the division of our subject [117] which was made in the first chapter of the first volume, he will find that we are now about to enter upon the examination of that school of Venetian architecture which forms an inter-mediate step between the Byzantine and Gothic forms ; but which I find may be conveniently considered in its connection with the latter style. In order that we may discern the tendency of each step of this change, it will be wise in the outset to endeavour to form some general idea of its final result. We know already what the Byzantine architecture is from which the transition was made, but we ought to know something of the Gothic architecture into which it led. I shall endeavour therefore to give the reader in this chapter an idea, at once broad and definite, of the true nature of Gothic architecture, properly so called ; not of that of Venice only, but of universal Gothic : for it will be one of the most interesting parts of our subsequent inquiry, to find out how far Venetian architecture reached the universal or perfect type of Gothic, and how far it either fell short of it, or assumed foreign and independent forms.

The principal difficulty in doing this arises from the fact that every building of the Gothic period differs in some important respect from every other ; and many include features which, if they occurred in other buildings, would not be considered Gothic at all ; so that all we have to reason upon is merely, if I may be allowed so to express it, a greater

or less degree of *Gothicness* in each building we examine.
And it is this Gothicness,—the character which, according
as it is found more or less in a building, makes it more or less
Gothic,—of which I want to define the nature ; and I feel
the same kind of difficulty in doing so which would be en-
countered by any one who undertook to explain, for instance,
the nature of Redness, without any actually red thing to
point to, but only orange and purple things. Suppose he
had only a piece of heather and a dead oak-leaf to do it with.
He might say, the colour which is mixed with the yellow in
this oak-leaf, and with the blue in this heather, would be red,
if you had it separate ; but it would be difficult, nevertheless,
to make the abstraction perfectly intelligible : and it is so in
a far greater degree to make the abstraction of the Gothic
character intelligible, because that character itself is made up
of many mingled ideas, and can consist only in their union.
That is to say, pointed arches do not constitute Gothic, nor
vaulted roofs, nor flying buttresses,[118] nor grotesque sculptures ;
but all or some of these things, and many other things with
them, when they come together so as to have life.

Observe also, that, in the definition proposed, I shall only
endeavour to analyse the idea which I suppose already to
exist in the reader's mind. We all have some notion, most
of us a very determined one, of the meaning of the term
Gothic ; but I know that many persons have this idea in
their minds without being able to define it : that is to say,
understanding generally that Westminster Abbey is Gothic,
and St. Paul's is not, that Strasburg Cathedral is Gothic,
and St. Peter's is not, they have, nevertheless, no clear
notion of what it is that they recognise in the one or miss
in the other, such as would enable them to say how far the
work at Westminster or Strasburg is good and pure of its
kind ; still less to say of any nondescript building, like
St. James's Palace or Windsor Castle, how much right Gothic
element there is in it, and how much wanting. And I believe
this inquiry to be a pleasant and profitable one ; and that

there will be found something more than usually interesting in tracing out this grey, shadowy, many-pinnacled image of the Gothic spirit within us : and discerning what fellowship there is between it and our Northern hearts. And if, at any point of the inquiry, I should interfere with any of the reader's previously formed conceptions, and use the term Gothic in any sense which he would not willingly attach to it, I do not ask him to accept, but only to examine and understand, my interpretation, as necessary to the intelligibility of what follows in the rest of the work.

We have, then, the Gothic character submitted to our analysis, just as the rough mineral is submitted to that of the chemist, entangled with many other foreign substances, itself perhaps in no place pure, or ever to be obtained or seen in purity for more than an instant ; but nevertheless a thing of definite and separate nature, however inextricable or confused in appearance. Now observe : the chemist defines his mineral by two separate kinds of character ; one external, its crystalline form, hardness, lustre, etc. ; the other internal, the proportions and nature of its constituent atoms. Exactly in the same manner, we shall find that Gothic architecture has external forms, and internal elements. Its elements are certain mental tendencies of the builders, legibly expressed in it ; as fancifulness, love of variety, love of richness, and such others. Its external forms are pointed arches, vaulted roofs, etc. And unless both the elements and the forms are there, we have no right to call the style Gothic. It is not enough that it has the Form, if it have not also the power and life. It is not enough that it has the Power, if it have not the form. We must therefore inquire into each of these characters successively ; and determine first, what is the Mental Expression, and secondly, what the Material Form, of Gothic architecture, properly so called.

1st. Mental Power or Expression. What characters, we have to discover, did the Gothic builders love, or instinctively express in their work, as distinguished from all other builders ?

Let us go back for a moment to our chemistry, and note that, in defining a mineral by its constituent parts, it is not one nor another of them, that can make up the mineral, but the union of all : for instance, it is neither in charcoal, nor in oxygen, nor in lime, that there is the making of chalk, but in the combination of all three in certain measures ; they are all found in very different things from chalk, and there is nothing like chalk either in charcoal or in oxygen, but they are nevertheless necessary to its existence.

So in the various mental characters which make up the soul of Gothic. It is not one nor another that produces it ; but their union in certain measures. Each one of them is found in many other architectures besides Gothic ; but Gothic cannot exist where they are not found, or, at least, where their place is not in some way supplied. Only there is this great difference between the composition of the mineral, and of the architectural style, that if we withdraw one of its elements from the stone, its form is utterly changed, and its existence as such and such a mineral is destroyed ; but if we withdraw one of its mental elements from the Gothic style, it is only a little less Gothic than it was before, and the union of two or three of its elements is enough already to bestow a certain Gothicness of character, which gains in intensity as we add the others, and loses as we again withdraw them.

I believe, then, that the characteristic or moral elements of Gothic are the following, placed in the order of their importance :

1. Savageness. 4. Grotesqueness.
2. Changefulness. 5. Rigidity.
3. Naturalism. 6. Redundance.

These characters are here expressed as belonging to the building ; as belonging to the builder, they would be expressed thus :—1. Savageness, or Rudeness. 2. Love of Change. 3. Love of Nature. 4. Disturbed Imagination.

5. Obstinacy. 6. Generosity. And I repeat, that the with-drawal of any one, or any two, will not at once destroy the Gothic character of a building, but the removal of a majority of them will. I shall proceed to examine them in their order.

1. SAVAGENESS. I am not sure when the word "Gothic" was first generically applied [119] to the architecture of the North; but I presume that, whatever the date of its original usage, it was intended to imply reproach, and express the barbaric character of the nations among whom that archi-tecture arose. It never implied that they were literally of Gothic lineage, far less that their architecture had been originally invented by the Goths themselves; but it did imply that they and their buildings together exhibited a degree of sternness and rudeness, which, in contradistinction to the character of Southern and Eastern nations, appeared like a perpetual reflection of the contrast between the Goth and the Roman in their first encounter. And when that fallen Roman, in the utmost impotence of his luxury, and insolence of his guilt, became the model for the imitation of civilised Europe, at the close of the so-called Dark ages, the word Gothic became a term of unmitigated contempt, not unmixed with aversion. From that contempt, by the ex-ertion of the antiquaries and architects of this century, Gothic architecture has been sufficiently vindicated; and perhaps some among us, in our admiration of the magnificent science of its structure, and sacredness of its expression, might desire that the term of ancient reproach should be withdrawn, and some other, of more apparent honourableness, adopted in its place. There is no chance, as there is no need, of such a substitution. As far as the epithet was used scorn-fully, it was used falsely; but there is no reproach in the word, rightly understood; on the contrary, there is a profound truth, which the instinct of mankind almost unconsciously recognises. It is true, greatly and deeply true, that the archi-tecture of the North is rude and wild; but it is not true,

that, for this reason, we are to condemn it, or despise. Far otherwise : I believe it is in this very character that it deserves our profoundest reverence.

The charts of the world [120] which have been drawn up by modern science have thrown into a narrow space the expression of a vast amount of knowledge, but I have never yet seen any one pictorial enough to enable the spectator to imagine the kind of contrast in physical character which exists between Northern and Southern countries. We know the differences in detail, but we have not that broad glance and grasp which would enable us to feel them in their fulness. We know that gentians grow on the Alps, and olives on the Apennines ; but we do not enough conceive for ourselves that variegated mosaic of the world's surface which a bird sees in its migration, that difference between the district of the gentian and of the olive which the stork and the swallow see far off, as they lean upon the sirocco wind. Let us, for a moment, try to raise ourselves even above the level of their flight, and imagine the Mediterranean lying beneath us like an irregular lake, and all its ancient promontories sleeping in the sun : here and there an angry spot of thunder, a grey stain of storm, moving upon the burning field ; and here and there a fixed wreath of white volcano smoke, surrounded by its circle of ashes ; but for the most part a great peacefulness of light, Syria and Greece, Italy and Spain, laid like pieces of a golden pavement into the sea-blue, chased, as we stoop nearer to them, with bossy beaten work of mountain chains, and glowing softly with terraced gardens, and flowers heavy with frankincense, mixed among masses of laurel, and orange, and plumy palm, that abate with their grey-green shadows the burning of the marble rocks, and of the ledges of porphyry sloping under lucent sand. Then let us pass farther towards the north, until we see the orient colours change gradually into a vast belt of rainy green, where the pastures of Switzerland, and poplar valleys of France, and dark forests of the Danube and Carpathians stretch from the mouths of the

Loire to those of the Volga, seen through clefts in grey swirls of rain-cloud and flaky veils of the mist of the brooks, spreading low along the pasture lands : and then, farther north still, to see the earth heave into mighty masses of leaden rock and heathy moor, bordering with a broad waste of gloomy purple that belt of field and wood, and splintering into irregular and grisly islands amidst the northern seas, beaten by storm, and chilled by ice-drift, and tormented by furious pulses of contending tide, until the roots of the last forests fail from among the hill ravines, and the hunger of the north wind bites their peaks into barrenness ; and, at last, the wall of ice, durable like iron, sets, deathlike, its white teeth against us out of the polar twilight. And, having once traversed in thought this gradation of the zoned iris of the earth [121] in all its material vastness, let us go down nearer to it, and watch the parallel change in the belt of animal life : the multitudes of swift and brilliant creatures that glance in the air and sea, or tread the sands of the southern zone ; striped zebras and spotted leopards, glistening serpents, and birds arrayed in purple and scarlet. Let us contrast their delicacy and brilliancy of colour, and swiftness of motion, with the frost-cramped strength, and shaggy covering, and dusky plumage of the northern tribes ; contrast the Arabian horse with the Shetland, the tiger and leopard with the wolf and bear, the antelope with the elk, the bird of paradise with the osprey : and then, submissively acknowledging the great laws by which the earth and all that it bears are ruled throughout their being, let us not condemn, but rejoice in the expression by man of his own rest in the statutes of the lands that gave him birth.[122] Let us watch him with reverence as he sets side by side the burning gems, and smooths with soft sculpture the jasper pillars, that are to reflect a ceaseless sunshine, and rise into a cloudless sky : but not with less reverence let us stand by him, when, with rough strength and hurried stroke, he smites an uncouth animation out of the rocks which he has torn from among

the moss of the moorland, and heaves into the darkened air
the pile of iron buttress and rugged wall, instinct with work
of an imagination as wild and wayward as the northern sea ;
creations of ungainly shape and rigid limb, but full of wolfish
life ; fierce as the winds that beat, and changeful as the
clouds that shade them.

There is, I repeat, no degradation, no reproach in this, but
all dignity and honourableness : and we should err grievously
in refusing either to recognise as an essential character of the
existing architecture of the North, or to admit as a desirable
character in that which it yet may be, this wildness of thought,
and roughness of work ; this look of mountain brotherhood
between the cathedral and the Alp ; this magnificence of
sturdy power, put forth only the more energetically because
the fine finger-touch was chilled away by the frosty wind,
and the eye dimmed by the moor-mist, or blinded by the
hail ; this outspeaking of the strong spirit of men who may
not gather redundant fruitage from the earth, nor bask in
dreamy benignity of sunshine, but must break the rock for
bread, and cleave the forest for fire, and show, even in what
they did for their delight, some of the hard habits of the arm
and heart that grew on them as they swung the axe or pressed
the plough.

If, however, the savageness of Gothic architecture, merely
as an expression of its origin among Northern nations, may
be considered, in some sort, a noble character, it possesses
a higher nobility still, when considered as an index, not of
climate, but of religious principle.

In the 13th and 14th paragraphs of Chapter XXI. of the
first volume of this work, it was noticed that the systems of
architectural ornament, properly so called, might be divided
into three :—1. Servile ornament, in which the execution or
power of the inferior workman is entirely subjected to the
intellect of the higher ;—2. Constitutional ornament, in
which the executive inferior power is, to a certain point,
emancipated and independent, having a will of its own

yet confessing its inferiority and rendering obedience to higher powers ;—and 3. Revolutionary ornament, in which no executive inferiority is admitted at all. I must here explain the nature of these divisions at somewhat greater length.

Of Servile ornament, the principal schools are the Greek, Ninevite, and Egyptian ; but their servility is of different kinds. The Greek master-workman was far advanced in knowledge and power above the Assyrian or Egyptian. Neither he nor those for whom he worked could endure the appearance of imperfection in anything ; and, therefore, what ornament he appointed to be done by those beneath him was composed of mere geometrical forms,—balls, ridges and perfectly symmetrical foliage,—which could be executed with absolute precision by line and rule, and were as perfect in their way, when completed, as his own figure sculpture. The Assyrian and Egyptian, on the contrary, less cognisant of accurate form in anything, were content to allow their figure sculpture to be executed by inferior workmen, but lowered the method of its treatment to a standard which every workman could reach, and then trained him by discipline so rigid, that there was no chance of his falling beneath the standard appointed. The Greek gave to the lower workman no subject which he could not perfectly execute. The Assyrian gave him subjects which he could only execute imperfectly, but fixed a legal standard for his imperfection. The workman was, in both systems, a slave.*

But in the mediæval, or especially Christian, system of ornament, this slavery is done away with altogether ; Christianity having recognised, in small things as well as great,

* The third kind of ornament, the Renaissance is that in which the inferior detail becomes principal, the executor of every minor portion being required to exhibit skill and possess knowledge as great as that which is possessed by the master of the design ; and in the endeavour to endow him with this skill and knowledge, his own original power is overwhelmed, and the whole building becomes a wearisome exhibition of well-educated imbecility. We must fully inquire into the nature of this form of error, when we arrive at the examination of the Renaissance schools. (R.)

the individual value of every soul. But it not only recognises
its value ; it confesses its imperfection, in only bestowing
dignity upon the acknowledgment of unworthiness. That
admission of lost power and fallen nature, which the Greek
or Ninevite felt to be intensely painful, and, as far as might
be, altogether refused, the Christian makes daily and hourly,
contemplating the fact of it without fear, as tending, in the
end, to God's greater glory. Therefore, to every spirit which
Christianity summons to her service, her exhortation is : Do
what you can, and confess frankly what you are unable to do ;
neither let your effort be shortened for fear of failure, nor
your confession silenced for fear of shame. And it is, perhaps,
the principal admirableness of the Gothic schools of archi-
tecture, that they thus receive the results of the labour of
inferior minds ; and out of fragments full of imperfection
and betraying that imperfection in every touch, indulgently
raise up a stately and unaccusable whole.

But the modern English mind has this much in common
with that of the Greek, that it intensely desires, in all things,
the utmost completion or perfection compatible with their
nature. This is a noble character in the abstract, but becomes
ignoble when it causes us to forget the relative dignities of
that nature itself, and to prefer the perfectness of the lower
nature to the imperfection of the higher ; not considering
that as, judged by such a rule, all the brute animals would
be preferable to man, because more perfect in their functions
and kind, and yet are always held inferior to him, so also in
the works of man, those which are more perfect in their kind
are always inferior to those which are, in their nature, liable
to more faults and shortcomings. For the finer the nature
the more flaws it will show through the clearness of it ; and
it is a law of this universe, that the best things shall be
seldomest seen in their best form. The wild grass grows well
and strongly, one year with another ; but the wheat is,
according to the greater nobleness of its nature, liable to the
bitterer blight. And therefore, while in all things that we

see, or do, we are to desire perfection, and strive for it, we are nevertheless not to set the meaner thing, in its narrow accomplishment, above the nobler thing, in its mighty progress; not to esteem smooth minuteness above shattered majesty; not to prefer mean victory to honourable defeat; not to lower the level of our aim, that we may the more surely enjoy the complacency of success. But, above all, in our dealings with the souls of other men, we are to take care how we check, by severe requirement or narrow caution, efforts which might otherwise lead to a noble issue; and, still more, how we withhold our admiration from great excellencies, because they are mingled with rough faults. Now, in the make and nature of every man, however rude or simple, whom we employ in manual labour, there are some powers for better things: some tardy imagination, torpid capacity of emotion, tottering steps of thought, there are, even at the worst; and in most cases it is all our own fault that they *are* tardy or torpid. But they cannot be strengthened, unless we are content to take them in their feebleness, and unless we prize and honour them in their imperfection above the best and most perfect manual skill. And this is what we have to do with all our labourers; to look for the *thoughtful* part of them, and get that out of them, whatever we lose for it, whatever faults and errors we are obliged to take with it. For the best that is in them cannot manifest itself, but in company with much error. Understand this clearly: You can teach a man to draw a straight line, and to cut one; to strike a curved line, and to carve it; and to copy and carve any number of given lines or forms, with admirable speed and perfect precision; and you find his work perfect of its kind: but if you ask him to think about any of those forms, to consider if he cannot find any better in his own head, he stops; his execution becomes hesitating; he thinks, and ten to one he thinks wrong; ten to one he makes a mistake in the first touch he gives to his work as a thinking being. But you have made a man of him for

all that. He was only a machine before, an animated
tool.

And observe, you are put to stern choice in this matter.
You must either make a tool of the creature, or a man of him.
You cannot make both. Men were not intended to work
with the accuracy of tools, to be precise and perfect in all
their actions. If you will have that precision out of them,
and make their fingers measure degrees like cog-wheels, and
their arms strike curves like compasses, you must unhumanise
them. All the energy of their spirits must be given to make
cogs and compasses of themselves. All their attention and
strength must go to the accomplishment of the mean act.
The eye of the soul must be bent upon the finger-point, and
the soul's force must fill all the invisible nerves that guide
it, ten hours a day, that it may not err from its steely pre-
cision, and so soul and sight be worn away, and the whole
human being be lost at last—a heap of sawdust, so far as its
intellectual work in this world is concerned ; saved only by
its Heart, which cannot go into the form of cogs and com-
passes, but expands, after the ten hours are over, into fireside
humanity. On the other hand, if you will make a man of the
working creature, you cannot make a tool. Let him but
begin to imagine, to think, to try to do anything worth doing ;
and the engine-turned precision is lost at once. Out come
all his roughness, all his dulness, all his incapability ; shame
upon shame, failure upon failure, pause after pause : but out
comes the whole majesty of him also ; and we know the
height of it only, when we see the clouds settling upon him.
And, whether the clouds be bright or dark, there will be
transfiguration behind and within them.

And now, reader, look round this English room of yours,[123]
about which you have been proud so often, because the
work of it was so good and strong, and the ornaments of
it so finished. Examine again all those accurate mould-
ings, and perfect polishings, and unerring adjustments of
the seasoned wood and tempered steel. Many a time you

have exulted over them, and thought how great England was, because her slightest work was done so thoroughly. Alas! if read rightly, these perfectnesses are signs of a slavery in our England a thousand times more bitter and more degrading than that of the scourged African, or helot Greek.[124] Men may be beaten, chained, tormented, yoked like cattle, slaughtered like summer flies, and yet remain in one sense, and the best sense, free. But to smother their souls within them, to blight and hew into rotting pollards the suckling branches of their human intelligence, to make the flesh and skin which, after the worm's work on it, is to see God, into leathern thongs to yoke machinery with,— this it is to be slave-masters indeed; and there might be more freedom in England, though her feudal lords' lightest words were worth men's lives, and though the blood of the vexed husbandman dropped in the furrows of her fields, than there is while the animation of her multitudes is sent like fuel to feed the factory smoke, and the strength of them is given daily to be wasted into the fineness of a web, or racked into the exactness of a line.

And, on the other hand, go forth again to gaze upon the old cathedral front, where you have smiled so often at the fantastic ignorance of the old sculptors: examine once more those ugly goblins, and formless monsters, and stern statues, anatomiless and rigid; but do not mock at them, for they are signs of the life and liberty of every workman who struck the stone; a freedom of thought, and rank in scale of being, such as no laws, no charters, no charities can secure; but which it must be the first aim of all Europe at this day to regain for her children.

Let me not be thought to speak wildly or extravagantly. It is verily this degradation of the operative into a machine, which, more than any other evil of the times, is leading the mass of the nations everywhere into vain, incoherent, destructive struggling for a freedom of which they cannot explain the nature to themselves. Their universal outcry against

wealth, and against nobility, is not forced from them either by the pressure of famine, or the sting of mortified pride. These do much, and have done much in all ages ; but the foundations of society were never yet shaken as they are at this day. It is not that men are ill fed, but that they have no pleasure in the work by which they make their bread, and therefore look to wealth as the only means of pleasure. It is not that men are pained by the scorn of the upper classes, but they cannot endure their own ; for they feel that the kind of labour to which they are condemned is verily a degrading one, and makes them less than men. Never had the upper classes so much sympathy with the lower, or charity for them, as they have at this day, and yet never were they so much hated by them : for, of old the separation between the noble and the poor was merely a wall built by law ; now it is a veritable difference in level of standing, a precipice between upper and lower grounds in the field of humanity, and there is pestilential air at the bottom of it. I know not if a day is ever to come when the nature of right freedom will be understood, and when men will see that to obey another man, to labour for him, yield reverence to him or to his place, is not slavery. It is often the best kind of liberty,—liberty from care. The man who says to one, Go, and he goeth, and to another, Come, and he cometh,[125] has, in most cases, more sense of restraint and difficulty than the man who obeys him. The movements of the one are hindered by the burden on his shoulder ; of the other, by the bridle on his lips : there is no way by which the burden may be lightened ; but we need not suffer from the bridle if we do not champ at it. To yield reverence to another, to hold ourselves and our lives at his disposal, is not slavery ; often, it is the noblest state in which a man can live in this world. There is, indeed, a reverence which is servile, that is to say, irrational or selfish : but there is also noble reverence, that is to say, reasonable and loving ; and a man is never so noble as when he is reverent in this kind ;

nay, even if the feeling pass the bounds of mere reason, so that it be loving, a man is raised by it. Which had, in reality, most of the serf nature in him,—the Irish peasant who was lying in wait yesterday for his landlord, with his musket muzzle thrust through the ragged hedge ; or that old mountain servant, who, 200 years ago, at Inverkeithing, gave up his own life and the lives of his seven sons for his chief ?*—as each fell, calling forth his brother to the death, " Another for Hector ! " And therefore, in all ages and all countries, reverence has been paid and sacrifice made by men to each other, not only without complaint, but rejoicingly ; and famine, and peril, and sword, and all evil, and all shame, have been borne willingly in the causes of masters and kings ; for all these gifts of the heart ennobled the men who gave, not less than the men who received them, and nature prompted, and God rewarded the sacrifice. But to feel their souls withering within them, unthanked, to find their whole being sunk into an unrecognised abyss, to be counted off into a heap of mechanism, numbered with its wheels, and weighed with its hammer strokes ;—this nature bade not,—this God blesses not,—this humanity for no long time is able to endure.

We have much studied and much perfected, of late, the great civilised invention of the division of labour ; only we give it a false name. It is not, truly speaking, the labour that is divided ; but the men :—Divided into mere segments of men—broken into small fragments and crumbs of life ; so that all the little piece of intelligence that is left in a man is not enough to make a pin, or a nail, but exhausts itself in making the point of a pin, or the head of a nail. Now it is a good and desirable thing, truly, to make many pins in a day ; but if we could only see with what crystal sand their points were polished,—sand of human soul, much to be magnified before it can be discerned for what it is,—we should think there might be some loss in it also. And the great cry that rises from all our manufacturing cities, louder than their

* Vide Preface to *Fair Maid of Perth*. (R.)

furnace blast, is all in very deed for this,—that we manu-
facture everything there except men ; we blanch cotton, and
strengthen steel, and refine sugar, and shape pottery ; but
to brighten, to strengthen, to refine, or to form a single living
spirit, never enters into our estimate of advantages. And all
the evil to which that cry is urging our myriads can be met
only in one way : not by teaching nor preaching, for to teach
them is but to show them their misery, and to preach to them,
if we do nothing more than preach, is to mock at it. It can
be met only by a right understanding, on the part of all classes,
of what kinds of labour are good for men, raising them, and
making them happy ; by a determined sacrifice of such con-
venience, or beauty, or cheapness as is to be got only by the
degradation of the workman ; and by equally determined
demand for the products and results of healthy and ennobling
labour.

And how, it will be asked, are these products to be recog-
nised, and this demand to be regulated ? Easily : by the
observance of three broad and simple rules :

1. Never encourage the manufacture of any article not
absolutely necessary, in the production of which *Invention*
has no share.

2. Never demand an exact finish for its own sake, but
only for some practical or noble end.

3. Never encourage imitation or copying of any kind
except for the sake of preserving record of great works.

The second of these principles is the only one which directly
rises out of the consideration of our immediate subject; but
I shall briefly explain the meaning and extent of the first
also, reserving the enforcement of the third for another place.

1. Never encourage the manufacture of anything not
necessary, in the production of which invention has no
share.

For instance. Glass beads [126] are utterly unnecessary, and
there is no design or thought employed in their manufacture.
They are formed by first drawing out the glass into rods ;

these rods are chopped up into fragments of the size of beads by the human hand, and the fragments are then rounded in the furnace. The men who chop up the rods sit at their work all day, their hands vibrating with a perpetual and exquisitely timed palsy, and the beads dropping beneath their vibration like hail. Neither they, nor the men who draw out the rods or fuse the fragments, have the smallest occasion for the use of any single human faculty ; and every young lady, therefore, who buys glass beads is engaged in the slave-trade, and in a much more cruel one than that which we have so long been endeavouring to put down.

But glass cups and vessels may become the subjects of exquisite invention ; and if in buying these we pay for the invention, that is to say for the beautiful form, or colour, or engraving, and not for mere finish of execution, we are doing good to humanity.

So, again, the cutting of precious stones, in all ordinary cases, requires little exertion of any mental faculty ; some tact and judgment in avoiding flaws, and so on, but nothing to bring out the whole mind. Every person who wears cut jewels merely for the sake of their value is, therefore, a slave-driver.

But the working of the goldsmith, and the various designing of grouped jewellery and enamel-work, may become the subject of the most noble human intelligence. Therefore, money spent in the purchase of well-designed plate, of precious engraved vases, cameos, or enamels, does good to humanity ; and, in work of this kind, jewels may be employed to heighten its splendour ; and their cutting is then a price paid for the attainment of a noble end, and thus perfectly allowable.

I shall perhaps press this law farther elsewhere, but our immediate concern is chiefly with the second, namely, never to demand an exact finish, when it does not lead to a noble end. For observe, I have only dwelt upon the rudeness of Gothic, or any other kind of imperfectness, as admirable,

where it was impossible to get design or thought without
it. If you are to have the thought of a rough and untaught
man, you must have it in a rough and untaught way; but
from an educated man, who can without effort express his
thoughts in an educated way, take the graceful expression,
and be thankful. Only *get* the thought, and do not silence
the peasant because he cannot speak good grammar, or
until you have taught him his grammar. Grammar and
refinement are good things, both, only be sure of the better
thing first. And thus in art, delicate finish is desirable
from the greatest masters, and is always given by them. In
some places Michael Angelo, Leonardo, Phidias, Perugino,
Turner, all finished with the most exquisite care; and the
finish they give always leads to the fuller accomplishment of
their noble purposes. But lower men than these cannot
finish, for it requires consummate knowledge to finish con-
summately, and then we must take their thoughts as they are
able to give them. So the rule is simple: Always look for
invention first, and after that, for such execution as will help
the invention, and as the inventor is capable of without
painful effort, and *no more*. Above all, demand no refine-
ment of execution where there is no thought, for that is
slaves' work, unredeemed. Rather choose rough work than
smooth work, so only that the practical purpose be answered,
and never imagine there is reason to be proud of anything
that may be accomplished by patience and sand-paper.

I shall only give one example, which however will show
the reader what I mean, from the manufacture already
alluded to, that of glass. Our modern glass is exquisitely
clear in its substance, true in its form, accurate in its cutting.
We are proud of this. We ought to be ashamed of it. The
old Venice glass was muddy, inaccurate in all its forms, and
clumsily cut, if at all. And the old Venetian was justly
proud of it. For there is this difference between the Eng-
lish and Venetian workman, that the former thinks only of
accurately matching his patterns, and getting his curves per-

fectly true and his edges perfectly sharp, and becomes a mere machine for rounding curves and sharpening edges, while the old Venetian cared not a whit whether his edges were sharp or not, but he invented a new design for every glass that he made, and never moulded a handle or a lip without a new fancy in it. And therefore, though some Venetian glass is ugly and clumsy enough, when made by clumsy and uninventive workmen, other Venetian glass is so lovely in its forms that no price is too great for it ; and we never see the same form in it twice. Now you cannot have the finish and the varied form too. If the workman is thinking about his edges, he cannot be thinking of his design ; if of his design, he cannot think of his edges. Choose whether you will pay for the lovely form or the perfect finish, and choose at the same moment whether you will make the worker a man or a grindstone.

Nay, but the reader interrupts me,—" If the workman can design beautifully, I would not have him kept at the furnace. Let him be taken away and made a gentleman, and have a studio, and design his glass there, and I will have it blown and cut for him by common workmen, and so I will have my design and my finish too."

All ideas of this kind are founded upon two mistaken suppositions : the first, that one man's thoughts can be, or ought to be, executed by another man's hands ; the second, that manual labour is a degradation, when it is governed by intellect.

On a large scale, and in work determinable by line and rule, it is indeed both possible and necessary that the thoughts of one man should be carried out by the labour of others ; in this sense I have already defined the best architecture to be the expression of the mind of manhood by the hands of childhood. But on a smaller scale, and in a design which cannot be mathematically defined, one man's thoughts can never be expressed by another : and the difference between the spirit of touch of the man who is inventing, and of the

man who is obeying directions, is often all the difference between a great and a common work of art. How wide the separation is between original and second-hand execution, I shall endeavour to show elsewhere ; it is not so much to our purpose here as to mark the other and more fatal error of despising manual labour when governed by intellect ; for it is no less fatal an error to despise it when thus regulated by intellect, than to value it for its own sake. We are always in these days endeavouring to separate the two ; we want one man to be always thinking, and another to be always working, and we call one a gentleman, and the other an operative ; whereas the workman ought often to be thinking and the thinker often to be working, and both should be gentlemen, in the best sense. As it is, we make both ungentle, the one envying, the other despising, his brother ; and the mass of society is made up of morbid thinkers, and miserable workers. Now it is only by labour that thought can be made healthy, and only by thought that labour can be made happy, and the two cannot be separated with impunity. It would be well if all of us were good handicraftsmen in some kind, and the dishonour of manual labour done away with altogether; so that though there should still be a trenchant distinction of race between nobles and commoners, there should not, among the latter, be a trenchant distinction of employment, as between idle and working men, or between men of liberal and illiberal professions. All professions should be liberal, and there should be less pride felt in peculiarity of employment, and more in excellence of achievement. And yet more, in each several profession, no master should be too proud to do its hardest work. The painter should grind his own colours ; the architect work in the mason's yard with his men ; the master-manufacturer be himself a more skilful operative than any man in his mills ; [127] and the distinction between one man and another be only in experience and skill, and the authority and wealth which these must naturally and justly obtain.

I should be led far from the matter in hand, if I were to pursue this interesting subject. Enough, I trust, has been said to show the reader that the rudeness or imperfection which at first rendered the term " Gothic " one of reproach is indeed, when rightly understood, one of the most noble characters of Christian architecture, and not only a noble but an *essential* one. It seems a fantastic paradox, but it is nevertheless a most important truth, that no architecture can be truly noble which is *not* imperfect. And this is easily demonstrable. For since the architect, whom we will suppose capable of doing all in perfection, cannot execute the whole with his own hands, he must either make slaves of his workmen in the old Greek, and present English fashion, and level his work to a slave's capacities, which is to degrade it ; or else he must take his workmen as he finds them, and let them show their weaknesses together with their strength, which will involve the Gothic imperfection, but render the whole work as noble as the intellect of the age can make it.

But the principle may be stated more broadly still. I have confined the illustration of it to architecture, but I must not leave it as if true of architecture only. Hitherto I have used the words imperfect and perfect merely to distinguish between work grossly unskilful, and work executed with average precision and science ; and I have been pleading that any degree of unskilfulness should be admitted, so only that the labourer's mind had room for expression. But, accurately speaking, no good work whatever can be perfect, and *the demand for perfection is always a sign of a misunderstanding of the ends of art.*

This for two reasons, both based on everlasting laws. The first, that no great man ever stops working till he has reached his point of failure ; that is to say, his mind is always far in advance of his powers of execution, and the latter will now and then give way in trying to follow it ; besides that he will always give to the inferior portions of his work

only such inferior attention as they require; and according to his greatness he becomes so accustomed to the feeling of dissatisfaction with the best he can do, that in moments of lassitude or anger with himself he will not care though the beholder be dissatisfied also. I believe there has only been one man who would not acknowledge this necessity, and strove always to reach perfection, Leonardo; the end of his vain effort being merely that he would take ten years to a picture, and leave it unfinished. And therefore, if we are to have great men working at all, or less men doing their best, the work will be imperfect, however beautiful. Of human work none but what is bad can be perfect, in its own bad way.*

The second reason is, that imperfection is in some sort essential to all that we know of life. It is the sign of life in a mortal body, that is to say, of a state of progress and change. Nothing that lives is, or can be, rigidly perfect; part of it is decaying, part nascent. The foxglove blossom,— a third part bud, a third part past, a third part in full bloom, —is a type of the life of this world. And in all things that live there are certain irregularities and deficiencies which are not only signs of life, but sources of beauty. No human face is exactly the same in its lines on each side, no leaf perfect in its lobes, no branch in its symmetry. All admit irregularity as they imply change; and to banish imperfection is to destroy expression, to check exertion, to paralyse vitality. All things are literally better, lovelier, and more beloved for the imperfections which have been divinely appointed, that the law of human life may be Effort, and the law of human judgment, Mercy.

Accept this then for a universal law, that neither architecture nor any other noble work of man can be good unless it

* The Elgin marbles are supposed by many persons to be " perfect." In the most important portions they indeed approach perfection, but only there. The draperies are unfinished, the hair and wool of the animals are unfinished, and the entire bas-reliefs of the frieze are roughly cut. (R.)

be imperfect ; and let us be prepared for the otherwise strange fact, which we shall discern clearly as we approach the period of the Renaissance, that the first cause of the fall of the arts of Europe was a relentless requirement of perfection, incapable alike either of being silenced by veneration for greatness, or softened into forgiveness of simplicity.

Thus far then of the Rudeness or Savageness, which is the first mental element of Gothic architecture. It is an element in many other healthy architectures also, as in Byzantine and Romanesque ; but true Gothic cannot exist without it.

 * * * * * *

The fifth element above named was RIGIDITY ; and this character I must endeavour carefully to define, for neither the word I have used, nor any other that I can think of, will express it accurately. For I mean, not merely stable, but *active* rigidity ; the peculiar energy which gives tension to movement, and stiffness to resistance, which makes the fiercest lightning forked rather than curved, and the stoutest oak-branch angular rather than bending, and is as much seen in the quivering of the lance as in the glittering of the icicle.

I have before had occasion (Vol. I. Chapter XIII.) to note some manifestations of this energy or fixedness ; [128] but it must be still more attentively considered here, as it shows itself throughout the whole structure and decoration of Gothic work. Egyptian and Greek buildings stand, for the most part, by their own weight and mass, one stone passively incumbent on another : but in the Gothic vaults and traceries there is a stiffness analogous to that of the bones of a limb, or fibres of a tree ; an elastic tension and communication of force from part to part, and also a studious expression of this throughout every visible line of the building. And, in like manner, the Greek and Egyptian ornament is either mere surface engraving, as if the face of the wall had been stamped with a seal, or its lines are flowing, lithe, and luxuriant ; in either case, there is no expression of energy in the framework of the ornament itself. But the Gothic ornament stands out

in prickly independence, and frosty fortitude, jutting into
crockets, and freezing into pinnacles ; here starting up into a
monster, there germinating into a blossom ; anon knitting
itself into a branch, alternately thorny, bossy, and bristly, or
writhed into every form of nervous entanglement ; but, even
when most graceful, never for an instant languid, always
quickset ; erring, if at all, ever on the side of brusquerie.

The feelings or habits in the workman which give rise
to this character in the work, are more complicated and
various than those indicated by any other sculptural expres-
sion hitherto named. There is, first, the habit of hard and
rapid working ; the industry of the tribes of the North,
quickened by the coldness of the climate, and giving an
expression of sharp energy to all they do (as above noted,
Vol. I. Chap. XIII.), as opposed to the languor of the
Southern tribes, however much of fire there may be in the
heart of that languor, for lava itself may flow languidly.
There is also the habit of finding enjoyment in the signs of
cold, which is never found, I believe, in the inhabitants of
countries south of the Alps. Cold is to them an unredeemed
evil to be suffered, and forgotten as soon as may be ; but
the long winter of the North forces the Goth (I mean the
Englishman, Frenchman, Dane, or German), if he would
lead a happy life at all, to find sources of happiness in foul
weather as well as fair, and to rejoice in the leafless as well as
in the shady forest. And this we do with all our hearts ; find-
ing perhaps nearly as much contentment by the Christmas fire
as in the summer sunshine, and gaining health and strength
on the ice-fields of winter, as well as among the meadows of
spring. So that there is nothing adverse or painful to our
feelings in the cramped and stiffened structure of vegetation
checked by cold ; and instead of seeking, like the Southern
sculptor, to express only the softness of leafage nourished in
all tenderness, and tempted into all luxuriance by warm
winds and glowing rays, we find pleasure in dwelling upon the
crabbed, perverse, and morose animation of plants that have

known little kindness from earth or heaven, but, season after season, have had their best efforts palsied by frost, their brightest buds buried under snow, and their goodliest limbs lopped by tempest.

There are many subtle sympathies and affections which join to confirm the Gothic mind in this peculiar choice of subject; and when we add to the influence of these, the necessities consequent upon the employment of a rougher material, compelling the workman to seek for vigour of effect, rather than refinement of texture or accuracy of form, we have direct and manifest causes for much of the difference between the Northern and Southern cast of conception : but there are indirect causes holding a far more important place in the Gothic heart, though less immediate in their influence on design. Strength of will, independence of character, resoluteness of purpose, impatience of undue control, and that general tendency to set the individual reason against authority, and the individual deed against destiny, which, in the Northern tribes, has opposed itself throughout all ages to the languid submission, in the Southern, of thought to tradition, and purpose to fatality, are all more or less traceable in the rigid lines, vigorous and various masses, and daringly projecting and independent structure of the Northern Gothic ornament : while the opposite feelings are in like manner legible in the graceful and softly guided waves and wreathed bands, in which Southern decoration is constantly disposed ; in its tendency to lose its independence, and fuse itself into the surface of the masses upon which it is traced ; and in the expression seen so often, in the arrangement of those masses themselves, of an abandonment of their strength to an inevitable necessity, or a listless repose.

There is virtue in the measure, and error in the excess, of both these characters of mind, and in both of the styles which they have created ; the best architecture, and the best temper, are those which unite them both ; and this fifth impulse of the Gothic heart is therefore that which needs

most caution in its indulgence. It is more definitely Gothic
than any other, but the best Gothic building is not that which
is *most* Gothic : it can hardly be too frank in its confession of
rudeness, hardly too rich in its changefulness, hardly too
faithful in its naturalism ; but it may go too far in its rigidity,
and, like the great Puritan spirit in its extreme, lose itself
either in frivolity of division, or perversity of purpose.* It
actually did so in its later times ; but it is gladdening to
remember that in its utmost nobleness, the very temper which
has been thought most adverse to it, the Protestant spirit of
self-dependence and inquiry, was expressed in its every line.
Faith and aspiration there were, in every Christian ecclesias-
tical building, from the first century to the fifteenth ; but the
moral habits to which England in this age owes the kind of
greatness that she has,—the habits of philosophical investiga-
tion, of accurate thought, of domestic seclusion and indepen-
dence, of stern self-reliance, and sincere upright searching
into religious truth,—were only traceable in the features
which were the distinctive creation of the Gothic schools, in
the veined foliage, and thorny fretwork, and shadowy niche,
and buttressed pier, and fearless height of subtle pinnacle
and crested tower, sent like an " unperplexed question up to
Heaven."†

Last, because the least essential, of the constituent elements
of this noble school, was placed that of REDUNDANCE,—the
uncalculating bestowal of the wealth of its labour. There is,
indeed, much Gothic, and that of the best period, in which
this element is hardly traceable, and which depends for its

* See the account of the meeting at Talla Linns, in 1682, given in the
fourth chapter of the *Heart of Midlothian*. At length they arrived at the
conclusion that " they who owned (or allowed) such names as Monday,
Tuesday, January, February,[129] and so forth, served themselves heirs to
the same if not greater punishment than had been denounced against the
idolaters of old." (R.)

† See the beautiful description of Florence in Elizabeth Browning's
Casa Guidi Windows, which is not only a noble poem, but the only book
I have seen which, favouring the Liberal cause in Italy, gives a just account
of the incapacities of the modern Italian. (R.)

THE NATURE OF GOTHIC 91

effect almost exclusively on loveliness of simple design and
grace of uninvolved proportion : still, in the most character-
istic buildings, a certain portion of their effect depends upon
accumulation of ornament ; and many of those which have
most influence on the minds of men, have attained it by means
of this attribute alone. And although, by careful study of
the school, it is possible to arrive at a condition of taste which
shall be better contented by a few perfect lines than by a whole
façade covered with fretwork, the building which only satisfies
such a taste is not to be considered the best. For the very
first requirement of Gothic architecture being, as we saw
above, that it shall both admit the aid, and appeal to the
admiration, of the rudest as well as the most refined minds,
the richness of the work is, paradoxical as the statement may
appear, a part of its humility. No architecture is so haughty
as that which is simple ; which refuses to address the eye,
except in a few clear and forceful lines ; which implies, in
offering so little to our regards, that all it has offered is perfect ;
and disdains, either by the complexity or the attractiveness
of its features, to embarrass our investigation, or betray us
into delight. That humility, which is the very life of the
Gothic school, is shown not only in the imperfection, but in
the accumulation, of ornament. The inferior rank of the
workman is often shown as much in the richness, as the rough-
ness, of his work ; and if the co-operation of every hand, and
the sympathy of every heart, are to be received, we must
be content to allow the redundance which disguises the failure
of the feeble, and wins the regard of the inattentive. There
are, however, far nobler interests mingling, in the Gothic
heart, with the rude love of decorative accumulation : a
magnificent enthusiasm, which feels as if it never could do
enough to reach the fulness of its ideal ; an unselfishness of
sacrifice, which would rather cast fruitless labour before the
altar than stand idle in the market ; and, finally, a profound
sympathy with the fulness and wealth of the material universe,
rising out of that Naturalism whose operation we have already

endeavoured to define. The sculptor who sought for his models among the forest leaves, could not but quickly and deeply feel that complexity need not involve the loss of grace, nor richness that of repose ; and every hour which he spent in the study of the minute and various work of Nature, made him feel more forcibly the barrenness of what was best in that of man : nor is it to be wondered at, that, seeing her perfect and exquisite creations poured forth in a profusion which conception could not grasp nor calculation sum, he should think that it ill became him to be niggardly of his own rude craftsmanship ; and where he saw throughout the universe a faultless beauty lavished on measureless spaces of broidered field and blooming mountain, to grudge his poor and imperfect labour to the few stones that he had raised one upon another, for habitation or memorial. The years of his life passed away before his task was accomplished ; but generation succeeded generation with unwearied enthusiasm, and the cathedral front was at last lost in the tapestry of its traceries, like a rock among the thickets and herbage of spring.

IX

EARLY RENAISSANCE

It was above stated, that the principal difference in general form and treatment between the Byzantine and Gothic palaces was the contraction [130] of the marble facing into the narrow spaces between the windows, leaving large fields of brick wall perfectly bare. The reason for this appears to have been, that the Gothic builders were no longer satisfied with the faint and delicate hues of the veined marble ; they wished for some more forcible and piquant mode of decoration, corresponding more completely with the gradually advancing splendour of chivalric costume and heraldic device. What I have said above of the simple habits of life of the thirteenth century, in no wise refers either to costumes of state, or of military service ; and any illumination of the thirteenth and early fourteenth centuries (the great period being, it seems to me, from 1250 to 1350), while it shows a peculiar majesty and simplicity in the fall of the robes (often worn over the chain armour), indicates, at the same time, an exquisite brilliancy of colour and power of design in the hems and borders, as well as in the armorial bearings with which they are charged ; and while, as we have seen, a peculiar simplicity is found also in the *forms* of the architecture, corresponding to that of the folds of the robes, its *colours* were constantly increasing in brilliancy and decision, corresponding to those of the quartering of the shield, and of the embroidery of the mantle.

Whether, indeed, derived from the quarterings of the

knights' shields, or from what other source, I know not ; but there is one magnificent attribute of the colouring of the late twelfth, the whole thirteenth, and the early fourteenth century, which I do not find definitely in any previous work, nor afterwards in general art, though constantly, and necessarily, in that of great colourists, namely, the union of one colour with another by reciprocal interference : that is to say, if a mass of red is to be set beside a mass of blue, a piece of the red will be carried into the blue, and a piece of the blue carried into the red ; sometimes in nearly equal portions, as in a shield divided into four quarters, of which the uppermost on one side will be of the same colour as the lowermost on the other ; sometimes in smaller fragments, but, in the periods above named, always definitely and grandly, though in a thousand various ways. And I call it a magnificent principle, for it is an eternal and universal one, not in art only,* but in human life. It is the great principle of Brotherhood, not by equality, nor by likeness, but by giving and receiving ; the souls that are unlike, and the nations that are unlike, and the natures that are unlike, being bound into one noble whole by each receiving something from, and of, the others' gifts and the others' glory. I have not space to follow out this thought,— it is of infinite extent and application,—but I note it for the reader's pursuit, because I have long believed, and the whole second volume of " Modern Painters " was written to prove,

* In the various works which Mr. Prout has written on light and shade, no principle will be found insisted on more strongly than this carrying of the dark into the light, and *vice versa*. It is curious to find the untaught instinct of a merely picturesque artist in the nineteenth century, fixing itself so intensely on a principle which regulated the entire sacred composition of the thirteenth. I say " untaught " instinct, for Mr. Prout was, throughout his life, the discoverer of his own principles ; fortunately so, considering what principles were taught in his time, but unfortunately in the abstract, for there were gifts in him, which, had there been any wholesome influences to cherish them, might have made him one of the greatest men of his age. He was great, under all adverse circumstances, but the mere wreck of what he might have been, if, after the rough training noticed in my pamphlet on Pre-Raphaelitism, as having fitted him for his great function in the world, he had met with a teacher who could have appreciated his powers, and directed them. (R.)

that in whatever has been made by the Deity externally
delightful to the human sense of beauty, there is some type of
God's nature or of God's laws ; nor are any of His laws, in
one sense, greater than the appointment that the most lovely
and perfect unity shall be obtained by the taking of one nature
into another. I trespass upon too high ground ; and yet I
cannot fully show the reader the extent of this law, but by
leading him thus far. And it is just because it is so vast and
so awful a law, that it has rule over the smallest things ; and
there is not a vein of colour on the lightest leaf which the
spring winds are at this moment unfolding in the fields around
us, but it is an illustration of an ordainment to which the
earth and its creatures owe their continuance, and their
Redemption.

It is perfectly inconceivable, until it has been made a
subject of special inquiry, how perpetually Nature employs
this principle in the distribution of her light and shade ; how
by the most extraordinary adaptations, apparently accidental,
but always in exactly the right place, she contrives to bring
darkness into light, and light into darkness ; and that so
sharply and decisively, that at the very instant when one
object changes from light to dark, the thing relieved upon it
will change from dark to light, and yet so subtly that the eye
will not detect the transition till it looks for it. The secret
of a great part of the grandeur in all the noblest compositions
is the doing of this delicately in *degree*, and broadly in *mass* ;
in colour it may be done much more decisively than in light
and shade, and, according to the simplicity of the work, with
greater frankness of confession, until, in purely decorative
art, as in the illumination, glass-painting, and heraldry of
the great periods, we find it reduced to segmental accuracy.
Its greatest masters, in high art, are Tintoret, Veronese,[131]
and Turner.

Together with this great principle of quartering is intro-
duced another, also of very high value as far as regards the
delight of the eye, though not of so profound meaning. As

soon as colour began to be used in broad and opposed fields, it was perceived that the mass of it destroyed its brilliancy, and it was *tempered* by chequering it with some other colour or colours in smaller quantities, mingled with minute portions of pure white. The two moral principles of which this is the type, are those of Temperance and Purity ; the one requiring the fulness of the colour to be subdued, and the other that it shall be subdued without losing either its own purity or that of the colours with which it is associated.

Hence arose the universal and admirable system of the diapered or chequered backgrounds of early ornamental art. They are completely developed in the thirteenth century, and extend through the whole of the fourteenth, gradually yielding to landscape and other pictorial backgrounds, as the designers lost perception of the purpose of their art, and of the value of colour. The chromatic decoration of the Gothic palaces of Venice was of course founded on these two great principles, which prevailed constantly wherever the true chivalric and Gothic spirit possessed any influence. The windows, with their intermediate spaces of marble, were considered as the objects to be relieved, and variously quartered with vigorous colour. The whole space of the brick wall was considered as a background ; it was covered with stucco,[132] and painted in fresco,[133] with diaper patterns.

What ? the reader asks in some surprise,—Stucco ! and in the great Gothic period ? Even so, but *not stucco to imitate stone*. Herein lies all the difference ; it is stucco confessed and understood, and laid on the bricks precisely as gesso [134] is laid on canvas, in order to form them into a ground for receiving colour from the human hand,—colour which, if well laid on, might render the brick wall more precious than if it had been built of emeralds. Whenever we wish to paint, we may prepare our paper as we choose ; the value of the ground in no wise adds to the value of the picture. A Tintoret on beaten gold would be of no more value than a Tintoret on coarse canvas ; the gold would

merely be wasted. All that we have to do is to make the ground as good and fit for the colour as possible, by whatever means.

I am not sure if I am right in applying the term " stucco " to the ground of fresco ; but this is of no consequence ; the reader will understand that it was white, and that the whole wall of the palace was considered as the page of a book to be illuminated : but he will understand also that the sea winds are bad librarians ; that, when once the painted stucco began to fade or to fall, the unsightliness of the defaced colour would necessitate its immediate restoration ; and that there-fore, of all the chromatic decoration of the Gothic palaces, there is hardly a fragment left.

Happily, in the pictures of Gentile Bellini,[135] the fresco colouring of the Gothic palaces is recorded, as it still remained in his time ; not with rigid accuracy, but quite distinctly enough to enable us, by comparing it with the existing coloured designs in the manuscripts and glass of the period, to ascertain precisely what it must have been.

The walls were generally covered with chequers of very warm colour, a russet inclining to scarlet, more or less relieved with white, black, and grey ; as still seen in the only example which, having been executed in marble, has been perfectly preserved, the front of the Ducal Palace. This, however, owing to the nature of its materials, was a peculiarly simple example ; the ground is white, crossed with double bars of pale red, and in the centre of each chequer there is a cross, alternately black with a red centre and red with a black centre where the arms cross. In painted work the grounds would be, of course, as varied and complicated as those of manuscripts ; but I only know of one example left, on the Casa Sagredo, where, on some fragments of stucco, a very early chequer background is traceable, composed of crimson quatrefoils interlaced, with cherubims stretching their wings filling the intervals.

It ought to be especially noticed, that, in all chequered

patterns employed in the coloured designs of these noble periods, the greatest care is taken to mark that they are *grounds* of design rather than designs themselves. Modern architects, in such minor imitations as they are beginning to attempt, endeavour to dispose the parts of the patterns so as to occupy certain symmetrical positions with respect to the parts of the architecture. A Gothic builder never does this : he cuts his ground into pieces of the shape he requires with utter remorselessness, and places his windows or doors upon it with no regard whatever to the lines in which they cut the pattern : and, in illuminations of manuscripts, the chequer itself is constantly changed in the most subtle and arbitrary way, wherever there is the least chance of its regularity attracting the eye, and making it of importance. So *intentional* is this, that a diaper pattern is often set obliquely to the vertical lines of the designs, for fear it should appear in any way connected with them.

On these russet or crimson backgrounds the entire space of the series of windows was relieved, for the most part, as a subdued white field of alabaster ; and on this delicate and veined white were set the circular discs of purple and green. The arms of the family were of course blazoned in their own proper colours, but I think generally on a pure azure ground ; the blue colour is still left behind the shields in the Casa Priuli and one or two more of the palaces which are unrestored, and the blue ground was used also to relieve the sculptures of religious subject. Finally, all the mouldings, capitals, cornices, cusps, and traceries, were either entirely gilded or profusely touched with gold.

The whole front of a Gothic palace in Venice may, therefore, be simply described as a field of subdued russet, quartered with broad sculptured masses of white and gold ; these latter being relieved by smaller inlaid fragments of blue, purple, and deep green.

Now, from the beginning of the fourteenth century, when painting and architecture were thus united, two processes

of change went on simultaneously to the beginning of the
seventeenth. The merely decorative chequerings on the
walls yielded gradually to more elaborate paintings of figure-
subject ; first small and quaint, and then enlarging into
enormous pictures filled by figures generally colossal. As
these paintings became of greater merit and importance
the architecture with which they were associated was less
studied ; and at last a style was introduced in which the
framework of the building was little more interesting than
that of a Manchester factory, but the whole space of its
walls was covered with the most precious fresco paintings.
Such edifices are of course no longer to be considered as
forming an architectural school ; they were merely large
preparations of artists' panels ; and Titian, Giorgione,[136] and
Veronese no more conferred merit on the later architecture
of Venice, as such, by painting on its façades, than Landseer
or Watts [137] could confer merit on that of London by first
whitewashing and then painting its brick streets from one
end to the other.

Contemporarily with this change in the relative values of
the colour decoration and the stonework, one equally im-
portant was taking place in the opposite direction, but of
course in another group of buildings. For in proportion as
the architect felt himself thrust aside or forgotten in one
edifice, he endeavoured to make himself principal in another ;
and, in retaliation for the painter's entire usurpation of certain
fields of design, succeeded in excluding him totally from those
in which his own influence was predominant. Or, more
accurately speaking, the architects began to be too proud
to receive assistance from the colourists ; and these latter
sought for ground which the architect had abandoned, for the
unrestrained display of their own skill. And thus, while one
series of edifices is continually becoming feebler in design and
richer in superimposed paintings, another, that of which we have
so often spoken as the earliest or Byzantine Renaissance, frag-
ment by fragment rejects the pictorial decoration ; supplies its

place first with marbles, and then, as the latter are felt by the
architect, daily increasing in arrogance and deepening in cold-
ness, to be too bright for his dignity, he casts even these aside
one by one : and when the last porphyry circle has vanished
from the façade, we find two palaces standing side by side,
one built, so far as mere masonry goes, with consummate care
and skill, but without the slightest vestige of colour in any
part of it ; the other utterly without any claim to interest in
its architectural form, but covered from top to bottom with
paintings by Veronese. At this period, then, we bid fare-
well to colour, leaving the painters to their own peculiar
field ; and only regretting that they waste their noblest work
on walls, from which in a couple of centuries, if not before,
the greater part of their labour must be effaced. On the
other hand, the architecture whose decline we are tracing,
has now assumed an entirely new condition, that of the
Central or True Renaissance, whose nature we are to examine
in the next chapter.

X

ROMAN RENAISSANCE—VISION AND KNOWLEDGE

OF all the buildings in Venice, later in date than the final additions to the Ducal Palace, the noblest is, beyond all question, that which, having been condemned by its proprietor, not many years ago, to be pulled down and sold for the value of its materials, was rescued by the Austrian government,[138] and appropriated—the government officers having no other use for it—to the business of the Post-Office ; though still known to the gondolier by its ancient name, the Casa Grimani. It is composed of three stories of the Corinthian order, at once simple, delicate, and sublime ; but on so colossal a scale, that the three-storied palaces on its right and left only reach to the cornice which marks the level of its first floor. Yet it is not at first perceived to be so vast ; and it is only when some expedient is employed to hide it from the eye, that by the sudden dwarfing of the whole reach of the Grand Canal, which it commands, we become aware that it is to the majesty of the Casa Grimani that the Rialto itself, and the whole group of neighbouring buildings, owe the greater part of their impressiveness. Nor is the finish of its details less notable than the grandeur of their scale. There is not an erring line, not a mistaken proportion, throughout its noble front ; and the exceeding fineness of the chiselling gives an appearance of lightness to the vast blocks of stone out of whose perfect union that front is composed. The decoration is

sparing, but delicate : the first story only simpler than the rest, in that it has pilasters instead of shafts,[139] but all with Corinthian capitals, rich in leafage, and fluted delicately ; the rest of the walls flat and smooth, and their mouldings sharp and shallow, so that the bold shafts look like crystals of beryl running through a rock of quartz.

This palace is the principal type at Venice, and one of the best in Europe, of the central architecture of the Renaissance schools ; that carefully studied and perfectly executed architecture to which those schools owe their principal claims to our respect, and which became the model of most of the important works subsequently produced by civilised nations. I have called it the Roman Renaissance, because it is founded, both in its principles of superimposition, and in the style of its ornament, upon the architecture of classic Rome at its best period. The revival of Latin literature both led to its adoption, and directed its form ; and the most important example of it which exists is the modern Roman basilica of St. Peter's. It had, at its Renaissance or new birth, no resemblance either to Greek, Gothic, or Byzantine forms, except in retaining the use of the round arch, vault, and dome ; in the treatment of all details, it was exclusively Latin ; the last links of connection with mediæval tradition having been broken by its builders in their enthusiasm for classical art, and the forms of true Greek or Athenian architecture being still unknown to them. The study of these noble Greek forms has induced various modifications of the Renaissance in our own times ; but the conditions which are found most applicable to the uses of modern life are still Roman, and the entire style may most fitly be expressed by the term " Roman Renaissance."

It is this style, in its purity and fullest form,—represented by such buildings as the Casa Grimani at Venice (built by San Micheli),[140] the Town Hall at Vicenza (by Palladio),[141] St. Peter's at Rome (by Michael Angelo),[142] St Paul's and Whitehall in London (by Wren [143] and Inigo Jones),[144]—

which is the true antagonist of the Gothic school. The intermediate, or corrupt conditions of it, though multiplied over Europe, are no longer admired by architects, or made the subjects of their study ; but the finished work of this central school is still, in most cases, the model set before the student of the nineteenth century, as opposed to those Gothic, Romanesque, or Byzantine forms which have long been considered barbarous, and are so still by most of the leading men of the day. That they are, on the contrary, most noble and beautiful, and that the antagonistic Renaissance is, in the main, unworthy and unadmirable, whatever perfection of a certain kind it may possess, it was my principal purpose to show, when I first undertook the labour of this work. It has been attempted already to put before the reader the various elements which unite in the Nature of Gothic, and to enable him thus to judge, not merely of the beauty of the forms which that system has produced already, but of its future applicability to the wants of mankind, and endless power over their hearts. I would now endeavour, in like manner, to set before the reader the Nature of Renaissance, and thus to enable him to compare the two styles under the same light, and with the same enlarged view of their relations to the intellect, and capacities for the service, of man.

The moral, or immoral, elements which unite to form the spirit of Central Renaissance architecture are, I believe, in the main, two,—Pride and Infidelity ; but the pride resolves itself into three main branches,—Pride of Science, Pride of State, and Pride of System : and thus we have four separate mental conditions which must be examined successively.

I. PRIDE OF SCIENCE. It would have been more charitable, but more confusing, to have added another element to our list, namely the *Love* of Science ; but the love is included in the pride, and is usually so very subordinate an element that it does not deserve equality of nomenclature. But whether pursued in pride or in affection (how far by either we shall see presently), the first notable characteristic of the

Renaissance central school is its introduction of accurate knowledge into all its work, so far as it possesses such knowledge ; and its evident conviction, that such science is necessary to the excellence of the work, and is the first thing to be expressed therein. So that all the forms introduced, even in its minor ornament, are studied with the utmost care ; the anatomy of all animal structure is thoroughly understood and elaborately expressed, and the whole of the execution skilful and practised in the highest degree. Perspective, linear and aerial, perfect drawing and accurate light and shade in painting, and true anatomy in all representations of the human form, drawn or sculptured, are the first requirements in all the work of this school.

Now, first considering all this in the most charitable light, as pursued from a real love of truth, and not from vanity, it would, of course, have been all excellent and admirable, had it been regarded as the aid of art, and not as its essence. But the grand mistake of the Renaissance schools lay in supposing that science and art were the same things, and that to advance in the one was necessarily to perfect the other. Whereas they are, in reality, things not only different, but so opposed that to advance in the one is, in ninety-nine cases out of the hundred, to retrograde in the other. This is the point to which I would at present especially bespeak the reader's attention.

Science and art are commonly distinguished by the nature of their actions ; the one as knowing, the other as changing, producing, or creating. But there is a still more important distinction in the nature of the things they deal with. Science deals exclusively with things as they are in themselves ; and art exclusively with things as they affect the human senses and human soul.* Her work is to portray the appearance of

* Or, more briefly, science has to do with facts, art with phenomena. To science, phenomena are of use only as they lead to facts ; and to art, facts are of use only as they lead to phenomena. I use the word " art " here with reference to the fine arts only, for the lower arts of mechanical production I should reserve the word " manufacture." (R.)

things, and to deepen the natural impressions which they produce upon living creatures. The work of science is to substitute facts for appearances, and demonstrations for impressions. Both, observe, are equally concerned with truth ; the one with truth of aspect, the other with truth of essence. Art does not represent things falsely, but truly as they appear to mankind. Science studies the relations of things to each other : but art studies only their relations to man ; and it requires of everything which is submitted to it imperatively this, and only this,—what that thing is to the human eyes and human heart, what it has to say to men, and what it can become to them : a field of question just as much vaster than that of science, as the soul is larger than the material creation.

Take a single instance. Science informs us that the sun is ninety-five millions of miles distant from, and 111 times broader than, the earth ; that we and all the planets revolve round it ; and that it revolves on its own axis in 25 days, 14 hours, and 4 minutes. With all this, art has nothing whatsoever to do. It has no care to know anything of this kind. But the things which it does care to know, are these : that in the heavens God hath set a tabernacle for the sun, " which is as a bridegroom coming out of his chamber, and rejoiceth as a strong man to run a race. His going forth is from the end of the heaven, and his circuit unto the ends of it, and there is nothing hid from the heat thereof." [145]

This, then, being the kind of truth with which art is exclusively concerned, how is such truth as this to be ascertained and accumulated ? Evidently, and only, by perception and feeling. Never either by reasoning or report. Nothing must come between Nature and the artist's sight ; nothing between God and the artist's soul. Neither calculation nor hearsay,—be it the most subtle of calculations, or the wisest of sayings,—may be allowed to come between the universe, and the witness which art bears to its visible nature. The whole value of that witness depends on its being *eye*-witness ;

the whole genuineness, acceptableness, and dominion of it depend on the personal assurance of the man who utters it. All its victory depends on the veracity of the one preceding word, "Vidi." [146]

The whole function of the artist in the world is to be a seeing and feeling creature; to be an instrument of such tenderness and sensitiveness, that no shadow, no hue, no line, no instantaneous and evanescent expression of the visible things around him, nor any of the emotions which they are capable of conveying to the spirit which has been given him, shall either be left unrecorded, or fade from the book of record. It is not his business either to think, to judge, to argue, or to know. His place is neither in the closet, nor on the bench, nor at the bar, nor in the library. They are for other men and other work. He may think, in a by-way; reason, now and then, when he has nothing better to do; know, such fragments of knowledge as he can gather without stooping, or reach without pains; but none of these things are to be his care. The work of his life is to be two-fold only; to see, to feel.

Nay, but, the reader perhaps pleads with me, one of the great uses of knowledge is to open the eyes; to make things perceivable which never would have been seen, unless first they had been known.

Not so. This could only be said or believed by those who do not know what the perceptive faculty of a great artist is, in comparison with that of other men. There is no great painter, no great workman in any art, but he sees more with the glance of a moment than he could learn by the labour of a thousand hours. God has made every man fit for his work; He has given to the man whom He means for a student, the reflective, logical, sequential faculties; and to the man whom He means for an artist, the perceptive, sensitive, retentive faculties. And neither of these men, so far from being able to do the other's work, can even comprehend the way in which it is done. The student has no understanding

of the vision, nor the painter of the process ; but chiefly, the student has no idea of the colossal grasp of the true painter's vision and sensibility.

The labour of the whole Geological Society, for the last fifty years, has but now arrived at the ascertainment of those truths respecting mountain form which Turner saw and expressed with a few strokes of a camel's hair pencil fifty years ago, when he was a boy. The knowledge of all the laws of the planetary system, and of all the curves of the motion of projectiles, would never enable the man of science to draw a waterfall or a wave ; and all the members of Surgeons' Hall helping each other could not at this moment see, or represent, the natural movement of a human body in vigorous action, as a poor dyer's son did two hundred years ago.*

But surely, it is still insisted, granting this peculiar faculty to the painter, he will still see more as he knows more, and the more knowledge he obtains, therefore, the better. No ; not even so. It is indeed true, that, here and there, a piece of knowledge will enable the eye to detect a truth which might otherwise have escaped it ; as, for instance, in watching a sunrise, the knowledge of the true nature of the orb may lead the painter to feel more profoundly, and express more fully, the distance between the bars of cloud that cross it, and the sphere of flame that lifts itself slowly beyond them into the infinite heaven. But, for one visible truth to which knowledge thus opens the eyes, it seals them to a thousand : that is to say, if the knowledge occur to the mind so as to occupy its powers of contemplation at the moment when the sight work is to be done, the mind retires inward, fixes itself upon the known fact, and forgets the passing visible ones ; and a *moment* of such forgetfulness loses more to the painter than a day's thought can gain. This is no new or strange assertion. Every person accustomed to careful reflection of any kind, knows that its natural operation is to close his eyes

* Tintoret. (R.)

to the external world. While he is thinking deeply, he neither sees nor feels, even though naturally he may possess strong powers of sight and emotion. He who, having journeyed all day beside the Leman Lake, asked of his companions, at evening, where it was,* probably was not wanting in sensibility ; but he was generally a thinker, not a perceiver. And this instance is only an extreme one of the effect which, in all cases, knowledge, becoming a subject of reflection, produces upon the sensitive faculties. It must be but poor and lifeless knowledge, if it has no tendency to force itself forward, and become ground for reflection, in despite of the succession of external objects. It will not obey their succession. The first that comes gives it food enough for its day's work ; it is its habit, its duty, to cast the rest aside, and fasten upon that. The first thing that a thinking and knowing man sees in the course of the day, he will not easily quit. It is not his way to quit anything without getting to the bottom of it, if possible. But the artist is bound to receive all things on the broad, white, lucid field of his soul, not to grasp at one. For instance, as the knowing and thinking man watches the sunrise, he sees something in the colour of a ray, or the change of a cloud, that is new to him ; and this he follows out forthwith into a labyrinth of optical and pneumatical laws, perceiving no more clouds nor rays all the morning. But the painter must catch all the rays, all the colours that come, and see them all truly, all in their real relations and succession ; therefore, everything that occupies room in his mind he must cast aside for the time, as completely as may be. The thoughtful man is gone far away to seek ; but the perceiving man must sit still, and open his heart to receive. The thoughtful man is knitting and sharpening himself into a two-edged sword, wherewith to pierce. The perceiving man is stretching himself into a four-cornered sheet, wherewith to catch. And all the breadth to which he can expand himself, and all the white emptiness into which he can blanch

* St. Bernard. (R.)

himself, will not be enough to receive what God has to give him.

What, then, it will be indignantly asked, is an utterly ignorant and unthinking man likely to make the best artist ? No, not so neither. Knowledge is good for him so long as he can keep it utterly, servilely, subordinate to his own divine work, and trample it under his feet, and out of his way, the moment it is likely to entangle him.

And in this respect, observe, there is an enormous difference between knowledge and education. An artist need not be a *learned* man, in all probability it will be a disadvantage to him to become so ; but he ought, if possible, always to be an *educated* man : that is, one who has understanding of his own uses and duties in the world, and therefore of the general nature of the things done and existing in the world ; and who has so trained himself, or been trained, as to turn to the best and most courteous account whatever faculties or knowledge he has. The mind of an educated man is greater than the knowledge it possesses ; it is like the vault of heaven, encompassing the earth which lives and flourishes beneath it : but the mind of an uneducated and learned man is like a caoutchouc band, with an everlasting spirit of contraction in it, fastening together papers which it cannot open, and keeps others from opening.

Half our artists are ruined for want of education, and by the possession of knowledge ; the best that I have known have been educated, and illiterate. The ideal of an artist, however, is not that he should be illiterate, but well read in the best books, and thoroughly high bred, both in heart and in bearing. In a word, he should be fit for the best society, *and should keep out of it.**

There are, indeed, some kinds of knowledge with which

* Society always has a destructive influence upon an artist ; first by its sympathy with his meanest powers ; secondly, by its chilling want of understanding of his greatest ; and, thirdly, by its vain occupation of his time and thoughts. Of course a painter of men must be *among* men ; but it ought to be as a watcher, not as a companion.

an artist ought to be thoroughly furnished ; those, for instance, which enable him to express himself : for this knowledge relieves instead of encumbering his mind, and permits it to attend to its purposes instead of wearying itself about means. The whole mystery of manipulation and manufacture should be familiar to the painter from a child. He should know the chemistry of all colours and materials whatsoever, and should prepare all his colours himself, in a little laboratory of his own. Limiting his chemistry to this one object, the amount of practical science necessary for it, and such accidental discoveries as might fall in his way in the course of his work, of better colours or better methods of preparing them, would be an infinite refreshment to his mind ; a minor subject of interest to which it might turn when jaded with comfortless labour, or exhausted with feverish invention, and yet which would never interfere with its higher functions, when it chose to address itself to them. Even a considerable amount of manual labour, sturdy colour-grinding and canvas-stretching, would be advantageous ; though this kind of work ought to be in great part done by pupils. For it is one of the conditions of perfect knowledge in these matters, that every great master should have a certain number of pupils, to whom he is to impart all the knowledge of materials and means which he himself possesses, as soon as possible ; so that, at any rate, by the time they are fifteen years old, they may know all that he knows himself in this kind ; that is to say, all that the world of artists know, and his own discoveries besides, and so never be troubled about methods any more. Not that the knowledge even of his own particular methods is to be of purpose confined to himself and his pupils, but that necessarily it must be so in some degree ; for only those who see him at work daily can understand his small and multitudinous ways of practice. These cannot verbally be explained to everybody, nor is it needful that they should, only let them be concealed from nobody who cares to see them ; in which case, of course, his attendant

scholars will know them best. But all that can be made public in matters of this kind should be so with all speed, every artist throwing his discovery into the common stock, and the whole body of artists taking such pains in this department of science as that there shall be no unsettled questions about any known material or method : that it shall be an entirely ascertained and indisputable matter which is the best white, and which is the best brown ; which the strongest canvas, and safest varnish ; and which the shortest and most perfect way of doing everything known up to that time : and if any one discovers a better, he is to make it public forthwith. All of them taking care to embarrass themselves with no theories or reasons for anything, but to work empirically only : it not being in any wise their business to know whether light moves in rays or in waves ; or whether the blue rays of the spectrum move slower or faster than the rest ; but simply to know how many minutes and seconds such and such a powder must be calcined, to give the brightest blue.

Now it is perhaps the most exquisite absurdity of the whole Renaissance system, that while it has encumbered the artist with every species of knowledge that is of no use to him, this one precious and necessary knowledge it has utterly lost. There is not, I believe, at this moment, a single question which could be put respecting pigments and methods, on which the body of living artists would agree in their answers. The lives of artists are passed in fruitless experiments ; fruitless, because undirected by experience and uncommunicated in their results. Every man has methods of his own, which he knows to be insufficient, and yet jealously conceals from his fellow-workmen : every colourman has materials of his own, to which it is rare that the artist can trust : and in the very front of the majestic advance of chemical science, the empirical science of the artist has been annihilated, and the days which should have led us to higher perfection are passed in guessing at, or in mourning over, lost processes ; while the so-called Dark ages, possessing no more knowledge of

chemistry than a village herbalist does now, discovered, established, and put into daily practice such methods of operation as have made their work, at this day, the despair of all who look upon it.

And yet even this, to the painter, the safest of sciences, and in some degree necessary, has its temptations, and capabilities of abuse. For the simplest means are always enough for a great man ; and when once he has obtained a few ordinary colours, which he is sure will stand, and a white surface that will not darken, nor moulder, nor rend, he is master of the world, and of his fellow-men. And, indeed, as if in these times we were bent on furnishing examples of every species of opposite error, while we have suffered the traditions to escape us of the simple methods of doing simple things, which are enough for all the arts, and to all the ages, we have set ourselves to discover fantastic modes of doing fantastic things,—new mixtures and manipulations of metal, and porcelain, and leather, and paper, and every conceivable condition of false substance and cheap work, to our own infinitely multiplied confusion,—blinding ourselves daily more and more to the great, changeless, and inevitable truth, that there is but one goodness in art ; and that is one which the chemist cannot prepare, nor the merchant cheapen, for it comes only of a rare human hand, and rare human soul.

Within its due limits, however, here is one branch of science which the artist may pursue ; and, within limits still more strict, another also, namely, the science of the appearances of things as they have been ascertained and registered by his fellow-men. For no day passes but some visible fact is pointed out to us by others, which, without their help, we should not have noticed ; and the accumulation and generalisation of visible facts have formed, in the succession of ages, the sciences of light and shade, and perspective, linear and aerial : so that the artist is now at once put in possession of certain truths respecting the appearances of things, which,

so pointed out to him, any man may in a few days understand and acknowledge ; but which, without aid, he could not probably discover in his lifetime. I say, probably could not, because the time which the history of art shows us to have been actually occupied in the discovery and systematisation of such truth, is no measure of the time *necessary* for such discovery. The lengthened period which elapsed between the earliest and the perfect development of the science of light (if I may so call it) was not occupied in the actual effort to ascertain its laws, but in *acquiring the disposition to make that effort.* It did not take five centuries to find out the appearance of natural objects ; but it took five centuries to make people care about representing them. An artist of the twelfth century did not desire to represent nature. His work was symbolical and ornamental. So long as it was intelligible and lovely, he had no care to make it like nature. As, for instance, when an old painter represented the glory round a saint's head by a burnished plate of pure gold, he had no intention of imitating an effect of light. He meant to tell the spectator that the figure so decorated was a saint, and to produce splendour of effect by the golden circle. It was no matter to him what light was like. So soon as it entered into his intention to represent the appearance of light, he was not long in discovering the natural facts necessary for his purpose.

But, this being fully allowed, it is still true that the accumulation of facts now known respecting visible phenomena, is greater than any man could hope to gather for himself, and that it is well for him to be made acquainted with them ; provided always, that he receive them only at their true value, and do not suffer himself to be misled by them. I say, at their true value ; that is, an exceedingly small one. All the information which men can receive from the accumulated experience of others, is of no use but to enable them more quickly and accurately to see for themselves. It will in no wise take the place of this personal sight. Nothing can be done well in art, except by vision. Scientific principles and

experiences are helps to the eye, as a microscope is ; and they are of exactly as much use *without* the eye. No science of perspective, or of anything else, will enable us to draw the simplest natural line accurately, unless we see it and feel it. Science is soon at her wits' end. All the professors of perspective in Europe, could not, by perspective, draw the line of curve of a sea beach ; nay, could not outline one pool of the quiet water left among the sand. The eye and hand can do it, nothing else. All the rules of aerial perspective that ever were written, will not tell me how sharply the pines on the hill top are drawn at this moment on the sky. I shall know if I see them, and love them ; not till then. I may study the laws of atmospheric gradation for fourscore years and ten, and I shall not be able to draw so much as a brick-kiln through its own smoke, unless I look at it ; and that in an entirely humble and unscientific manner, ready to see all that the smoke, my master, is ready to show me, and expecting to see nothing more.

So that all the knowledge a man has must be held cheap, and neither trusted nor respected, the moment he comes face to face with Nature. If it help him, well ; if not, but, on the contrary, thrust itself upon him in an impertinent and contradictory temper, and venture to set itself in the slightest degree in opposition to, or comparison with, his sight, let it be disgraced forthwith. And the slave is less likely to take too much upon herself, if she has not been bought for a high price. All the knowledge an artist needs, will, in these days, come to him almost without his seeking ; if he has far to look for it, he may be sure he does not want it. Prout became Prout, without knowing a single rule of perspective to the end of his days ; and all the perspective in the Encyclopædia will never produce us another Prout.

And observe, also, knowledge is not only very often unnecessary, but it is often *untrustworthy*. It is inaccurate, and betrays us where the eye would have been true to us. Let us take the single instance of the knowledge of aerial

perspective, of which the moderns are so proud, and see how it betrays us in various ways. First by the conceit of it which often prevents our enjoying work in which higher and better things were thought of than effects of mist. The other day I showed a fine impression of Albert Dürer's " St. Hubert " to a modern engraver, who had never seen it nor any other of Albert Dürer's works. He looked at it for a minute contemptuously, then turned away : " Ah, I see that man did not know much about aerial perspective ! " All the glorious work and thought of the mighty master, all the redundant landscape, the living vegetation, the magnificent truth of line, were dead letters to him, because he happened to have been taught one particular piece of knowledge which Dürer despised.

But not only in the conceit of it, but in the inaccuracy of it, this science betrays us. Aerial perspective, as given by the modern artist, is, in nine cases out of ten, a gross and ridiculous exaggeration, as is demonstrable in a moment. The effect of air in altering the hue and depth of colour is of course great in the exact proportion of the volume of air between the observer and the object. It is not violent within the first few yards, and then diminished gradually, but it is equal for each foot of interposing air. Now in a clear day, and clear climate, such as that generally presupposed in a work of fine colour, objects are completely visible at a distance of ten miles ; visible in light and shade, with gradations between the two. Take, then, the faintest possible hue of shadow, or of any colour, and the most violent and positive possible, and set them side by side. The interval between them is greater than the real difference (for objects may often be seen clearly much farther than ten miles, I have seen Mont Blanc at 120) caused by the ten miles of intervening air between any given hue of the nearest, and most distant, objects ; but let us assume it, in courtesy to the masters of aerial perspective, to be the real difference. Then roughly estimating a mile at less than it really is, also in courtesy to them, or at 5000 feet, we have this difference between tints

produced by 50,000 feet of air. Then, ten feet of air will produce the 5000th part of this difference. Let the reader take the two extreme tints, and carefully gradate the one into the other. Let him divide this gradated shadow or colour into 5000 successive parts ; and the difference in depth between one of these parts and the next is the exact amount of aerial perspective between one object, and another, ten feet behind it, on a clear day.

Now, in Millais' " Huguenot," [147] the figures were standing about three feet from the wall behind them ; and the wise world of critics, which could find no other fault with the picture, professed to have its eyes hurt by the want of an aerial perspective, which, had it been accurately given (as, indeed, I believe it was), would have amounted to the $\frac{1}{3}$5000th, or less than the 15,000 part of the depth of any given colour. It would be interesting to see a picture painted by the critics, upon this scientific principle. The aerial perspective usually represented is entirely conventional and ridiculous ; a mere struggle on the part of the pretendedly well-informed, but really ignorant, artist, to express distances by mist which he cannot by drawing.

It is curious that the critical world is just as much offended by the true *presence* of aerial perspective, over distances of fifty miles, and with definite purpose of representing mist, in the works of Turner, as by the true *absence* of aerial perspective, over distances of three feet, and in clear weather, in those of Millais.

" Well but," still answers the reader, " this kind of error may here and there be occasioned by too much respect for undigested knowledge ; but, on the whole, the gain is greater than the loss, and the fact is, that a picture of the Renaissance period, or by a modern master, does indeed represent nature more faithfully than one wrought in the ignorance of old times." No, not one whit ; for the most part less faithfully. Indeed, the outside of nature is more truly drawn ; the material commonplace, which can be systematised, catalogued,

and taught to all pains-taking mankind,—forms of ribs and scapulæ, of eyebrows and lips, and curls of hair. Whatever can be measured and handled, dissected and demonstrated,—in a word, whatever is of the body only,—that the schools of knowledge do resolutely and courageously possess themselves of, and portray. But whatever is immeasurable, intangible, indivisible, and of the spirit, that the schools of knowledge do as certainly lose, and blot out of their sight : that is to say, all that is worth art's possessing or recording at all ; for whatever can be arrested, measured, and systematised, we can contemplate as much as we will in Nature herself. But what we want art to do for us is to stay what is fleeting, and to enlighten what is incomprehensible, to incorporate the things that have no measure, and immortalise the things that have no duration. The dimly seen, momentary glance, the flitting shadow of faint emotion, the imperfect lines of fading thought, and all that by and through such things as these is recorded on the features of man, and all that in man's person and actions, and in the great natural world, is infinite and wonderful ; having in it that spirit and power which man may witness, but not weigh ; conceive, but not comprehend ; love, but not limit ; and imagine, but not define ;—this, the beginning and the end of the aim of all noble art, we have, in the ancient art, by perception ; and we have *not*, in the newer art, by knowledge. Giotto [148] gives it us, Orcagna [149] gives it us, Angelico, Memmi,[150] Pisano,[151] it matters not who,—all simple and unlearned men, in their measure and manner,—give it us ; and the learned men that followed them give it us not, and we, in our supreme learning, own ourselves at this day farther from it than ever.

" Nay," but it is still answered, " this is because we have not yet brought our knowledge into right use, but have been seeking to accumulate it, rather than to apply it wisely to the ends of art. Let us now do this, and we may achieve all that was done by that elder ignorant art, and infinitely more." No, not so ; for as soon as we try to put our know-

ledge to good use, we shall find that we have much more than we can use, and that what more we have is an encumbrance. All our errors in this respect arise from a gross misconception as to the true nature of knowledge itself. We talk of learned and ignorant men, as if there were a certain quantity of knowledge, which to possess was to be learned, and which not to possess was to be ignorant ; instead of considering that knowledge is infinite, and that the man most learned in human estimation is just as far from knowing anything as he ought to know it, as the unlettered peasant. Men are merely on a lower or higher stage of an eminence, whose summit is God's throne, infinitely above all ; and there is just as much reason for the wisest as for the simplest man being discontented with his position, as respects the real quantity of knowledge he possesses. And, for both of them, the only true reasons for contentment with the sum of knowledge they possess are these : that it is the kind of knowledge they need for their duty and happiness in life ; that all they have is tested and certain, so far as it is in their power ; that all they have is well in order, and within reach when they need it ; that it has not cost too much time in the getting ; that none of it, once got, has been lost ; and that there is not too much to be easily taken care of.

Consider these requirements a little, and the evils that result in our education and polity from neglecting them. Knowledge is mental food, and is exactly to the spirit what food is to the body (except that the spirit needs several sorts of food, of which knowledge is only one), and it is liable to the same kind of misuses. It may be mixed and disguised by art, till it becomes unwholesome ; it may be refined, sweetened and made palatable, until it has lost all its power of nourishment ; and, even of its best kind, it may be eaten to surfeiting, and minister to disease and death.

Therefore, with respect to knowledge, we are to reason and act exactly as with respect to food. We no more live to know, than we live to eat. We live to contemplate, enjoy,

act, adore ; and we may know all that is to be known in this world, and what Satan knows in the other, without being able to do any of these. We are to ask, therefore, first, is the knowledge we would have fit food for us, good and simple, not artificial and decorated ? and secondly, how much of it will enable us best for our work ; and will leave our hearts light, and our eyes clear ? For no more than that is to be eaten without the old Eve-sin.

Observe, also, the difference between tasting knowledge, and hoarding it. In this respect it is also like food ; since, in some measure, the knowledge of all men is laid up in granaries, for future use ; much of it is at any given moment dormant, not fed upon or enjoyed, but in store. And by all it is to be remembered, that knowledge in this form may be kept without air till it rots, or in such unthreshed disorder that it is of no use ; and that, however good or orderly, it is still only in being tasted that it becomes of use ; and that men may easily starve in their own granaries, men of science, perhaps, most of all, for they are likely to seek accumulation of their store, rather than nourishment from it. Yet let it not be thought that I would undervalue them. The good and great among them are like Joseph,[152] to whom all nations sought to buy corn ; or like the sower [153] going forth to sow beside all waters, sending forth thither the feet of the ox and the ass : only let us remember that this is not all men's work. We are not intended to be all keepers of granaries, nor all to be measured by the filling of a storehouse ; but many, nay, most of us, are to receive day by day our daily bread, and shall be as well nourished and as fit for our labour, and often, also, fit for nobler and more divine labour, in feeding from the barrel of meal that does not waste, and from the cruse of oil that does not fail,[154] than if our barns were filled with plenty, and our presses bursting out with new wine.[155]

It is for each man to find his own measure in this matter ; in great part, also, for others to find it for him, while he is yet a youth. And the desperate evil of the whole Renais-

sance system is, that all idea of measure is therein forgotten, that knowledge is thought the one and the only good, and it is never inquired whether men are vivified by it or paralysed. Let us leave figures. The reader may not believe the analogy I have been pressing so far ; but let him consider the subject in itself, let him examine the effect of knowledge in his own heart, and see whether the trees of knowledge and of life [156] are one now, any more than in Paradise. He must feel that the real animating power of knowledge is only in the moment of its being first received, when it fills us with wonder and joy ; a joy for which, observe, the previous ignorance is just as necessary as the present knowledge. That man is always happy who is in the presence of something which he cannot know to the full, which he is always going on to know. This is the necessary condition of a finite creature with divinely rooted and divinely directed intelligence ; this, therefore, its happy state,—but observe, a state, not of triumph or joy in what it knows, but of joy rather in the continual discovery of new ignorance, continual self-abasement, continual astonish-ment. Once thoroughly our own, the knowledge ceases to give us pleasure. It may be practically useful to us, it may be good for others, or good for usury to obtain more ; but, in itself, once let it be thoroughly familiar, and it is dead. The wonder is gone from it, and all the fine colour which it had when first we drew it up out of the infinite sea. And what does it matter how much or how little of it we have laid aside, when our only enjoyment is still in the casting of that deep sea line ? What does it matter ? Nay, in one respect, it matters much, and not to our advantage. For one effect of knowledge is to deaden the force of the imagination and the original energy of the whole man : under the weight of his knowledge he cannot move so lightly as in the days of his simplicity. The pack-horse is furnished for the journey, the war-horse is armed for war ; but the freedom of the field and the lightness of the limb are lost for both. Knowledge is, at best, the pilgrim's burden or the soldier's

panoply, often a weariness to them both : and the Renaissance knowledge is like the Renaissance armour of plate, binding and cramping the human form ; while all good knowledge is like the crusader's chain mail, which throws itself into folds with the body, yet it is rarely so forged as that the clasps and rivets do not gall us. All men feel this, though they do not think of it, nor reason out its consequences. They look back to the days of childhood as of greatest happiness, because those were the days of greatest wonder, greatest simplicity, and most vigorous imagination. And the whole difference between a man of genius and other men, it has been said a thousand times, and most truly, is that the first remains in great part a child, seeing with the large eyes of children, in perpetual wonder, not conscious of much knowledge,—conscious, rather, of infinite ignorance, and yet infinite power ; a fountain of eternal admiration, delight, and creative force within him meeting the ocean of visible and governable things around him.

That is what we have to make men, so far as we may. All are to be men of genius in their degree,—rivulets or rivers, it does not matter, so that the souls be clear and pure ; not dead walls encompassing dead heaps of things known and numbered, but running waters in the sweet wilderness of things unnumbered and unknown, conscious only of the living banks, on which they partly refresh and partly reflect the flowers, and so pass on.

Let each man answer for himself how far his knowledge has made him this, or how far it is loaded upon him as the pyramid is upon the tomb. Let him consider, also, how much of it has cost him labour and time that might have been spent in healthy, happy action, beneficial to all mankind ; how many living souls may have been left uncomforted and unhelped by him, while his own eyes were failing by the midnight lamp ; how many warm sympathies have died within him as he measured lines or counted letters ; how many draughts of ocean air, and steps on mountain turf, and openings of the

highest heaven he has lost for his knowledge ; how much of that knowledge, so dearly bought, is now forgotten or despised, leaving only the capacity of wonder less within him, and, as it happens in a thousand instances, perhaps even also the capacity of devotion. And let him,—if, after thus dealing with his own heart, he can say that his knowledge has indeed been fruitful to him,—yet consider how many there are who have been forced by the inevitable laws of modern education into toil utterly repugnant to their natures, and that in the extreme, until the whole strength of the young soul was sapped away ; and then pronounce with fearfulness how far, and in how many senses, it may indeed be true that the wisdom of this world is foolishness with God.[157]

Now all this possibility of evil, observe, attaches to knowledge pursued for the noblest ends, if it be pursued imprudently. I have assumed, in speaking of its effect both on men generally and on the artist especially, that it was sought in the true love of it, and with all honesty and directness of purpose. But this is granting far too much in its favour. Of knowledge in general, and without qualification, it is said by the Apostle that " it puffeth up ; " [158] and the father of all modern science,[159] writing directly in its praise, yet asserts this danger even in more absolute terms, calling it a " venomousness " in the very nature of knowledge itself.

There is, indeed, much difference in this respect between the tendencies of different branches of knowledge ; it being a sure rule that exactly in proportion as they are inferior, nugatory, or limited in scope, their power of feeding pride is greater. Thus philology, logic, rhetoric, and the other sciences of the schools, being for the most part ridiculous and trifling, have so pestilent an effect upon those who are devoted to them, that their students cannot conceive of any higher sciences than these, but fancy that all education ends in the knowledge of words : but the true and great sciences, more especially natural history, make men gentle and modest in proportion to the largeness of their apprehension, and just

perception of the infiniteness of the things they can never know. And this, it seems to me, is the principal lesson we are intended to be taught by the book of Job; for there God has thrown open to us the heart of a man most just and holy, and apparently perfect in all things possible to human nature except humility. For this he is tried: and we are shown that no suffering, no self-examination, however honest, however stern, no searching out of the heart by its own bitterness, is enough to convince man of his nothingness before God; but that the sight of God's creation will do it. For, when the Deity himself has willed to end the temptation, and to accomplish in Job that for which it was sent, He does not vouchsafe to reason with him, still less does He overwhelm him with terror, or confound him by laying open before his eyes the book of his iniquities. He opens before him only the arch of the dayspring, and the fountains of the deep; and amidst the covert of the reeds, and on the heaving waves, He bids him watch the kings of the children of pride,— " Behold now Behemoth, which I made with thee : " And the work is done.

Thus, if, I repeat, there is any one lesson in the whole book which stands forth more definitely than another, it is this of the holy and humbling influence of natural science on the human heart. And yet, even here, it is not the science, but the perception, to which the good is owing; and the natural sciences may become as harmful as any others, when they lose themselves in classification and catalogue-making. Still, the principal danger is with the sciences of words and methods; and it was exactly into those sciences that the whole energy of men during the Renaissance period was thrown. They discovered suddenly that the world for ten centuries had been living in an ungrammatical manner, and they made it forthwith the end of human existence to be grammatical. And it mattered thenceforth nothing what was said, or what was done, so only that it was said with scholarship, and done with system. Falsehood in a Ciceronian

dialect had no opposers ; truth in patois no listeners. A Roman phrase was thought worth any number of Gothic facts. The sciences ceased at once to be anything more than different kinds of grammars,—grammar of language, grammar of logic, grammar of ethics, grammar of art ; and the tongue, wit, and invention of the human race were supposed to have found their utmost and most divine mission in syntax and syllogism, perspective and five orders.

Of such knowledge as this, nothing but pride could come ; and, therefore, I have called the first mental characteristic of the Renaissance schools, the " pride " of science. If they had reached any science worthy the name, they might have loved it ; but of the paltry knowledge they possessed, they could only be proud. There was not anything in it capable of being loved. Anatomy, indeed, then first made a subject of accurate study, is a true science, but not so attractive as to enlist the affections strongly on its side : and therefore, like its meaner sisters, it became merely a ground of pride ; and the one main purpose of the Renaissance artists, in all their work, was to show how much they knew.

There were, of course, noble exceptions ; but chiefly belonging to the earliest periods of the Renaissance, when its teaching had not yet produced its full effect. Raphael, Leonardo, and Michael Angelo were all trained in the old school ; they all had masters who knew the true ends of art, and had reached them ; masters nearly as great as they were themselves, but imbued with the old, religious and earnest spirit, which their disciples receiving from them, and drinking at the same time deeply from all the fountains of knowledge opened in their day, became the world's wonders. Then the dull wondering world believed that their greatness rose out of their new knowledge, instead of out of that ancient religious root, in which to abide was life, from which to be severed was annihilation. And from that day to this, they have tried to produce Michael Angelos and Leonardos by teaching the barren sciences, and still have mourned and

marvelled that no more Michael Angelos came; not per-
ceiving that those great Fathers were only able to receive
such nourishment because they were rooted on the rock of all
ages, and that our scientific teaching, nowadays, is nothing
more nor less than the assiduous watering of trees whose
stems are cut through. Nay, I have even granted too much
in saying that those great men were able to receive pure
nourishment from the sciences; for my own conviction is,
and I know it to be shared by most of those who love Raphael
truly,—that he painted best when he knew least. Michael
Angelo was betrayed again and again, into such vain and
offensive exhibition of his anatomical knowledge as, to this
day, renders his higher powers indiscernible by the greater
part of men; and Leonardo fretted his life away in engineer-
ing, so that there is hardly a picture left to bear his name.
But, with respect to all who followed, there can be no question
that the science they possessed was utterly harmful; serving
merely to draw away their hearts at once from the purposes
of art and the power of nature, and to make, out of the
canvas and marble, nothing more than materials for the
exhibition of petty dexterity and useless knowledge.

It is sometimes amusing to watch the naïve and childish
way in which this vanity is shown. For instance, when
perspective was first invented, the world thought it a mighty
discovery, and the greatest men it had in it were as proud
of knowing that retiring lines converge, as if all the wisdom
of Solomon had been compressed into a vanishing point.
And, accordingly, it became nearly impossible for any one
to paint a Nativity, but he must turn the stable and manger
into a Corinthian arcade, in order to show his knowledge of
perspective; and half the best architecture of the time,
instead of being adorned with historical sculpture, as of old,
was set forth with bas-relief of minor corridors and galleries,
thrown into perspective.

Now that perspective can be taught to any schoolboy in
a week, we can smile at this vanity. But the fact is, that all

pride in knowledge is precisely as ridiculous, whatever its kind, or whatever its degree. There is, indeed, nothing of which man has any right to be proud; but the very last thing of which, with any shadow of reason, he can make his boast is his knowledge, except only that infinitely small portion of it which he has discovered for himself. For what is there to be more proud of in receiving a piece of knowledge from another person, than in receiving a piece of money? Beggars should not be proud, whatever kind of alms they receive. Knowledge is like current coin. A man may have some right to be proud of possessing it, if he has worked for the gold of it, and assayed it, and stamped it, so that it may be received of all men as true; or earned it fairly, being already assayed: but if he has done none of these things, but only had it thrown in his face by a passer-by, what cause has he to be proud? And though, in this mendicant fashion, he had heaped together the wealth of Crœsus, would pride any more, for this, become him, as, in some sort, it becomes the man who has laboured for his fortune, however small? So, if a man tells me the sun is larger than the earth, have I any cause for pride in knowing it? or, if any multitude of men tell me any number of things, heaping all their wealth of knowledge upon me, have I any reason to feel proud under the heap? And is not nearly all the knowledge of which we boast in these days cast upon us in this dishonourable way; worked for by other men, proved by them, and then forced upon us, even against our wills, and beaten into us in our youth, before we have the wit even to know if it be good or not? (Mark the distinction between knowledge and thought.) Truly a noble possession to be proud of! Be assured, there is no part of the furniture of a man's mind which he has a right to exult in, but that which he has hewn and fashioned for himself. He who has built himself a hut on a desert heath, and carved his bed, and table, and chair out of the nearest forest, may have some right to take pride in the appliances of his narrow chamber, as

assuredly he will have joy in them. But the man who has had a palace built, and adorned, and furnished for him, may, indeed, have many advantages above the other, but he has no reason to be proud of his upholsterer's skill ; and it is ten to one if he has half the joy in his couches of ivory that the other will have in his pallet of pine.

And observe how we feel this, in the kind of respect we pay to such knowledge as we are indeed capable of estimating the value of. When it is our own, and new to us, we cannot judge of it ; but let it be another's also, and long familiar to us, and see what value we set on it. Consider how we regard a schoolboy, fresh from his term's labour. If he begin to display his newly acquired small knowledge to us, and plume himself thereupon, how soon do we silence him with contempt ! But it is not so if the schoolboy begins to feel or see anything. In the strivings of his soul within him he is our equal ; in his power of sight and thought he stands separate from us, and may be a greater than we. We are ready to hear him forthwith. "You saw that ? you felt that ? No matter for your being a child ; let us hear."

Consider that every generation of men stands in this relation to its successors. It is as the schoolboy : the knowledge of which it is proudest will be as the alphabet to those who follow. It had better make no noise about its knowledge ; a time will come when its utmost, in that kind, will be food for scorn. Poor fools ! was that all they knew ? and behold how proud they were ! But what we see and feel will never be mocked at. All men will be thankful to us for telling them that. "Indeed !" they will say, "they felt that in their day ? saw that ? Would God we may be like them, before we go to the home where sight and thought are not !"

This unhappy and childish pride in knowledge, then, was the first constituent element of the Renaissance mind, and it was enough, of itself, to have cast it into swift decline : but it was aided by another form of pride, which was above called ..le of State ; and which we have next to examine.

ORIGIN AND TYPES OF THE GROTESQUE

Now all the forms of art which result from the comparatively recreative exertion of minds more or less blunted or encumbered by other cares and toils, the art which we may call generally art of the wayside, as opposed to that which is the business of men's lives, is, in the best sense of the word, Grotesque. And it is noble or inferior, first, according to the tone of the minds which have produced it, and in proportion to their knowledge, wit, love of truth, and kindness ; secondly, according to the degree of strength they have been able to give forth ; but yet, however much we may find in it needing to be forgiven, always delightful so long as it is the work of good and ordinarily intelligent men. And its delightfulness ought mainly to consist *in those very imperfections* which mark it for work done in times of rest. It is not its own merit so much as the enjoyment of him who produced it, which is to be the source of the spectator's pleasure ; it is to the strength of his sympathy, not to the accuracy of his criticism, that it makes appeal ; and no man can indeed be a lover of what is best in the higher walks of art, who has not feeling and charity enough to rejoice with the rude sportiveness of hearts that have escaped out of prison, and to be thankful for the flowers which men have laid their burdens down to sow by the wayside.

And consider what a vast amount of human work this right understanding of its meaning will make fruitful and admirable to us, which otherwise we could only have

by with contempt. There is very little architecture in the world which is, in the full sense of the words, good and noble. A few pieces of Italian Gothic and Romanesque, a few scattered fragments of Gothic cathedrals, and perhaps two or three of Greek temples, are all that we possess approaching to an ideal of perfection. All the rest—Egyptian, Norman, Arabian, and most Gothic, and, which is very noticeable, for the most part all the strongest and mightiest—depend for their power on some development of the grotesque spirit ; but much more the inferior domestic architecture of the middle ages, and what similar conditions remain to this day in countries from which the life of art has not yet been banished by its laws. The fantastic gables, built up in scroll-work and steps, of the Flemish street ; the pinnacled roofs set with their small humourist double windows, as if with so many ears and eyes, of Northern France ; the blackened timbers, crossed and carved into every conceivable waywardness of imagination, of Normandy and old England ; the rude hewing of the pine timbers of the Swiss cottage ; the projecting turrets and bracketed oriels of the German street ; these, and a thousand other forms, not in themselves reaching any high degree of excellence, are yet admirable, and most precious, as the fruits of a rejoicing energy in uncultivated minds. It is easier to take away the energy, than to add the cultivation ; and the only effect of the better knowledge which civilised nations now possess, has been, as we have seen in a former chapter, to forbid their being happy, without enabling them to be great.

Inordinate play. We have now to consider the expression throughout of the minds of men who indulge themselves in unnecessary play. It is evident that a large number of these men will be more refined and more highly educated than those who only play necessarily ; their power of pleasure-seeking implies, in general, fortunate circumstances of life. It is evident also that their play will not be so hearty, so simple, or so joyful ; and this deficiency of

brightness will affect it in proportion to its unnecessary and unlawful continuance, until at last it becomes a restless and dissatisfied indulgence in excitement, or a painful delving after exhausted springs of pleasure.

The art through which this temper is expressed will, in all probability, be refined and sensual,—therefore, also, assuredly feeble ; and because, in the failure of the joyful energy of the mind, there will fail, also, its perceptions and its sympathies, it will be entirely deficient in expression of character, and acuteness of thought, but will be peculiarly restless, manifesting its desire for excitement in idle changes of subject and purpose. Incapable of true imagination, it will seek to supply its place by exaggerations, incoherencies, and monstrosities ; and the form of the grotesque to which it gives rise will be an incongruous chain of hackneyed graces, idly thrown together,—prettinesses or sublimities, not of its own invention, associated in forms which will be absurd without being fantastic, and monstrous without being terrible. And because, in the continual pursuit of pleasure, men lose both cheerfulness and charity, there will be small hilarity, but much malice, in this grotesque ; yet a weak malice, incapable of expressing its own bitterness, not having grasp enough of truth to become forcible, and exhausting itself in impotent or disgusting caricature.

The minds of the class of men who do not play at all are little likely to find expression in any trivial form of art, except in bitterness of mockery ; and this character at once stamps the work in which it appears, as belonging to the class of terrible, rather than of playful, grotesque. We have, therefore, row to examine the state of mind which gave rise to this second and more interesting branch of imaginative work.

Two great and principal passions are evidently appointed by the Deity to rule the life of man ; namely, the love of God and the fear of sin, and of its companion—Death. How many motives we have for Love, how much there is in the

universe to kindle our admiration and to claim our gratitude, there are, happily, multitudes among us who both feel and teach. But it has not, I think, been sufficiently considered how evident, throughout the system of creation, is the purpose of God that we should often be affected by Fear ; not the sudden, selfish, and contemptible fear of immediate danger, but the fear which arises out of the contemplation of great powers in destructive operation, and generally from the perception of the presence of death. Nothing appears to me more remarkable than the array of scenic magnificence by which the imagination is appalled, in myriads of instances, when the actual danger is comparatively small ; so that the utmost possible impression of awe shall be produced upon the minds of all, though direct suffering is inflicted upon few. Consider, for instance, the moral effect of a single thunder-storm. Perhaps two or three persons may be struck dead within a space of a hundred square miles ; and their deaths, unaccompanied by the scenery of the storm, would produce little more than a momentary sadness in the busy hearts of living men. But the preparation for the Judgment, by all that mighty gathering of the clouds ; by the questioning of the forest leaves, in their terrified stillness, which way the winds shall go forth ; by the murmuring to each other, deep in the distance, of the destroying angels before they draw forth their swords of fire ; by the march of the funeral darkness in the midst of the noon-day, and the rattling of the dome of heaven beneath the chariot-wheels of death ;—on how many minds do not these produce an impression almost as great as the actual witnessing of the fatal issue ! and how strangely are the expressions of the threatening elements fitted to the apprehension of the human soul ! The lurid colour, the long, irregular convulsive sound, the ghastly shapes of flaming and heaving cloud, are all as true and faithful in their appeal to our instinct of danger, as the moaning or wailing of the human voice itself is to our instinct of pity. It is not a reasonable calculating terror which they awake in us ; it is

no matter that we count distance by seconds, and measure probability by averages. That shadow of the thunder-cloud will still do its work upon our hearts, and we shall watch its passing away as if we stood upon the threshing-floor of Araunah.[160]

Now the things which are the proper subjects of human fear are twofold ; those which have the power of Death, and those which have the nature of Sin. Of which there are many ranks, greater or less in power and vice, from the evil angels themselves down to the serpent which is their type, and which, though of a low and contemptible class, appears to unite the deathful and sinful natures in the most clearly visible and intelligible form ; for there is nothing else which we know, of so small strength and occupying so unimportant a place in the economy of creation, which yet is so mortal and so malignant. It is, then, on these two classes of objects that the mind fixes for its excitement, in that mood which gives rise to the terrible grotesque : and its subject will be found always to unite some expression of vice and danger, but regarded in a peculiar temper ; sometimes (A) of predetermined or involuntary apathy, sometimes (B) of mockery, sometimes (C) of diseased and ungoverned imaginativeness.

For observe, the difficulty which, as I above stated, exists in distinguishing the playful from the terrible grotesque arises out of this cause ; that the mind, under certain phases of excitement, *plays* with *terror*, and summons images which, if it were in another temper, would be awful, but of which, either in weariness or in irony, it refrains for the time to acknowledge the true terribleness. And the mode in which this refusal takes place distinguishes the noble from the ignoble grotesque. For the master of the noble grotesque knows the depth of all at which he seems to mock, and would feel it at another time, or feels it in a certain undercurrent of thought even while he jests with it ; but the workman of the ignoble grotesque can feel and understand nothing,

and mocks at all things with the laughter of the idiot and the cretin.

To work out this distinction completely is the chief difficulty in our present inquiry ; and, in order to do so, let us consider the above-named three conditions of mind in succession, with relation to objects of terror.

(A). Involuntary or predetermined apathy. We saw above that the grotesque was produced, chiefly in subordinate or ornamental art, by rude, and in some degree uneducated men, and in their times of rest. At such times, and in such subordinate work, it is impossible that they should represent any solemn or terrible subject with a full and serious entrance into its feeling. It is not in the languor of a leisure hour that a man will set his whole soul to conceive the means of representing some important truth, nor to the projecting angle of a timber bracket that he would trust its representation, if conceived. And yet, in this languor, and in this trivial work, he must find some expression of the serious part of his soul, of what there is within him capable of awe, as well as of love. The more noble the man is, the more impossible it will be for him to confine his thoughts to mere loveliness, and that of a low order. Were his powers and his time unlimited, so that, like Frà Angelico, he could paint the Seraphim, in that order of beauty he could find contentment, bringing down heaven to earth. But by the conditions of his being, by his hard-worked life, by his feeble powers of execution, by the meanness of his employment and the languour of his heart, he is bound down to earth. It is the world's work that he is doing, and world's work is not to be done without fear. And whatever there is of deep and eternal consciousness within him, thrilling his mind with the sense of the presence of sin and death around him, must be expressed in that slight work, and feeble way, come of it what will. He cannot forget it, among all that he sees of beautiful in nature ; he may not bury himself among the leaves of the violet on the rocks, and of the lily in the glen, and twine out of them

garlands of perpetual gladness. He sees more in the eart'ı
than these,—misery and wrath, and discordance, and danger,
and all the work of the dragon and his angels ; this he sees
with too deep feeling ever to forget. And though, when he
returns to his idle work,—it may be to gild the letters upon
the page, or to carve the timbers of the chamber, or the stones
of the pinnacle,—he cannot give his strength of thought any
more to the woe or to the danger, there is a shadow of them
still present with him : and as the bright colours mingle
beneath his touch, and the fair leaves and flowers grow at
his bidding, strange horrors and phantasms rise by their side ;
grisly beasts and venomous serpents, and spectral fiends and
nameless inconsistencies of ghastly life, rising out of things
most beautiful, and fading back into them again, as the harm
and the horror of life do out of its happiness. He has seen
these things ; he wars with them daily ; he cannot but give
them their part in his work, though in a state of comparative
apathy to them at the time. He is but carving and gilding,
and must not turn aside to weep ; but he knows that hell is
burning on, for all that, and the smoke of it withers his
oak-leaves.

Now, the feelings which give rise to the false or ignoble
grotesque, are exactly the reverse of these. In the true
grotesque, a man of naturally strong feeling is accidentally
or resolutely apathetic ; in the false grotesque, a man naturally
apathetic is forcing himself into temporary excitement. The
horror which is expressed by the one, comes upon him whether
he will or not ; that which is expressed by the other, is sought
out by him, and elaborated by his art. And therefore, also,
because the fear of the one is true, and of true things, how-
ever fantastic its expression may be, there will be reality in it,
and force. It is not a manufactured terribleness, whose
author, when he had finished it, knew not if it would terrify
any one else or not : but it is a terribleness taken from the
life ; a spectre which the workman indeed saw, and which,
as it appalled him, will appal us also. But the other work-

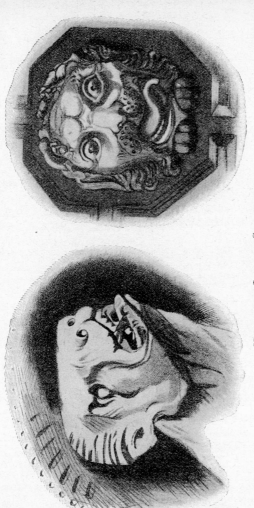

NOBLE AND IGNOBLE GROTESQUE.

(Face page 134.)

man never felt any Divine fear ; he never shuddered when he heard the cry from the burning towers of the earth,

" Venga Medusa ; sì lo farem di smalto." [161]

He is stone already, and needs no gentle hand laid upon his eyes to save him.

I do not mean what I say in this place to apply to the creations of the imagination. It is not as the creating, but as the *seeing* man, that we are here contemplating the master of the true grotesque. It is because the dreadfulness of the universe around him weighs upon his heart, that his work is wild ; and therefore through the whole of it we shall find the evidence of deep insight into nature. His beasts and birds, however monstrous, will have profound relations with the true. He may be an ignorant man, and little acquainted with the laws of nature ; he is certainly a busy man, and has not much time to watch nature ; but he never saw a serpent cross his path, nor a bird flit across the sky, nor a lizard bask upon a stone, without learning so much of the sublimity and inner nature of each as will not suffer him thenceforth to conceive them coldly. He may not be able to carve plumes or scales well ; but his creatures will bite and fly, for all that. The ignoble workman is the very reverse of this. He never felt, never looked at nature ; and if he endeavour to imitate the work of the other, all his touches will be made at random, and all his extravagances will be ineffective ; he may knit brows, and twist lips, and lengthen beaks, and sharpen teeth, but it will be all in vain. He may make his creatures disgusting, but never fearful.

There is, however, often another cause of difference than this. The true grotesque being the expression of the *repose* or play of a *serious* mind, there is a false grotesque opposed to it, which is the result of the *full exertion* of a *frivolous* one. There is much grotesque which is wrought out with exquisite care and pains, and as much labour given to it as if it were of the noblest subject ; so that the workman is evidently no

longer apathetic, and has no excuse for unconnectedness of thought, or sudden unreasonable fear. If he awakens horror now, it ought to be in some truly sublime form. His strength is in his work ; and he must not give way to sudden humour, and fits of erratic fancy. If he does so, it must be because his mind is naturally frivolous, or is for the time degraded into the deliberate pursuit of frivolity. And herein lies the real distinction between the base grotesque of Raphael and the Renaissance, above alluded to, and the true Gothic grotesque. Those grotesques or arabesques of the Vatican, and other such work, which have become the patterns of ornamentations in modern times, are the fruit of great minds degraded to base objects. The care, skill, and science, applied to the distribution of the leaves, and the drawing of the figures, are intense, admirable, and accurate ; therefore, they ought to have produced a grand and serious work, not a tissue of nonsense. If we can draw the human head perfectly, and are masters of its expression and its beauty, we have no business to cut it off, and hang it up by the hair at the end of a garland. If we can draw the human body in the perfection of its grace and movement, we have no business to take away its limbs, and terminate it with a bunch of leaves. Or rather our doing so will imply that there is something wrong with us ; that, if we can consent to use our best powers for such base and vain trifling, there must be something wanting in the powers themselves ; and that, however skilful we may be, or however learned, we are wanting both in the earnestness which can apprehend a noble truth, and in the thoughtfulness which can feel a noble fear. No Divine terror will ever be found in the work of the man who wastes a colossal strength in elaborating toys ; for the first lesson which that terror is sent to teach us, is the value of the human soul, and the shortness of mortal time.

And are we never, then, it will be asked, to possess a refined or perfect ornamentation ? Must all decoration be the work of the ignorant and the rude ? Not so ; but ex-

actly in proportion as the ignorance and rudeness diminish, must the ornamentation become rational, and the grotesqueness disappear. The noblest lessons may be taught in ornamentation, the most solemn truths compressed into it. The Book of Genesis, in all the fulness of its incidents, in all the depth of its meaning, is bound within the leaf-borders of the gates of Ghiberti.[162] But Raphael's arabesque is mere elaborate idleness. It has neither meaning nor heart in it; it is an unnatural and monstrous abortion.

Now, this passing of the grotesque into higher art, as the mind of the workman becomes informed with better knowledge, and capable of more earnest exertion, takes place in two ways. Either, as his power increases, he devotes himself more and more to the beauty which he now feels himself able to express, and so the grotesqueness expands, and softens into the beautiful, as in the above-named instance of the gates of Ghiberti ; or else, if the mind of the workman be naturally inclined to gloomy contemplation, the imperfection or apathy of his work rises into nobler terribleness, until we reach the point of the grotesque of Albert Dürer,[163] where, every now and then, the playfulness or apathy of the painter passes into perfect sublime. Take the Adam and Eve, for instance. When he gave Adam a bough to hold, with a parrot on it, and a tablet hung to it, with " Albertus Dürer Noricus faciebat, 1504," thereupon, his mind was not in Paradise. He was half in play, half apathetic with respect to his subject, thinking how to do his work well, as a wise master-graver, and how to receive his just reward of fame. But he rose into the true sublime in the head of Adam, and in the profound truthfulness of every creature that fills the forest. So again, in that magnificent coat of arms, with the lady and the satyr, as he cast the fluttering drapery hither and thither around the helmet, and wove the delicate crown upon the woman's forehead, he was in a kind of play ; but there is none in the dreadful skull upon the shield. And in the " Knight and Death," and in the dragons of the illustrations to the Apoca-

lypse, there is neither play nor apathy; but their grotesque is of the ghastly kind which best illustrates the nature of death and sin. And this leads us to the consideration of the second state of mind out of which the noble grotesque is developed: that is to say, the temper of mockery.

(B). Mockery, or Satire. In the former part of this chapter, when I spoke of the kinds of art which were produced in the recreation of the lower orders, I only spoke of forms of ornament, not of the expression of satire or humour. But it seems probable, that nothing is so refreshing to the vulgar mind as some exercise of this faculty, more especially on the failings of their superiors; and that, wherever the lower orders are allowed to express themselves freely, we shall find humour, more or less caustic, becoming a principal feature in their work. The classical and Renaissance manufactures of modern times having silenced the independent language of the operative, his humour and satire pass away in the word-wit which has of late become the especial study of the group of authors headed by Charles Dickens; all this power was formerly thrown into noble art, and became permanently expressed in the sculptures of the cathedral. It was never thought that there was anything discordant or improper in such a position: for the builders evidently felt very deeply a truth of which, in modern times, we are less cognisant; that folly and sin are, to a certain extent, synonymous, and that it would be well for mankind in general, if all could be made to feel that wickedness is as contemptible as it is hateful. So that the vices were permitted to be represented under the most ridiculous forms, and all the coarsest wit of the workman to be exhausted in completing the degradation of the creatures supposed to be subjected to them.

Nor were even the supernatural powers of evil exempt from this species of satire. For with whatever hatred or horror the evil angels were regarded, it was one of the conditions of Christianity that they should also be looked upon as vanquished; and this not merely in their great combat

with the King of Saints, but in daily and hourly combats with the weakest of His servants. In proportion to the narrowness of the powers of abstract conception in the workman, the nobleness of the idea of spiritual nature diminished, and the traditions of the encounters of men with fiends in daily temptations were imagined with less terrific circumstances, until the agencies which in such warfare were almost always represented as vanquished with disgrace, became, at last, as much the objects of contempt as of terror.

The superstitions which represented the devil as assuming various contemptible forms or disguises in order to accomplish his purposes aided this gradual degradation of conception, and directed the study of the workman to the most strange and ugly conditions of animal form, until at last, even in the most serious subjects, the fiends are oftener ludicrous than terrible. Nor, indeed, is this altogether avoidable, for it is not possible to express intense wickedness without some condition of degradation. Malice, subtlety, and pride, in their extreme, cannot be written upon noble forms ; and I am aware of no effort to represent the Satanic mind in the angelic form, which has succeeded in painting. Milton succeeds only because he separately describes the movements of the mind, and therefore leaves himself at liberty to make the form heroic ; but that form is never distinct enough to be painted. Dante, who will not leave even external forms obscure, degrades them before he can feel them to be demoniacal ; so also John Bunyan : both of them, I think, having firmer faith than Milton's in their own creations, and deeper insight into the nature of sin. Milton makes his fiends too noble, and misses the foulness, inconstancy, and fury of wickedness. His Satan possesses some virtues, not the less virtues for being applied to evil purpose. Courage, resolution, patience, deliberation in council, this latter being eminently a wise and holy character, as opposed to the " Insania " of excessive sin : and all this, if not a shallow and false, is a smoothed and artistical, conception.

On the other hand, I have always felt that there was a peculiar grandeur in the indescribable ungovernable fury of Dante's fiends, ever shortening its own powers, and disappointing its own purposes ; the deaf, blind, speechless, unspeakable rage, fierce as the lightning, but erring from its mark or turning senselessly against itself, and still further debased by foulness of form and action. Something is indeed to be allowed for the rude feelings of the time, but I believe all such men as Dante are sent into the world at the time when they can do their work best ; and that, it being appointed for him to give to mankind the most vigorous realisation possible both of Hell and Heaven, he was born both in the country and at the time which furnished the most stern opposition of Horror and Beauty, and permitted it to be written in the clearest terms. And, therefore, though there are passages in the " Inferno " which it would be impossible for any poet now to write, I look upon it as all the more perfect for them. For there can be no question but that one characteristic of excessive vice is indecency, a general baseness in its thoughts and acts concerning the body,* and that the full portraiture of it cannot be given without marking, and that in the strongest lines, this tendency to corporeal degradation ; which, in the time of Dante, could be done frankly, but cannot now. And, therefore, I think the twenty-first and twenty-second books of the " Inferno " the most perfect portraitures of fiendish nature which we possess ; and, at the same time, in their mingling of the extreme of horror (for it seems to me that the silent swiftness of the first demon, " con l' ali aperte e sovra i pie leggiero," [164] cannot be surpassed in dreadfulness) with ludicrous actions and images, they present the most perfect instances with which I am acquainted of the terrible grotesque. But the whole of the " Inferno " is full of this grotesque, as well as the " Faërie Queen " ; and these two poems, together with the works of Albert

* Let the reader examine, with especial reference to this subject, the general character of the language of Iago. (R.)

Dürer, will enable the reader to study it in its noblest forms, without reference to Gothic cathedrals.

Now, just as there are base and noble conditions of the apathetic grotesque, so also are there of this satirical grotesque. The condition which might be mistaken for it is that above described as resulting from the malice of men given to pleasure, and in which the grossness and foulness are in the workman as much as in his subject, so that he chooses to represent vice and disease rather than virtue and beauty, having his chief delight in contemplating them ; though he still mocks at them with such dull wit as may be in him, because, as Young has said most truly,

" 'Tis not in folly not to scorn a fool." [165]

Now it is easy to distinguish this grotesque from its noble counterpart, by merely observing whether any forms of beauty or dignity are mingled with it or not ; for, of course, the noble grotesque is only employed by its master for good purposes, and to contrast with beauty : but the base workman cannot conceive anything but what is base ; and there will be no loveliness in any part of his work, or, at the best, a loveliness measured by line and rule, and dependent on legal shapes of feature. But, without resorting to this test, and merely by examining the ugly grotesque itself, it will be found that, if it belongs to the base school, there will be, first, no Horror in it ; secondly, no Nature in it ; and, thirdly, no Mercy in it.

I say, first, no Horror. For the base soul has no fear of sin, and no hatred of it : and, however it may strive to make its work terrible, there will be no genuineness in the fear ; the utmost it can do will be to make its work disgusting.

Secondly, there will be no Nature in it. It appears to be one of the ends proposed by Providence in the appointment of the forms of the brute creation, that the various vices to which mankind are liable should be severally expressed in them so distinctly and clearly as the men could not but

understand the lesson ; while yet these conditions of vice might, in the inferior animal, be observed without the disgust and hatred which the same vices would excite, if seen in men, and might be associated with features of interest which would otherwise attract and reward contemplation. Thus, ferocity, cunning, sloth, discontent, gluttony, uncleanness, and cruelty are seen, each in its extreme, in various animals ; and are so vigorously expressed, that, when men desire to indicate the same vices in connection with human forms, they can do it no better than by borrowing here and there the features of animals. And when the workman is thus led to the contemplation of the animal kingdom, finding therein the expressions of vice which he needs, associated with power, and nobleness, and freedom from disease, if his mind be of right tone he becomes interested in this new study ; and all noble grotesque is, therefore, full of the most admirable rendering of animal character. But the ignoble workman is capable of no interest of this kind ; and, being too dull to appreciate, and too idle to execute, the subtle and wonderful lines on which the expression of the lower animal depends, he contents himself with vulgar exaggeration, and leaves his work as false as it is monstrous, a mass of blunt malice and obscene ignorance.

Lastly, there will be no Mercy in it. Wherever the satire of the noble grotesque fixes upon human nature, it does so with much sorrow mingled amidst its indignation : in its highest forms there is an infinite tenderness, like that of the fool in Lear ; and even in its more heedless or bitter sarcasm, it never loses sight altogether of the better nature of what it attacks, nor refuses to acknowledge its redeeming or pardonable features. But the ignoble grotesque has no pity : it rejoices in iniquity, and exists only to slander.

I have not space to follow out the various forms of transition which exist between the two extremes of great and base in the satirical grotesque. The reader must always remember, that, although there is an infinite distance between the best

and worst, in this kind the interval is filled by endless conditions more or less inclining to the evil or the good ; impurity and malice stealing gradually into the nobler forms, and invention and wit elevating the lower, according to the countless minglings of the elements of the human soul.

XII

CONCLUSION

THE grotesques of the seventeenth and eighteenth centuries, the nature of which we examined in the last chapter, close the career of the architecture of Europe. They were the last evidences of any feeling consistent with itself, and capable of directing the efforts of the builder to the formation of anything worthy the name of a style or school. From that time to this, no resuscitation of energy has taken place, nor does any for the present appear possible. How long this impossibility may last, and in what direction with regard to art in general, as well as to our lifeless architecture, our immediate efforts may most profitably be directed, are the questions I would endeavour briefly to consider in the present chapter.

That modern science, with all its additions to the comforts of life, and to the fields of rational contemplation, has placed the existing races of mankind on a higher platform than any that preceded them, none can doubt for an instant; and I believe the position in which we find ourselves is somewhat analogous to that of thoughtful and laborious youth succeeding a restless and heedless infancy. Not long ago, it was said to me by one of the masters of modern science: "When men invented the locomotive, the child was learning to go; when they invented the telegraph, it was learning to speak." He looked forward to the manhood of mankind, as assuredly the nobler in proportion to the slowness of its development. What might not be expected from the prime

and middle strength of the order of existence whose infancy had lasted six thousand years ? And, indeed, I think this the truest, as well as the most cheering, view that we can take of the world's history. Little progress has been made as yet. Base war, lying policy, thoughtless cruelty, senseless improvidence,—all things which, in nations, are analogous to the petulance, cunning, impatience, and carelessness of infancy,—have been, up to this hour, as characteristic of mankind as they were in the earliest periods ; so that we must either be driven to doubt of human progress at all, or look upon it as in its very earliest stage. Whether the opportunity is to be permitted us to redeem the hours that we have lost ; whether He, in whose sight a thousand years are as one day, has appointed us to be tried by the continued possession of the strange powers with which He has lately endowed us ; or whether the periods of childhood and of probation are to cease together, and the youth of mankind is to be one which shall prevail over death, and bloom for ever in the midst of a new heaven and a new earth, are questions with which we have no concern. It is indeed right that we should look for, and hasten, so far as in us lies, the coming of the Day of God ; but not that we should check any human efforts by anticipations of its approach. We shall hasten it best by endeavouring to work out the tasks that are appointed for us here ; and, therefore, reasoning as if the world were to continue under its existing dispensation, and the powers which have just been granted to us were to be continued through myriads of future ages.

It seems to me, then, that the whole human race, so far as their own reason can be trusted, may at present be regarded as just emergent from childhood ; and beginning for the first time to feel their strength, to stretch their limbs, and explore the creation around them. If we consider that, till within the last fifty years, the nature of the ground we tread on, of the air we breathe, and of the light by which we see, were not so much as conjecturally conceived by us ; that the duration

of the globe, and the races of animal life by which it was
inhabited, are just beginning to be apprehended ; and that
the scope of the magnificent science which has revealed them,
is as yet so little received by the public mind, that presumption
and ignorance are still permitted to raise their voices against
it unrebuked ; that perfect veracity in the representation of
general nature by art has never been attempted until the
present day, and has in the present day been resisted with
all the energy of the popular voice ;* that the simplest
problems of social science are yet so little understood, as that
doctrines of liberty and equality can be openly preached, and
so successfully as to affect the whole body of the civilised
world with apparently incurable disease ; that the first
principles of commerce were acknowledged by the English
Parliament only a few months ago, in its free trade measures,
and are still so little understood by the million, that no
nation dares to abolish its custom-houses ; that the simplest
principles of policy are still not so much as stated, far less
received, and that civilised nations persist in the belief that
the subtlety and dishonesty which they know to be ruinous
in dealings between man and man, are serviceable in dealings
between multitude and multitude ; finally, that the scope
of the Christian religion, which we have been taught for two
thousand years, is still so little conceived by us, that we
suppose the laws of charity and of self-sacrifice bear upon
individuals in all their social relations, and yet do not bear
upon nations in any of their political relations ;—when, I say,
we thus review the depth of simplicity in which the human
race are still plunged with respect to all that it most profoundly
concerns them to know, and which might, by them, with
most ease have been ascertained, we can hardly determine
how far back on the narrow path of human progress we ought
to place the generation to which we belong, how far the
swaddling clothes are unwound from us, and childish things
beginning to be put away.

* In the works of Turner and the Pre-Raphaelites. (R.)

On the other hand, a power of obtaining veracity in the representation of material and tangible things, which within certain limits and conditions, is unimpeachable, has now been placed in the hands of all men,* almost without labour. The foundation of every natural science is now at last firmly laid, not a day passing without some addition of buttress and pinnacle to their already magnificent fabric. Social theorems, if fiercely agitated, are therefore the more likely to be at last determined, so that they never can be matters of question more. Human life has been in some sense prolonged by the increased powers of locomotion, and an almost limitless power of converse. Finally, there is hardly any serious mind in Europe but is occupied, more or less, in the investigation of the questions which have so long paralysed the strength of religious feeling, and shortened the dominion of religious faith. And we may therefore at least look upon ourselves as so far in a definite state of progress, as to justify our caution in guarding against the dangers incident to every period of change, and especially to that from childhood into youth.

Those dangers appear, in the main, to be twofold ; consisting partly in the pride of vain knowledge, partly in the pursuit of vain pleasure. A few points are still to be noticed with respect to each of these heads.

Enough, it might be thought, had been said already, touching the pride of knowledge ; but I have not yet applied the principles, at which we arrived in the third chapter, to the practical questions of modern art. And I think those principles, together with what were deduced from the consideration of the nature of Gothic in the second volume, so necessary and vital, not only with respect to the progress of

* I intended to have given a sketch in this place (above referred to) of the probable results of the daguerreotype and calotype within the next few years, in modifying the application of the engraver's art, but I have not had time to complete the experiments necessary to enable me to speak with certainty. Of one thing, however, I have little doubt, that an infinite service will soon be done to a large body of our engravers : namely, the making of them draughtsmen (in black and white) on paper instead of steel.

art, but even to the happiness of society, that I will rather run the risk of tediousness than of deficiency, in their illustration and enforcement.

In examining the nature of Gothic, we concluded that one of the chief elements of power in that, and in *all good* architecture, was the acceptance of uncultivated and rude energy in the workman. In examining the nature of Renaissance, we concluded that its chief element of weakness was that pride of knowledge which not only prevented all rudeness in expression, but gradually quenched all energy which could only be rudely expressed ; nor only so, but, for the motive and matter of the work itself, preferred science to emotion, and experience to perception.

The modern mind differs from the Renaissance mind in that its learning is more substantial and extended, and its temper more humble ; but its errors, with respect to the cultivation of art, are precisely the same,—nay, as far as regards execution, even more aggravated, We require, at present, from our general workmen, more perfect finish than was demanded in the most skilful Renaissance periods, except in their very finest productions ; and our leading principles in teaching, and in the patronage which necessarily gives tone to teaching, are, that the goodness of work consists primarily in firmness of handling and accuracy of science, that is to say, in hand-work and head-work ; whereas heart-work, which is the *one* work we want, is not only independent of both, but often, in great degree, inconsistent with either.

Here, therefore, let me finally and firmly enunciate the great principle to which all that has hitherto been stated is subservient :—that art is valuable or otherwise, only as it expresses the personality, activity, and living perception of a good and great human soul ; that it may express and contain this with little help from execution, and less from science ; and that if it have not this, if it show not the vigour, perception, and invention of a mighty human spirit, it is worthless. Worthless, I mean, as *art* ; it may be precious in some other way, but, as art, it is nugatory.

Once let this be well understood among us, and magnificent consequences will soon follow. Let me repeat it in other terms, so that I may not be misunderstood. All art is great, and good, and true, only so far as it is distinctively the work of *manhood* in its entire and highest sense ; that is to say, not the work of limbs and fingers, but of the soul, aided, according to her necessities, by the inferior powers ; and therefore distinguished in essence from all products of those inferior powers unhelped by the soul. For as a photograph is not a work of art, though it requires certain delicate manipulations of paper and acid, and subtle calculations of time, in order to bring out a good result ; so, neither would a drawing *like* a photograph, made directly from nature, be a work of art, although it would imply many delicate manipulations of the pencil and subtle calculations of effects of colour and shade. It is no more art * to manipulate a camel's hair pencil, than to manipulate a china tray and a glass vial. It is no more art to lay on colour delicately, than to lay on acid delicately. It is no more art to use the cornea and retina for the reception of an image, than to use a lens and a piece of silvered paper. But the moment that inner part of the man, or rather that entire and only being of the man, of which cornea and retina, fingers and hands, pencils and colours, are all the mere servants and instruments ; that manhood which has light in itself, though the eyeball be sightless, and can gain in strength when the hand and the foot are hewn off and cast into the fire ; the moment this part of the man stands forth with its solemn " Behold, it is I," then the work becomes art indeed, perfect in honour, priceless in value, boundless in power.

Yet observe, I do not mean to speak of the body and

* I mean art in its highest sense. All that men do ingeniously is art, in one sense. In fact, we want a definition of the word " art " much more accurate than any in our minds at present. For, strictly speaking, there is no such thing as " fine " or " high " art. All *art* is a low and common thing, and what we indeed respect is not art at all, but *instinct* or *inspiration* expressed by the help of art.

soul as separable. The man is made up of both : they are to be raised and glorified together,[166] and all art is an expression of the one, by and through the other. All that I would insist upon is, the necessity of the whole man being in his work ; the body *must* be in it. Hands and habits must be in it, whether we will or not ; but the nobler part of the man may often not be in it. And that nobler part acts principally in love, reverence, and admiration, together with those conditions of thought which arise out of them. For we usually fall into much error by considering the intellectual powers as having dignity in themselves, and separable from the heart ; whereas the truth is, that the intellect becomes noble or ignoble according to the food we give it, and the kind of subjects with which it is conversant. It is not the reasoning power which, of itself, is noble, but the reasoning power occupied with its proper objects. Half of the mistakes of metaphysicians have arisen from their not observing this ; namely, that the intellect, going through the same processes, is yet mean or noble according to the matter it deals with, and wastes itself away in mere rotatory motion, if it be set to grind straws and dust. If we reason only respecting words, or lines, or any trifling and finite things, the reason becomes a contemptible faculty ; but reason employed on holy and infinite things, becomes herself holy and infinite. So that, by work of the soul, I mean the reader always to understand the work of the entire immortal creature, proceeding from a quick, perceptive, and eager heart, perfected by the intellect, and finally dealt with by the hands, under the direct guidance of these higher powers.

And now observe, the first important consequence of our fully understanding this pre-eminence of the soul, will be the due understanding of that subordination of knowledge respecting which so much has already been said. For it must be felt at once, that the increase of knowledge, merely as such, does not make the soul larger or smaller ; that, in the sights of God, all the knowledge man can gain is as nothing ;

but that the soul, for which the great scheme of redemption [167] was laid, be it ignorant or be it wise, is all in all; and in the activity, strength, health, and well-being of this soul, lies the main difference, in His sight, between one man and another. And that which is all in all in God's estimate is also, be assured, all in all in man's labour; and to have the heart open, and the eyes clear, and the emotions and thoughts warm and quick, and not the knowing of this or the other fact, is the state needed for all mighty doing in this world. And therefore finally, for this, the weightiest of all reasons, let us take no pride in our knowledge. We may, in a certain sense, be proud of being immortal; we may be proud of being God's children: we may be proud of loving, thinking, seeing, and of all that we are by no human teaching: but not of what we have been taught by rote; not of the ballast and freight of the ship of the spirit, but only of its pilotage, without which all the freight will only sink it faster, and strew the sea more richly with its ruin. There is not at this moment a youth of twenty, having received what we moderns ridiculously call education, but he knows more of everything, except the soul, than Plato or St. Paul did; but he is not for that reason a greater man, or fitter for his work, or more fit to be heard by others, than Plato or St. Paul. There is not at this moment a junior student in our schools of painting, who does not know fifty times as much about the art as Giotto did; but he is not for that reason greater than Giotto; no, nor his work better, nor fitter for our beholding. Let him go on to know all that the human intellect can discover and contain in the term of a long life, and he will not be one inch, one line, nearer to Giotto's feet. But let him leave his academy benches, and, innocently, as one knowing nothing, go out into the highways and hedges, and there rejoice with them that rejoice, and weep with them that weep; [168] and in the next world, among the companies of the great and good, Giotto will give his hand to him, and lead him into their white circle, and say, "This is our brother."

And the second important consequence of our feeling the
soul's pre-eminence will be our understanding the soul's
language, however broken, or low, or feeble, or obscure
in its words ; and chiefly that great symbolic language of
past ages, which has now so long been unspoken. It is
strange that the same cold and formal spirit which the Renais-
sance teaching has raised amongst us, should be equally
dead to the languages of imitation and of symbolism ; and
should at once disdain the faithful rendering of real nature
by the modern school of the Pre-Raphaelites,[169] and the
symbolic rendering of imagined nature in the work of the
thirteenth century. But so it is ; and we find the same
body of modern artists rejecting Pre-Raphaelitism because
it is not ideal ! and thirteenth-century work, because it is not
real !—their own practice being at once false and un-ideal,
and therefore equally opposed to both.

It is therefore, at this juncture, of much importance to
mark for the reader the exact relation of healthy symbolism
and of healthy imitation ; and, in order to do so, let us
return to one of our Venetian examples of symbolic art, to
the central cupola of St. Mark's. On that cupola, as has
been already stated, there is a mosaic representing the
Apostles on the Mount of Olives, with an olive-tree separ-
ating each from the other ; and we shall easily arrive at our
purpose, by comparing the means which would have been
adopted by a modern artist bred in the Renaissance schools,
—that is to say, under the influence of Claude and Poussin,[170]
and of the common teaching of the present day,—with those
adopted by the Byzantine mosaicist to express the nature of
these trees.

The reader is doubtless aware that the olive is one of the
most characteristic and beautiful features of all Southern
scenery. On the slopes of the northern Apennines, olives
are the usual forest timber ; the whole of the Val d'Arno is
wooded with them, every one of its gardens is filled with
them, and they grow in orchard-like ranks out of its fields

of maize, or corn, or vine ; so that it is physically impossible in most parts of the neighbourhood of Florence, Pistoja, Lucca, or Pisa, to choose any site of landscape which shall not owe its leading character to the foliage of these trees. What the elm and the oak are to England, the olive is to Italy ; nay, more than this, its presence is so constant, that, in the case of at least four fifths of the drawings made by any artist in North Italy, he must have been somewhat impeded by branches of olive coming between him and the landscape. Its classical associations double its importance in Greece ; and in the Holy Land the remembrances connected with it are of course more touching than can ever belong to any other tree of the field. Now, for many years back, at least one third out of all the landscapes painted by English artists have been chosen from Italian scenery ; sketches in Greece and in the Holy Land have become as common as sketches on Hampstead Heath ; our galleries also are full of sacred subjects, in which, if any background be introduced at all, the foliage of the olive ought to have been a prominent feature.

And here I challenge the untravelled English reader to tell me what an olive-tree is like ?

I know he cannot answer my challenge. He has no more idea of an olive-tree than if olives grew only in the fixed stars. Let him meditate a little on this one fact, and consider its strangeness, and what a wilful and constant closing of the eyes to the most important truths it indicates on the part of the modern artist. Observe, a want of perception, not of science. I do not want painters to tell me any scientific facts about olive-trees. But it had been well for them to have felt and seen the olive-tree ; to have loved it for Christ's sake, partly also for the helmed Wisdom's [171] sake which was to the heathen in some sort as that nobler Wisdom [172] which stood at God's right hand, when He founded the earth and established the heavens. To have loved it, even to the hoary dimness of its delicate foliage, subdued and faint of hue, as

if the ashes of the Gethsemane agony had been cast upon it
for ever ; and to have traced, line by line, the gnarled writhing
of its intricate branches, and the pointed fretwork of its light
and narrow leaves, inlaid on the blue field of the sky, and the
small rosy-white stars of its spring blossoming, and the beads
of sable fruit scattered by autumn along its topmost boughs
—the right, in Israel, of the stranger, the fatherless, and the
widow,—and, more than all, the softness of the mantle,
silver grey, and tender like the down on a bird's breast,
with which, far away, it veils the undulation of the mountains ;
—these it had been well for them to have seen and drawn,
whatever they had left unstudied in the gallery.

And if the reader would know the reason why this has
not been done (it is one instance only out of the myriads
which might be given of sightlessness in modern art), and
will ask the artists themselves, he will be informed of another
of the marvellous contradictions and inconsistencies in the
base Renaissance art ; for it will be answered him, that it is
not right, nor according to law, to draw trees so that one
should be known from another, but that trees ought to be
generalised into a universal idea of a tree : that is to say,
that the very school which carries its science in the represent-
ation of man down to the dissection of the most minute
muscle, refuses so much science to the drawing of a tree as
shall distinguish one species from another ; and also, while
it attends to logic, and rhetoric, and perspective, and atmo-
sphere, and every other circumstance which is trivial, verbal,
external, or accidental, in what it either says or sees, it will
not attend to what is essential and substantial,—being
intensely solicitous, for instance, if it draws two trees, one
behind the other, that the farthest off shall be as much
smaller as mathematics show that it should be, but totally
unsolicitous to show, what to the spectator is a far more
important matter, whether it is an apple or an orange-tree.

This, however, is not to our immediate purpose. Let it
be granted that an idea of an olive-tree is indeed to be given

us in a special manner; how, and by what language, this idea is to be conveyed, are questions on which we shall find the world of artists again divided; and it was this division which I wished especially to illustrate by reference to the mosaics of St. Mark's.

Now the main characteristics of an olive-tree are these. It has sharp and slender leaves of a greyish green, nearly grey on the under surface, and resembling, but somewhat smaller than, those of our common willow. Its fruit, when ripe, is black and lustrous; but of course so small, that, unless in great quantity, it is not conspicuous upon the tree. Its trunk and branches are peculiarly fantastic in their twisting, showing their fibres at every turn; and the trunk is often hollow, and even rent into many divisions like separate stems, but the extremities are exquisitely graceful, especially in the setting on of the leaves; and the notable and characteristic effect of the tree in the distance is of a rounded and soft mass or ball of downy foliage.

Supposing a modern artist to address himself to the rendering of this tree with his best skill: he will probably draw accurately the twisting of the branches, but yet this will hardly distinguish the tree from an oak: he will also render the colour and intricacy of the foliage, but this will only confuse the idea of an oak with that of a willow. The fruit, and the peculiar grace of the leaves at the extremities, and the fibrous structure of the stems, will all be too minute to be rendered consistently with his artistical feeling of breadth, or with the amount of labour which he considers it dexterous and legitimate to bestow upon the work: but, above all, the rounded and monotonous form of the head of the tree will be at variance with his ideas of " composition ; " he will assuredly disguise or break it, and the main points of the olive-tree will all at last remain untold.

Now observe, the old Byzantine mosaicist begins his work at enormous disadvantage. It is to be some one hundred and fifty feet above the eye, in a dark cupola; executed

not with free touches of the pencil, but with square pieces of glass ; not by his own hand, but by various workmen under his superintendence ; finally, not with a principal purpose of drawing olive-trees, but mainly as a decoration of the cupola. There is to be an olive-tree beside each apostle, and their stems are to be the chief lines which divide the dome. He therefore at once gives up the irregular twisting of the boughs hither and thither, but he will not give up their fibres. Other trees have irregular and fantastic branches, but the knitted cordage of fibres is the olive's own. Again, were he to draw the leaves of their natural size, they would be so small that their forms would be invisible in the darkness ; and were he to draw them so large as that their shape might be seen, they would look like laurel instead of olive. So he arranges them in small clusters of five each, nearly of the shape which the Byzantines give to the petals of the lily, but elongated so as to give the idea of leafage upon a spray ; and these clusters,—his object always, be it remembered, being *decoration* not less than *representation*,—he arranges symmetrically on each side of his branches, laying the whole on a dark ground most truly suggestive of the heavy rounded mass of the tree, which, in its turn, is relieved against the gold of the cupola. Lastly, comes the question respecting the fruit. The whole power and honour of the olive is in its fruit ; and, unless that be represented, nothing is represented. But if the berries were coloured black or green, they would be totally invisible ; if of any other colour, utterly unnatural, and violence would be done to the whole conception. There is but one conceivable means of showing them, namely, to represent them as golden. For the idea of golden fruit of various kinds was already familiar to the mind, as in the apples of the Hesperides, without any violence to the distinctive conception of the fruit itself. So the mosaicist introduced small round golden berries into the dark ground between each leaf, and his work was done.

I believe the reader will now see, that in these mosaics,

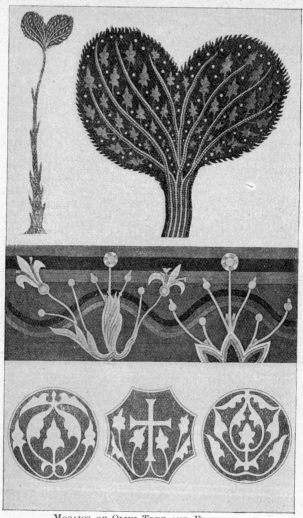

MOSAICS OF OLIVE-TREE AND FLOWERS.

(*Face page* 157.)

which the careless traveller is in the habit of passing by with contempt, there is a depth of feeling and of meaning greater than in most of the best sketches from nature of modern times ; and, without entering into any question whether these conventional representations are as good as, under the required limitations, it was possible to render them, they are at all events good enough completely to illustrate that mode of symbolical expression which appeals altogether to thought, and in no wise trusts to realisation. And little as, in the present state of our schools, such an assertion is likely to be believed, the fact is that this kind of expression is the *only one allowable in noble art.*

I pray the reader to have patience with me for a few moments. I do not mean that no art is noble but Byzantine mosaic ; but that no art is noble which in any wise depends upon direct imitation for its effect upon the mind. This was asserted in the opening chapters of " Modern Painters," but not upon the highest grounds ; the results at which we have now arrived in our investigation of early art, will enable me to place it on a loftier and firmer foundation.

We have just seen that all great art is the work of the whole living creature, body and soul, and chiefly of the soul. But it is not only *the work* of the whole creature, it likewise *addresses* the whole creature. That in which the perfect being speaks, must also have the perfect being to listen. I am not to spend my utmost spirit, and give all my strength and life to my work, while you, spectator or hearer, will give me only the attention of half your soul. You must be all mine, as I am all yours ; it is the only condition on which we can meet each other. All your faculties, all that is in you of greatest and best, must be awake in you, or I have no reward. The painter is not to cast the entire treasure of his human nature into his labour, merely to please a part of the beholder ; not merely to delight his senses, not merely to amuse his fancy, not merely to beguile him into emotion, not merely to lead him into thought ; but to do *all* this.

Senses, fancy, feeling, reason, the whole of the beholding spirit, must be stilled in attention or stirred with delight; else the labouring spirit has not done its work well. For observe, it is not merely its *right* to be thus met, face to face, heart to heart; but it is its *duty* to evoke this answering of the other soul: its trumpet call must be so clear, that though the challenge may by dulness or indolence be unanswered, there shall be no error as to the meaning of the appeal; there must be a summons in the work, which it shall be our own fault if we do not obey. We require this of it, we beseech this of it. Most men do not know what is in them, till they receive this summons from their fellows: their hearts die within them, sleep settles upon them, the lethargy of the world's miasmata; there is nothing for which they are so thankful as for that cry, " Awake, thou that sleepest."[173] And this cry must be most loudly uttered to their noblest faculties; first of all, to the imagination, for that is the most tender, and the soonest struck into numbness by the poisoned air: so that one of the main functions of art, in its service to man, is to rouse the imagination from its palsy, like the angel troubling the Bethesda pool; [174] and the art which does not do this is false to its duty, and degraded in its nature. It is not enough that it be well imagined, it must task the beholder also to imagine well; and this so imperatively, that if he does not choose to rouse himself to meet the work, he shall not taste it, nor enjoy it in any wise. Once that he is well awake, the guidance which the artist gives him should be full and authoritative: the beholder's imagination must not be suffered to take its own way, or wander hither and thither; but neither must it be left at rest; and the right point of realisation, for any given work of art, is that which will enable the spectator to complete it for himself, in the exact way the artist would have him, but not that which will save him the trouble of effecting the completion. So soon as the idea is entirely conveyed, the artist's labour should cease; and every touch which he adds beyond the point when, with

the help of the beholder's imagination, the story ought to have been told, is a degradation to his work. So that the art is wrong, which either realises its subject completely, or fails in giving such definite aid as shall enable it to be realised by the beholding imagination.

It follows, therefore, that the quantity of finish or detail which may rightly be bestowed upon any work, depends on the number and kind of ideas which the artist wishes to convey, much more than on the amount of realisation necessary to enable the imagination to grasp them. It is true that the differences of judgment formed by one or another observer are in great degree dependent on their unequal imaginative powers, as well as their unequal efforts in following the artist's intention; and it constantly happens that the drawing which appears clear to the painter in whose mind the thought is formed, is slightly inadequate to suggest it to the spectator. These causes of false judgment, or imperfect achievement, must always exist, but they are of no importance. For, in nearly every mind, the imaginative power, however unable to act independently, is so easily helped and so brightly animated by the most obscure suggestion, that there is no form of artistical language which will not readily be seized by it, if once it set itself intelligently to the task; and even without such effort there are few hieroglyphics of which, once understanding that it is to take them as hieroglyphics, it cannot make itself a pleasant picture.

Thus, in the case of all sketches, etchings, unfinished engravings, &c., no one ever supposes them to be imitations. Black outlines on white paper cannot produce a deceptive resemblance of anything; and the mind, understanding at once that it is to depend on its own powers for great part of its pleasure, sets itself so actively to the task that it can completely enjoy the rudest outline in which meaning exists. Now, when it is once in this temper, the artist is infinitely to be blamed who insults it by putting anything into his work which is not suggestive: having summoned the im-

aginative power, he must turn it to account and keep it
employed, or it will turn against him in indignation. What-
ever he does merely to realise and substantiate an idea is
impertinent ; he is like a dull storyteller, dwelling on points
which the hearer anticipates or disregards. The imagination
will say to him : " I knew all that before ; I don't want to
be told that. Go on ; or be silent, and let me go on in my
own way. I can tell the story better than you."

Observe, then, whenever finish is given for the sake of
realisation, it is wrong ; whenever it is given for the sake of
adding ideas, it is right. All true finish consists in the addi-
tion of ideas, that is to say, in giving the imagination more
food ; for once well awaked, it is ravenous for food : but the
painter who finishes in order to substantiate takes the food
out of its mouth, and it will turn and rend him.

Let us go back, for instance, to our olive grove,—or, lest
the reader should be tired of olives, let it be an oak copse,—
and consider the difference between the substantiating and
the imaginative methods of finish in such a subject. A few
strokes of the pencil, or dashes of colour, will be enough to
enable the imagination to conceive a tree ; and in those
dashes of colour Sir Joshua Reynolds [175] would have rested,
and would have suffered the imagination to paint what more
it liked for itself, and grow oaks, or olives, or apples, out of
the few dashes of colour at its leisure. On the other hand,
Hobbima,[176] one of the worst of the realists, smites the im-
agination on the mouth, and bids it be silent, while he sets
to work to paint his oak of the right green, and fill up its
foliage laboriously with jagged touches, and furrow the bark
all over its branches, so as, if possible, to deceive us into
supposing that we are looking at a real oak. Which, indeed,
we had much better do at once, without giving any one the
trouble to deceive us in the matter.

Now, the truly great artist neither leaves the imagination
to itself, like Sir Joshua, nor insults it by realisation, like
Hobbima, but finds it continual employment of the happiest

kind. Having summoned it by his vigorous first touches, he says to it : " Here is a tree for you, and it is to be an oak. Now I know that you can make it green and intricate for yourself, but that is not enough : an oak is not only green and intricate, but its leaves have most beautiful and fantastic forms which I am very sure you are not quite able to complete without help ; so I will draw a cluster or two perfectly for you, and then you can go on and do all the other clusters. So far so good : but the leaves are not enough ; the oak is to be full of acorns, and you may not be quite able to imagine the way they grow, nor the pretty contrast of their glossy almond-shaped nuts with the chasing of their cups ; so I will draw a bunch or two of acorns for you, and you can fill up the oak with others like them. Good : but that is not enough ; it is to be a bright day in summer, and all the outside leaves are to be glittering in the sunshine as if their edges were of gold ; I cannot paint this, but you can ; so I will really gild some of the edges nearest you,* and you can turn the gold into sunshine, and cover the tree with it. Well done : but still this is not enough ; the tree is so full foliaged and so old that the wood birds come in crowds to build there ; they are singing, two or three under the shadow of every bough. I cannot show you them all ; but here is a large one on the outside spray, and you can fancy the others inside."

In this way the calls upon the imagination are multiplied as a great painter finishes ; and from these larger incidents he may proceed into the most minute particulars, and lead the companion imagination to the veins in the leaves and the mosses on the trunk, and the shadows of the dead leaves upon the grass, but always multiplying thoughts, or subjects of thought, never working for the sake of realisation ; the amount of realisation actually reached depending on his space, his materials, and the nature of the thoughts he wishes

* The reader must not suppose that the use of gold, in this manner, is confined to early art. Tintoret, the greatest master of pictorial effect that ever existed, has gilded the ribs of the fig-leaves in his " Resurrection," in the Scuola di San Rocco. (R.)

to suggest. In the sculpture of an oak-tree, introduced
above an Adoration of the Magi on the tomb of the Doge
Marco Dolfino (fourteenth century), the sculptor has been
content with a few leaves, a single acorn, and a bird ; while,
on the other hand, Millais' willow-tree with the robin, in the
background of his " Ophelia," or the foreground of Hunt's
" Two Gentlemen of Verona," carries the appeal to the
imagination into particulars so multiplied and minute, that
the work nearly reaches realisation. But it does not matter
how near realisation the work may approach in its fulness,
or how far off it may remain in its slightness, so long as
realisation is not the end proposed, but the informing one
spirit of the thoughts of another. And in this greatness
and simplicity of purpose all noble art is alike, however slight
its means, or however perfect, from the rudest mosaics of
St. Mark's to the most tender finishing of the " Huguenot "
or the " Ophelia."

So then, whatever may be the means, or whatever the more
immediate end of any kind of art, all of it that is good agrees
in this, that it is the expression of one soul talking to another,
and is precious according to the greatness of the soul that
utters it. And consider what mighty consequences follow
from our acceptance of this truth ! what a key we have
herein given us for the interpretation of the art of all time !
For, as long as we held art to consist in any high manual
skill, or successful imitation of natural objects, or any scientific
and legalised manner of performance whatever, it was neces-
sary for us to limit our admiration to narrow periods and to
few men. According to our own knowledge and sympathies,
the period chosen might be different, and our rest might be
in Greek statues, or Dutch landscapes, or Italian Madonnas ;
but, whatever our choice, we were therein captive, barred from
all reverence but of our favourite masters, and habitually
using the language of contempt towards the whole of the
human race to whom it had not pleased Heaven to reveal
the arcana of the particular craftsmanship we admired, and

who, it might be, had lived their term of seventy years upon the earth, and fitted themselves therein for the eternal world, without any clear understanding, sometimes even with an insolent disregard, of the laws of perspective and chiaroscuro.

But let us once comprehend the holier nature of the art of man, and begin to look for the meaning of the spirit, however syllabled, and the scene is changed; and we are changed also. Those small and dexterous creatures whom once we worshipped, those fur-capped divinities with sceptres of camel's hair, peering and poring in their one-windowed chambers over the minute preciousness of the laboured canvas; how are they swept away and crushed into un-noticeable darkness! And in their stead, as the walls of the dismal rooms that enclosed them, and us, are struck by the four winds of Heaven, and rent away, and as the world opens to our sight, lo! far back into all the depths of time, and forth from all the fields that have been sown with human life, how the harvest of the dragon's teeth is springing! how the companies of the gods are ascending out of the earth! The dark stones that have so long been the sepulchres of the thoughts of nations, and the forgotten ruins wherein their faith lay charnelled, give up the dead that were in them; and beneath the Egyptian ranks of sultry and silent rock, and amidst the dim golden lights of the Byzantine dome, and out of the confused and cold shadows of the Northern cloister, behold, the multitudinous souls come forth with singing, gazing on us with the soft eyes of newly comprehended sympathy, and stretching their white arms to us across the grave, in the solemn gladness of everlasting brotherhood.

The other danger to which, it was above said, we were primarily exposed under our present circumstances of life, is the pursuit of vain pleasure, that is to say, false pleasure; delight, which is not indeed delight; as knowledge vainly accumulated, is not indeed knowledge. And this we are exposed to chiefly in the fact of our ceasing to be children. For the child does not seek false pleasure; its pleasures

are true, simple, and instinctive : but the youth is apt to abandon his early and true delight for vanities,—seeking to be like men, and sacrificing his natural and pure enjoyments to his pride. In like manner, it seems to me that modern civilisation sacrifices much pure and true pleasure to various forms of ostentation from which it can receive no fruit. Consider, for a moment, what kind of pleasures are open to human nature, undiseased. Passing by the consideration of the pleasures of the higher affections, which lie at the root of everything, and considering the definite and practical pleasures of daily life, there is, first, the pleasure of doing good ; the greatest of all, only apt to be despised from not being often enough tasted : and then, I know not in what order to put them, nor does it matter,—the pleasure of gaining knowledge ; the pleasure of the excitement of imagination and emotion (or poetry and passion) ; and, lastly, the gratification of the senses, first of the eye, then of the ear, and then of the others in their order.

All these we are apt to make subservient to the desire of praise ; nor unwisely, when the praise sought is God's and the conscience's : but if the sacrifice is made for man's admiration, and knowledge is only sought for praise, passion repressed or affected for praise, and the arts practised for praise, we are feeding on the bitterest apples of Sodom, suffering always ten mortifications for one delight. And it seems to me, that in the modern civilised world we make such sacrifice doubly : first, by labouring for merely ambitious purposes ; and secondly, which is the main point in question, by being ashamed of simple pleasures, more especially of the pleasure in sweet colour and form, a pleasure evidently so necessary to man's perfectness and virtue, that the beauty of colour and form has been given lavishly throughout the whole of creation, so that it may become the food of all, and with such intricacy and subtlety that it may deeply employ the thoughts of all. If we refuse to accept the natural delight which the Deity has thus provided for us, we must either

become ascetics, or we must seek for some base and guilty pleasures to replace those of Paradise, which we have denied ourselves.

Some years ago, in passing through some of the cells of the Grande Chartreuse, noticing that the window of each apartment looked across the little garden of its inhabitant to the wall of the cell opposite, and commanded no other view, I asked the monk beside me, why the window was not rather made on the side of the cell whence it would open to the solemn fields of the Alpine valley. " We do not come here," he replied, " to look at the mountains."

The same answer is given, practically, by the men of this century, to every such question ; only the walls with which they enclose themselves are those of Pride, not of Prayer. But in the middle ages it was otherwise. Not, indeed, in landscape itself, but in the art which can take the place of it, in the noble colour and form with which they illumined, and into which they wrought, every object around them that was in any wise subjected to their power, they obeyed the laws of their inner nature, and found its proper food. The splendour and fantasy even of dress, which in these days we pretend to despise, or in which, if we even indulge, it is only for the sake of vanity, and therefore to our infinite harm, were in those early days studied for love of their true beauty and honourableness, and became one of the main helps to dignity of character, and courtesy of bearing. Look back to what we have been told of the dress of the early Venetians, that it was so invented " that in clothing themselves with it, they might clothe themselves also with modesty and honour ; " consider what nobleness of expression there is in the dress of any of the portrait figures of the great times, nay, what perfect beauty, and more than beauty, there is in the folding of the robe round the imagined form even of the saint or of the angel ; and then consider whether the grace of vesture be indeed a thing to be despised. We cannot despise it if we would ; and in all our highest poetry and happiest

thought we cling to the magnificence which in daily life we disregard. The essence of modern romance is simply the return of the heart and fancy to the things in which they naturally take pleasure ; and half the influence of the best romances, of Ivanhoe, or Marmion, or the Crusaders, or the Lady of the Lake, is completely dependent upon the accessaries of armour and costume. Nay, more than this, deprive the Iliad itself of its costume, and consider how much of its power would be lost. And that delight and reverence which we feel in, and by means of, the mere imagination of these accessaries, the middle ages had in the vision of them ; the nobleness of dress exercising, as I have said, a perpetual influence upon character, tending in a thousand ways to increase dignity and self-respect, and together with grace of gesture, to induce serenity of thought.

I do not mean merely in its magnificence ; the most splendid time was not the best time. It was still in the thirteenth century,—when, as we have seen, simplicity and gorgeousness were justly mingled, and the " leathern girdle and clasp of bone " were worn, as well as the embroidered mantle,—that the manner of dress seems to have been noblest. The chain mail of the knight, flowing and falling over his form in lapping waves of gloomy strength, was worn under full robes of one colour in the ground, his crest quartered on them, and their borders enriched with subtle illumination. The women wore first a dress close to the form in like manner, and then long and flowing robes, veiling them up to the neck, and delicately embroidered around the hem, the sleeves, and the girdle. The use of plate armour gradually introduced more fantastic types ; the nobleness of the form was lost beneath the steel ; the gradually increasing luxury and vanity of the age strove for continual excitement in more quaint and extravagant devices ; and in the fifteenth century, dress reached its point of utmost splendour and fancy, being in many cases still exquisitely graceful, but now, in its morbid magnificence, devoid of all wholesome influence on manners.

From this point, like architecture, it was rapidly degraded ; and sank through the buff coat, and lace collar, and jack boot, to the bag-wig, tailed coat, and high-heeled shoe ; and so to what it is now.

Precisely analogous to this destruction of beauty in dress, has been that of beauty in architecture ; its colour, and grace, and fancy, being gradually sacrificed to the base forms of the Renaissance, exactly as the splendour of chivalry has faded into the paltriness of fashion. And observe the form in which the necessary reaction has taken place ; necessary, for it was not possible that one of the strongest instincts of the human race could be deprived altogether of its natural food. Exactly in the degree that the architect withdrew from his buildings the sources of delight which in early days they had so richly possessed, demanding, in accordance with the new principles of taste, the banishment of all happy colour and healthy invention, in that degree the minds of men began to turn to landscape as their only resource. The picturesque school of art rose up to address those capacities of enjoyment for which, in sculpture, architecture, or the higher walks of painting, there was employment no more ; and the shadows of Rembrandt, and savageness of Salvator, arrested the admiration which was no longer permitted to be rendered to the gloom or the grotesqueness of the Gothic aisle. And thus the English school of landscape, culminating in Turner, is in reality nothing else than a healthy effort to fill the void which the destruction of Gothic architecture has left.

But the void cannot thus be completely filled ; no, nor filled in any considerable degree. The art of landscape-painting will never become thoroughly interesting or sufficing to the minds of men engaged in active life, or concerned principally with practical subjects. The sentiment and imagination necessary to enter fully into the romantic forms of art are chiefly the characteristics of youth ; so that near ly all men as they advance in years, and some even from th eir

childhood upwards, must be appealed to, if at all, by a direct and substantial art, brought before their daily observation and connected with their daily interests. No form of art answers these conditions so well as architecture, which, as it can receive help from every character of mind in the workman, can address every character of mind in the spectator; forcing itself into notice even in his most languid moments, and possessing this chief and peculiar advantage, that it is the property of all men. Pictures and statues may be jealously withdrawn by their possessors from the public gaze, and to a certain degree their safety requires them to be so withdrawn; but the outsides of our houses belong not so much to us as to the passer-by, and whatever cost and pains we bestow upon them, though too often arising out of ostentation, have at least the effect of benevolence.

If, then, considering these things, any of my readers should determine, according to their means, to set themselves to the revival of a healthy school of architecture in England, and wish to know in few words how this may be done, the answer is clear and simple. First, let us cast out utterly whatever is connected with the Greek, Roman, or Renaissance architecture, in principle or in form. We have seen above, that the whole mass of the architecture, founded on Greek and Roman models, which we have been in the habit of building for the last three centuries, is utterly devoid of all life, virtue, honourableness, or power of doing good. It is base, unnatural, unfruitful, unenjoyable, and impious. Pagan in its origin, proud and unholy in its revival, paralysed in its old age, yet making prey in its dotage of all the good and living things that were springing around it in their youth, as the dying and desperate king, who had long fenced himself so strongly with the towers of it, is said to have filled his failing veins with the blood of children; * an architecture invented, as it

* Louis the Eleventh. " In the month of March, 1481, Louis was seized with a fit of apoplexy at *St. Bénoît-du-lac-mort*, near Chinon. He remained speechless and bereft of reason three days; and then, but very imperfectly

seems, to make plagiarists of its architects, slaves of its
workmen, and Sybarites of its inhabitants ; an architecture
in which intellect is idle, invention impossible, but in which
all luxury is gratified, and all insolence fortified ;—the first
thing we have to do is to cast it out, and shake the dust of it
from our feet for ever. Whatever has any connection with
the five orders, or with any one of the orders,—whatever is
Doric, or Ionic, or Tuscan, or Corinthian, or Composite, or
in any way Grecised or Romanised ; whatever betrays the
smallest respect for Vitruvian laws,[177] or conformity with
Palladian work,—that we are to endure no more. To cleanse
ourselves of these " cast clouts and rotten rags " is the first
thing to be done in the court of our prison.

Then, to turn our prison into a palace is an easy thing.
We have seen above, that exactly in the degree in which
Greek and Roman architecture is lifeless, unprofitable, and
unchristian, in that same degree our own ancient Gothic
is animated, serviceable, and faithful. We have seen that
it is flexible to all duty, enduring to all time, instructive to
all hearts, honourable and holy in all offices. It is capable
alike of all lowliness and all dignity, fit alike for cottage
porch or castle gateway ; in domestic service familiar, in
religious, sublime ; simple, and playful, so that childhood
may read it, yet clothed with a power that can awe the
mightiest, and exalt the loftiest of human spirits : an
architecture that kindles every faculty in its workman, and
addresses every emotion in its beholder ; which, with every
stone that is laid on its solemn walls, raises some human
heart a step nearer heaven, and which from its birth has
been incorporated with the existence, and in all its form is
symbolical of the faith, of Christianity. In this architecture
let us henceforward build, alike the church, the palace, and

restored, he languished in a miserable state... To cure him," says a
contemporary historian, " wonderful and terrible medicines were com-
pounded. It was reported among the people that his physicians opened
the veins of little children, and made him drink their blood, to correct
the poorness of his own." Bussey's *History of France*. London, 1850. (R.)

the cottage ; but chiefly let us use it for our civil and do-
mestic buildings. These once ennobled, our ecclesiastical
work will be exalted together with them : but churches are
not the proper scenes for experiments in untried architecture,
nor for exhibitions of unaccustomed beauty. It is certain
that we must often fail before we can again build a natural
and noble Gothic : let not our temples be the scenes of our
failures. It is certain that we must offend many deep-rooted
prejudices, before ancient Christian architecture * can be
again received by all of us : let not religion be the first
source of such offence. We shall meet with difficulties in
applying Gothic architecture to churches, which would in no
wise affect the designs of civil buildings, for the most beauti-
ful forms of Gothic chapels are not those which are best
fitted for Protestant worship. As it was noticed when
speaking of the Cathedral of Torcello, it seems not unlikely,
that as we study either the science of sound, or the practice
of the early Christians, we may see reason to place the pulpit
generally at the extremity of the apse or chancel ; an arrange-
ment entirely destructive of the beauty of a Gothic church,
as seen in existing examples, and requiring modifications of
its design in other parts with which we should be unwise at
present to embarrass ourselves ; besides, that the effort to
introduce the style exclusively for ecclesiastical purposes,
excites against it the strong prejudices of many persons who
might otherwise be easily enlisted among its most ardent
advocates. I am quite sure, for instance, that if such noble
architecture as has been employed for the interior of the
church just built in Margaret Street† had been seen in a civil
building, it would have decided the question with many men

* Observe, I call Gothic " Christian " architecture, not " ecclesiastical."
There is a wide difference. I believe it is the only architecture which
Christian men should build, but not at all an architecture necessarily
connected with the services of their church. (R.)

† Mr. Hope's Church, in Margaret Street, Portland Place. I do not
altogether like the arrangements of colour in the brickwork ; but these
will hardly attract the eye, where so much has been already done with

at once ; whereas, at present, it will be looked upon with fear and suspicion, as the expression of the ecclesiastical principles of a particular party. But, whether thus regarded or not, this church assuredly decides one question conclusively, that of our present capability of Gothic design. It is the first piece of architecture I have seen, built in modern days, which is free from all signs of timidity or incapacity. In general proportion of parts, in refinement and piquancy of mouldings, above all, in force, vitality and grace of floral ornament, worked in a broad and masculine manner, it challenges fearless comparison with the noblest work of any time. Having done this, we may do anything ; there need be no limits to our hope or our confidence ; and I believe it to be possible for us, not only to equal, but far to surpass, in some respects, any Gothic yet seen in Northern countries. In the introduction of figure-sculpture, we must, indeed, for the present, remain utterly inferior, for we have no figures to study from. No architectural sculpture was ever good for anything which did not represent the dress and persons of the people living at the time ; and our modern dress will *not* form decorations for spandrils and niches. But in floral sculpture we may go far beyond what has yet been done, as well as in refinement of inlaid work and general execution. For, although the glory of Gothic architecture is to receive the rudest work, it refuses not the best ; and, when once we have been content to admit the handling of the simplest workman, we shall soon be rewarded by finding many of our simple workmen become cunning ones : and, with the help of modern wealth and science, we may do things like Giotto's campanile, instead of like our own rude cathedrals ; but better than Giotto's campanile, insomuch as we may adopt the pure and perfect forms of the Northern Gothic, and work them out with the Italian refinement. It

precious and beautiful marble, and is yet to be done in fresco. Much will depend, however, upon the colouring of this latter portion. I wish that either Holman Hunt or Millais could be prevailed upon to do at least some of these smaller frescoes.

is hardly possible at present to imagine what may be the splendour of buildings designed in the forms of English and French thirteenth-century *surface* Gothic, and wrought out with the refinement of Italian art in the details, and with a deliberate resolution, since we cannot have figure-sculpture, to display in them the beauty of every flower and herb of the English fields, each by each ; doing as much for every tree that roots itself in our rocks, and every blossom that drinks our summer rains, as our ancestors did for the oak, the ivy, and the rose. Let this be the object of our ambition, and let us begin to approach it, not ambitiously, but in all humility, accepting help from the feeblest hands ; and the London of the nineteenth century may yet become as Venice without her despotism, and as Florence without her dispeace.

NOTES

1. Architectural technique usually distinguishes five styles or "orders" according to the form of the capital. The Doric has the simplest form, presenting horizontal lines without decoration ; the Corinthian the most complex, being double-curved and covered with richly carved natural forms. In § 19 Ruskin rejects the division into five orders.

2. Noah's three sons—Shem, Ham, and Japheth—having re-peopled the world after the Flood, were taken by the old ethnology as the fathers of the three great human families, the Semite, Hamite, and Japhetic. Of Semitic stock were the Jews and Arabs, Abraham being the covenanted forefather of the former and Ishmael, Abraham's uncovenanted son, the forefather of the latter ; from Ham were supposed to be descended the Canaanite and certain North African tribes, from Japheth the European nations. Genesis ix. 18-27 and x. gives the Jewish mythological account of these origins. Semite and Hamite are terms still in use, Japhetic has fallen into desuetude since Ruskin's day.

3. The Catholic Christian, both Roman and Greek, which Ruskin, being a Puritan Protestant, regards as decaying till the sack of Rome and Constantinople, the capitals of the two Roman empires and metropolises of the two forms of ancient Christianity, by the Germanic tribes and the Turks, respectively, which is the "rough awakening" of I. 24.

4. The Huns, Mongol by race, invaded Europe in the first century A.D. and pushed continually further west. Finally, Attila, their greatest leader, forced the Eastern Emperor, Theodosius II., to submission, but, advancing in 451 A.D. against the Western Empire, was smashingly defeated by Franks, Visigoths and Imperial troops at Châlons. He turned and overran North Italy, sparing Rome at Pope Leo I.'s request. His death in 453 ended the Hun terror. The Goths were a Teutonic tribe who moved south through Russia and, in the first century A.D., were divided by the Dnieper into Eastern or Ostrogoths and Western or Visigoths. Both tribes were a thorn in the side of the Roman Empire. In 410 Alaric the Goth sacked Rome. For a short time there was an Ostrogothic kingdom around Rome. A part of the Visigoths moved into Spain and established a kingdom there.

5. A life-size statue by Antonio Rizzo, set in the south pillar of the arch opening into the inner court of the Ducal Palace and opposite the Giants' staircase, from which the statue is best seen rather than from below.

6. A Roman aqueduct near Avignon.

7. English water-colourist (1783-1852) whose main success was in catching the peculiar charms in old Continental buildings in exquisite line-drawings. Ruskin had already written a memoir of him in 1849 and owed a great deal to his methods in his own drawing.

8. For Ruskin's ironic castigation of windows of this style see Vol. I. Chap. 17, § 16.

9. Three of the abstract lines taken from natural forms— mountains, a spruce branch, a paper nautilus, various leaves— represented in Plate 7 of Vol. I. as containing all possible curves for ornamentation.

10. Italian, " ought to be's."

11. Playful use of Shakespeare's names for three fairies in *A Midsummer Night's Dream*.

12. Job xxvii. 25 and 26.

13. Greek, "The sea. The sea." The " wearied ones " were the 10,000 Greeks returning from the invasion of Persia ; the sea was the Black Sea. (Xenophon, Book IV. Chap 7, § 24.)

14. 2 Timothy ii. 15—part of Paul's advice to Timothy is a true analysis and understanding of the Scriptures.

15. Matt. xiii. 52.

16. Part of the closing warning of the last book of the New Testament—Revelation xxii. 18.

17. The old post road, which Ruskin is about to traverse, is that which he followed in his first journey to Venice, and the remainder of the passage is an undoubted reminiscence of experiences then.

18. Plan of Torcello church, given four pages earlier, shows the nave separated from the side aisles by two lines of nine pillars each, the pulpit being supported by four small shafts between the sixth and seventh pillars on the north side of the nave. The last three columns on each side of the nave are enclosed by a screen with the apse, and the seventh columns are connected, just behind the screen, by six light pillars.

19. Runs up the aisle-side of the seventh column, then up the front of the same, then turns forward at right angles into the pulpit.

20. From the Veneti's last church on the mainland, hence already carved in a design.

21. On the south side, opposite the opening between the first and second pillars.

22. A style of architecture prevalent in Romanized Europe between the classical and Gothic periods.

23. As is done in St. Mark's to-day, a slight wooden framework covered with deep purple hangings being erected before the south end over and covering the less rich of the two pulpits.

24. The whole of this passage to the end of the paragraph is a mosaic of reminiscences and half-quotations from the Bible, a sign of the impregnation of the English language and of Ruskin with the language of the Bible for purposes of solemn declamation.

25. From Christ's Parable of the Sower, Matthew xiii., Luke viii.

26. Revelation iii. 20.

27. Proverbs i. 24.

28. Ezekiel xxxviii.

29. Numbers xx.

30. Note Ruskin's growing ability to criticise the Protestant views in which he was brought up.

31. The Flood, related in Genesis vii., from which Noah and his family and selected animals were saved, springs naturally to Ruskin's mind as an image for the invasion of the Langobards which totally destroyed the home of the Veneti on the mainland and from which they barely escaped.

32. Mark iv. 37, Luke viii. 23.

33. Here, of course, the bishop looking from his throne in the apse down the nave of the Torcello church.

34. Psalm xcv. 5,

35. A Romano-Greek style of architecture coloured by Arabian influence, created at Byzantium, the seat of the Eastern Roman Empire, and brought to Venice by the Greek architects and workmen who built the main part of St. Mark's and the earliest Venetian palaces. "The earliest parts of the building (St. Mark's) belong to the eleventh, twelfth, and first part of the thirteenth century, the Gothic portions to the fourteenth, some of the altars and embellishments to the fifteenth and sixteenth, and the modern portions of the mosaics to the seventeenth" (Ruskin).

36. A mediæval Christian church was built with its chancel (for the altar) at the East end, towards the Holy Land of Palestine. The West end would, then, contain the main entrance, and the West front is usually magnificently decorated, in cathedrals, with arches and windows and sculpture.

37. A cathedral is the central church of an ecclesiastical district in Christendom, called a see, of which a bishop is the head. The chapter is the council of dean and canons of the cathedral who deal with its domestic affairs. Bishop and chapter have houses by the side of the cathedral in ground which is private, hence called " close."

38. Italian, " courtyard," in Venice generally a side courtyard off the street and faced on both sides by mean houses.

39. Italian, " Fried food and wines sold here."

40. The regular word for a street in Venice.

41. " Home wine at 28·32 soldi " (about 5½d.) Contrast the raillery at the Catholic worship of Mary, the mother of Jesus, in this passage with the warning to Protestants in the previous selection. Ruskin is still attached, however, to Protestantism.

42. Austria was then (1853) mistress of Venice, and the Austrians would be officials. Tourists would, then also, be English.

43. Ruskin is introducing us to St. Mark's Square from the south-west corner where, between shops and through a tunnel dark with columns, the Bocca di Piazza opens up the marvellous vista of St. Mark's Square, the immense space bounded left and right by the " countless arches " of the Old and New Procuratie and leading up to the " vision " of St. Mark's Church like a jewel at the end. The Doges' Palace at the south-east corner is almost blocked out by the great Campanile or bell-tower (" the vast tower of St. Mark ") which was felled by lightning on July 14, 1902, and now stands again fresh and identical with the old. St. Mark's Square is not a literal square nor even rectangular, but the Campanile restores the symmetry and gives also a measure for St. Mark's and the Doges' Palace.

44. Shakespeare, *Antony and Cleopatra*, II. 4, 29.

45. The acanthus was the favourite leaf-form in Greek decoration, notably on the bells of Corinthian capitals. The vine typifies Christ in Gothic decoration.

46. Four bronze horses, gilded, taken by the Venetians from Constantinople in 1205 and set up over the main door of St. Mark's.

47. The lion is one of the four beasts seen in ecstatic vision by the author of the Revelation (Revelation iv. 6-8). These beasts were associated by early Christian mystics with the Four Evangelists, and the lion was attached to St. Mark. Hence St. Mark's lion is everywhere depicted in the sculpture and paintings of Venice.

48. Lido ("lagoon-dune"), an island to the south of Venice, whose southern shore has been for long the favourite pleasure-resort of Venetians. Its sands in summer are still crowded with bathers.

49. Matthew xxi. 12. The toy-vendors collect where the crowds are thickest at the doors of the church, as the dove-sellers used to do in the outer court of the temple at Jerusalem, whence Christ drove them out, saying that God's house is for prayer, not trafficking. A comparison is suggested between Venice and Jerusalem in the decline of religion.

50. Latin, "Have pity." A mediæval church hymn for the dead, based on Psalm l.

51. The pillars were brought to Venice in 1256.

52. The small square opening from the south-east corner of St. Mark's Square by the Campanile and running along the west side of the Doges' Palace to the sea at the Riva degli Schiavoni (landing-place where the Slavs formerly landed their wares).

53. French word, designating carving done lightly into a metal, wood or stone surface.

54. Doge from 1343 to 1354. His "History," the "Chronicon Danduli," covers Venetian annals up till 1280.

55. Ephesians iii. 10.

56. *Paradise Lost*, v. 601.

57. An expression in the preaching of John the Baptist, Matthew iii. 10.

58. Matthew iii. 10.

59. *I.e.* with gold mosaic-work.

60. The main Cross hanging before the altar. (Old English "rōd" = "cross.")

61. Ruskin is entirely hostile to Mariolatry or the worship of Mary, the mother of Jesus, in place of Jesus, and here contrasts the Christ-worship of ancient Catholicism with its modern Mary-worship. Cf. Ruskin's note at the end of the selection.

62. Representations of the Ascension and Second Coming of Christ.

63. Term of reproach for Roman Catholicism, marking Ruskin's religious views at the time. The following paragraph illustrates fairly fully his earlier views.

64. See Ruskin's note at the end of the selection.

65. Practices of the ancient Persian priests of Mithra and of Hindu priests to enslave the common worshipper by superstition.

66. The high places of the Greek Eleusinian mysteries, Indian Buddhism and Egyptian Horus-worship respectively.

67. Mosaic-work, discussed in the immediately preceding paragraphs.

68. John vi. 58.

69. A saying of Christ recorded in John x. 7.

70. The pouring out of the Spirit of God upon the first Christians at Pentecost after the Ascension of Christ, related in Acts ii. 1-4.

71. The Christians conceive of God under three aspects, as Father, as Son, and as Holy Spirit, and these form the Trinity. The Second Person, or the Son (Christ), is mystically represented as a Lamb, a sacrificial animal, because He died for the sins of men ; the Third Person, or the Holy Spirit, as a Dove, the peace-bringer.

72. These scenes, with one exception, are related in the four lives of Christ. The descent into Hades, supposed to occupy the period between Christ's death and His resurrection, is an early Christian belief, based on a single obscure passage in 1 Peter iv. 19 and the apocryphal Gospel of Nicodemus. Christ is supposed to have entered Hell and given the souls there a chance of salvation through hearing Him, hence the famous mediæval Mystery play "The Harrowing of Hell."

73. Because the rainbow was said, in Jewish story, to have been first seen after the Deluge as a sign that God would never again drown the world for its sin.

74. Acts i. 11.

75. According to Matthew's gospel, Christ's coming and personality were prefigured in many prophecies recorded in the Old Testament.

76 In the Book of the Revelation, the Christian Church is figured as a Heavenly Bride to be united with Christ.

77 Psalm cxix. 14.

78. 1 John ii. 18.

79. A brilliant star which, Matthew says, stood over the birth-place of Jesus and led three Wise Men (Magi) from the East to worship Him.

80. *I.e.* the walls of the Doges' Palace which abut on St. Mark's Church. St. Mark's was originally the chapel of the Doges.

81. *I.e.* the prisons, behind the Palace but still next to the church. For a similar utterance on the follies of Venice, see Browning's " A Toccata of Galuppi's."

82. Ecclesiastes xi. 9.

83. Given as No. 4 in Plate XI. is found as a decoration on a house at San Giovanni Grisostomo in Venice which once belonged to the traveller Marco Polo (1254-1324).

84. The eleventh to the thirteenth centuries.

85. Romans viii. 22. According to Christian Dogma, mankind was created through Christ, who also redeemed it from sin by His death. The Crucifixion is thus directly related to the Creation, being the act of Divine re-Creation when mankind was spiritually dead.

86. These plaques are set, as Ruskin describes, on to the walls of Byzantine buildings above or between the arches.

87. "The Turks' Establishment," a great building on the Grand Canal, built in the eleventh century and originally the property of the Pesaro family, received its present name from its being let to Turkish merchants as a house of trade. It was ruinous in 1853, but was " restored " in 1880 and is now the Museo Civico.

88. Ruskin's own name for a house on the Grand Canal, four houses from the Casa Businello, restored by his time but retaining five windows, in the second storey, of the Byzantine period with a " plaited or braided border and basket-worked sides."

89. Ancient Greek city of the " Ægean " civilisation. Schliemann's opening, in 1876, of the graves—supposed to be of Agamemnon, Cassandra, etc.—just inside the entrance to the citadel —called the Lion Gate from the carving of two lions facing each other above it—finally disposed of such theories as Ruskin suggests here by giving a date near 1600 B.C. to the graves.

90. Ezekiel xvii. 3-6.

91. Purple heather-flowers and green grass.

92. Christ, in speaking of His spiritual relationship to His disciples, said, " I am the vine, ye are the branches." Hence the symbolism of the vine.

93. At His baptism, Christ saw the Spirit of God descend upon Himself in the form of a dove. He later spoke to His disciples of the Spirit as the Comforter, or Strengthener, which He promised should come to them after His death. It came at Pentecost (see note 70).

94. The best known is that of the fifteenth and early sixteenth centuries, of Titian (1477-1576) and Tintoretto (1518-1594), known as the Venetian colourists. Ruskin, in thinking of Venetian colour-schools, has oftener in mind the earlier painters, Gentile Bellini (1429-1507) and Giovanni Bellini (1430-1516).

95. Flemish painter (1577-1640).

96. Antonio Allegri (1494-1534), called Correggio from his birthplace, became one of the greatest of the Italian painters.

97. (1387-1455), Dominican friar and great painter of the pietistic type, called " the Angelic " from soon after his death.

98. (1615-1673), Neapolitan painter.

99. Proverbs xiv. 13.

100. Those of the Teniers, father and son, Cuyp, Berghems, of the seventeenth century, for example.

101. Those, for instance, of Hubert Van Eyck (1366-1426) and Jan van Eyck (1385-1440).

102. For the Bellinis, see note 94. Francia (1450-1517), painter of Bologna. Perugino (1446-1524).

103. The Caraccis were three Bolognese painters, uncle and two nephews, of the second half of the sixteenth century ; Guido Reni (1575-1642), Bolognese master ; Rembrandt (1606-1669), greatest of the Dutch masters.

104. Arranging the seven colours of the rainbow under the three primary colours, yellow, red and blue, and thus forming a mystical parallel with the Trinity of the Divine Nature according to Christian views. Three and seven are the most favoured numbers in mysticism and magic.

105. Meaning " Perseverer with God," the name Jacob received when he won a blessing by wrestling with the angel of God (Genesis xxxii. 28). It became the general name of the tribes of Jews descended from him. Joseph, the favourite of the twelve sons of Jacob, received, according to a translation now disputed, a coat of many colours from his father.

106. Exodus xxvi.

107. The Greeks wrongly supposed Ecbatana to be the capital of Media. Deioces is said to have founded it and to have surrounded the palace with seven concentric walls of different colours.

108. As in Esther i. 19, and Daniel vi. 8.

109. The Semitic.

110. Semitic nations have been justly famous for their love of noble colour in religion and art. Solomon's temple, Arab architecture and, to some extent, Mughal paintings exemplify this, while modern Zoroastrianism continues the instinct.

111. Japheth.

112. On the Grotesque in Architecture, see selection 11.

113. Byron, *Childe Harold* iv. 27.

114. Revelation xvii. 2.

115. Christ used " the city set on a hill " and " the candle set in the candlestick which giveth light to all that are in the house," as symbols of the truly religious man.

116. This, like the " mighty Humanity " and " mighty Myth-ology " below, refers to the creations of Venetian artists—the mosaics, paintings and statues which preserve the features of the landscape of the mainland seen from Venice, and of Venetian men and women, and of the saints and angels of Venetian faith in her greatest days.

117. Vol. I. Chap. 1, §§ 20, 21, and 34—the Byzantine, Gothic and Renaissance styles of architecture.

118. So called because they touch the wall which they support only at their upper extremity and then sweep in an airy arch to the ground or to the top of a supporting wall.

119. The term " Gothic " was first applied by Italian Renais-sance writers to all architecture later than the Roman. It was narrowed later to mean mediæval architecture later than about 1150.

120. Modern maps are pure abstractions, using varieties of lines, generally agreed on by geographers, to represent frontiers, roads, railways, lakes, etc., and flat colours to distinguish pro-vinces and countries. Ruskin's following description is more inspired by the mediæval and Renaissance maps which showed actual castles, houses, flora and fauna in large-scale maps with detailed accuracy, cf. the map in Visscher's view of London, 1616, showing Shakespeare's theatre, each separate house in elevation on the south bank of the Thames, smoke rising and boats sailing.

121. Iris, the Greek goddess-messenger, has given her name to the rainbow, whose coloured bands Ruskin here uses, by trans-ference, to picture the zones of life in Europe from torrid to arctic.

122. The character of the building materials and of the archi-tect in each zone govern the character of the architecture.

123. Mid-Victorian architecture, interior-decoration and furni-ture, made by machinery, hence soul-destroying in Ruskin's sense.

124. Types of the slave-gangs that built Egyptian and Greek temples and palaces.

125. Luke vii. 8. Saying of the centurion whose servant Christ healed.

126. Ruskin is thinking particularly of Venetian beads.

127. This was so in England in Ruskin's youth, and is still occasionally found.

128. Ruskin contrasts, in the passage given, the rigid energy of a Northerner fighting a snowstorm with the languor of a Southerner reclining in the sun.

129. Names taken from Northern or Latin divinities and customs—the moon, the Germanic god Tiw, the Roman god Janus, the custom of expiation—hence idolatrous in origin to strict Puritan Christians.

130. That is, the Byzantine architects faced the whole of their walls outside with marble, while the Gothic architects were content to face only the spaces between the windows in this way, and so left the larger part of the wall bare.

131. Master-painter of Venice (1528-1588).

132. Italian, a plaster surface laid on walls.

133. Italian, literally " fresh." Technical name for paintings on freshly-plastered wall surfaces.

134. Italian, literally " chalk." Technical term for the plaster of which the rough forms of statues are made.

135. Canvases of this painter in the Venice Academy of Fine Arts show the architecture of St. Mark's Square and of Gothic buildings in other parts of Venice in their days of greatest splendour.

136. Venetian master (1477-1510).

137. Contemporaries of Ruskin, the former famous for paintings of animals, the latter of figures.

138. See note 42.

139. *I.e.* pillars set into the walls instead of standing entirely apart.

140. 1484-1559.

141. 1518-1580.

142. 1475-1564.

143. 1632-1723.

144. 1573-1651.

145. Quotation from Psalm xix. 4-6.

146. Latin, " I have seen."

147. Painted 1852.

148. (1267-1337) Florentine, with whom painting entered into its modern era in Europe.

149. (1308-1368) A follower of Giotto.

150. Lippo Memmi, Sienese painter of the fourteenth century.

151. Niccola Pisano, Italian sculptor and architect (1206-1278).

152. Genesis xli. 57.

153. Isaiah xxxii. 20.

154. From the story ot Elijah and the widow of Zarephath, 1 Kings xvii. 16.

155. Proverbs iii. 10.

156. Genesis ii. 9.

157. 1 Corinthians iii. 19.

158. Paul, in 1 Corinthians viii. 1.

159. Francis Bacon, in *The Advancement of Learning*, Book I.—
"but it is merely the quality of knowledge, which, be it in quantity
more or less, if it be taken without the true corrective thereof, hath
in it some nature of venom or malignity, and some effects of that
venom, which is ventosity or swelling."

160. Where the "angel of the Lord" stayed that brought
pestilence on the Jews for three days. 2 Samuel xxiv. 16.

161. *Inferno*, ix. 52. Spoken by one of the Greek Furies—
Alecto, Megara and Tisiphone—on seeing Dante, a living man,
in the underworld.

> "Hasten Medusa ; so to adamant
> Him shall we change."
> (Cary's translation.)

162. Lorenzo Ghiberti (1378-1455), Florentine sculptor. The
bronze gates are those of the Baptistery at Florence, representing
subjects from the Old Testament. On the first of the two gates
he spent twenty years. Michelangelo declared them worthy to be
the gates of Paradise.

163. (1471-1528) German engraver, draughtsman and painter,
of Nuremberg (Noricus). The "Adam and Eve" engraving,
intended at first for an "Apollo and Diana," was influenced by
a Venetian, Jacopo de Barbari. The "Coat of Arms with the
Skull," described twelve lines below, is of the same year probably.
"The Knight and Death" is a copper-engraving of 1513.

164. *Inferno*, xxi. 33.

> " with wings
> Buoyant outstretch'd and feet of nimblest tread."
> (Cary's translation.)

165. 1683-1765.

166. Pauline doctrine, visible especially in Romans viii. 11,
1 Corinthians vi. 20, and 2 Corinthians xv. 42-58.

167. Scotch Calvinism, in which Ruskin was brought up,
based its religious teaching on the " scheme " which was developed
by the logic of the Swiss Protestant reformer Calvin (1509-1564)
from Pauline teaching.

168. Romans xii. 15.

169. A group of painters, of whom Holman Hunt, Millais,
D. G. Rossetti and Ford Madox Brown were the chief, who, in
the 1850's, sought inspiration in early Italian art before Raphael.

170. Claude (1600-1682) and Gaspar Poussin (1613-1675), French lansdcape painters much admired in England in the 1840's and severely criticised for falseness to Nature and human feeling by Ruskin in *Modern Painters,* vol. I.

171. Pallas Athene, tutelary goddess of Athens.

172. Christ.

173. Ephesians v. 14.

174. John v. 4.

175. (1723-1792) Famous English portraitist and first President of the Royal Academy. To his " Discourses delivered to the Students of the Royal Academy " Ruskin always refers with admiration.

176. More generally spelt Hobbema, Dutch landscapist (1638-1709).

177. Architectural laws found in the ten books of a treatise, *De Architectura,* by Marcus Vitruvius Pollio, a Roman architect, accepted by Renaissance architects as the infallible guide in this art.

E. A. PARKER.

LEADING BOOKS ON RUSKIN

BIOGRAPHICAL

1. *Praeterita*, by JOHN RUSKIN.

The master's own account of his childhood and early days, written during his last years. An autobiography of the greatest charm and simplicity.

2. *Life and Letters of John Ruskin*, by W. G. COLLINGWOOD. 2 vols. 1893.

The earliest attempt at a biography of Ruskin, by one who was a pupil of his at Oxford and a neighbour and literary assistant for many years till Ruskin's death. The writer brings one very much into the atmosphere of Ruskin and close to the master's point of view. The book, having been published in Ruskin's life-time, is reticent about his intimate experiences. The pictorial illustrations —most beautiful and happily chosen—fulfil what Ruskin would have demanded of such a book and render it fit for inclusion in the library edition of his works. It is a main source book for all later biographies.

3. *Life and Letters of John Ruskin*, by E. T. COOK. 2 vols. 1911.

A very much fuller work than Collingwood's and freer in choice of materials, but less Ruskinian in atmosphere. The author was able to enter into details, a knowledge of which had become necessary for a complete understanding of Ruskin, and the book is likely to remain the standard biography.

4. *Records of Tennyson, Ruskin and Browning*, by ANNE THACK- ERAY RITCHIE. 1 vol. 1892.

Reminiscences by the eldest daughter of Thackeray. The ninety pages devoted to Ruskin cover memories of him from 1894, and were the best picture of him till Collingwood's *Life* appeared. The slight characterisations of his works and thought are no longer valuable, but the book still adds much, in recollections and side- lights, to the fuller pictures of Ruskin which have since been published.

5. *John Ruskin*, by FREDERIC HARRISON. English Men of Letters Series.

The handiest account of Ruskin's life by the leading English Positivist of the last sixty years. Harrison knew and worked

with Ruskin in 1860 and after, when he was one of the chief inspirers of intellectual socialism, and can speak with definiteness and authority of the socio-economic side of Ruskin's activity. Though very sympathetic and sometimes admiring, Harrison can criticise his subject with the freedom and authority of a co-worker in the same field, but with independent views and methods.

CRITICAL

6. *John Ruskin,* by MRS. MEYNELL.　Modern English Writers Series.　1901.

For an appraisement of Ruskin's ideas, particularly of those in art, Mrs. Meynell's is the first book to take in hand.　The writer's penetrating mind and pure and graceful English offer both an enlightenment and a pleasure to the reader which no other work of the kind on Ruskin renders.　Like everything from Mrs. Meynell's pen, it is a masterpiece.

7. *The Art Teaching of John Ruskin,* by W. G. COLLINGWOOD. 1891.

A solid work of 350 quarto pages for the more advanced student of Ruskin's artistic theories.　It combines the sympathy of an understanding disciple with the authority of an artist and connoisseur.

QUESTIONS

1. What is Ruskin's view, in the " Stones," on the relation of Art to Nature ?

2. Is Ruskin sound in mixing ethical and social considerations with architecture ?

3. State what Ruskin considers the ideal relations between workman and architect. Can we re-introduce them to-day ?

4. How far can modern science serve the art of building ?

5. What are Ruskin's objections to Renaissance architecture ? Do they apply to any building you know ?

6. What form of decoration do you think most suitable to a modern town-house ?

ESSAY SUBJECTS

1. The finest Gothic building I know. An Impression (or Description).

2. Ferro-Concrete versus Stone for great public buildings.

3. An ideal middle-class house of six or eight rooms constructed on principles of utility and modest beauty.

4. Venice in the days of Marco Polo and of Byron. A Contrast.

5. Architecture the mother of decorative arts.

6. " Architecture is frozen music."

PRINTED IN GREAT BRITAIN BY ROBERT MACLEHOSE AND CO. LTD., THE UNIVERSITY PRESS, GLASGOW.